**Perspectives on Medieval Art**
Learning through Looking

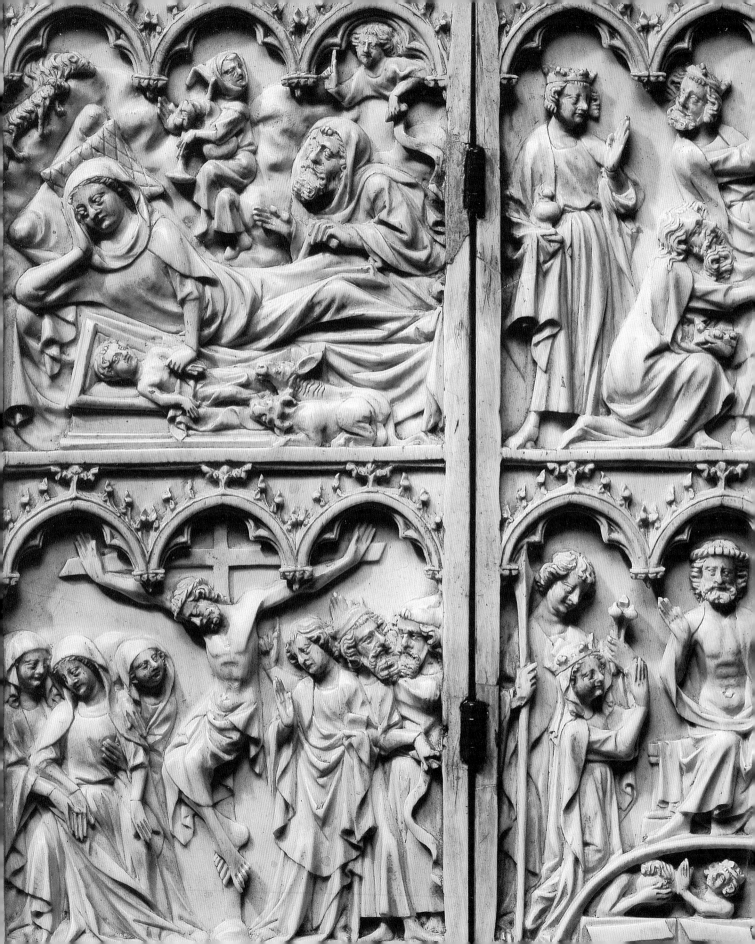

# Perspectives on Medieval Art
## Learning through Looking

Edited by Ena Giurescu Heller and Patricia C. Pongracz
With an essay by Thomas Cahill
And contributions by
Dirk Breiding
Margot Fassler
Ena Giurescu Heller
Robin M. Jensen
Kathryn Kueny
C. Griffith Mann
Mary C. Moorman
Patricia C. Pongracz
Xavier John Seubert
Nancy Wu

MUSEUM OF BIBLICAL ART
MOBIA **g**

Museum of Biblical Art, New York
in association with D Giles Limited, London

This volume is published from the proceedings of the symposium *Seeing the Medieval: Realms of Faith/Visions for Today* organized by the Fordham Center on Religion and Culture, Fordham University and the Museum of Biblical Art (MOBIA), New York in conjunction with the exhibition *Realms of Faith: Medieval Art from the Walters Art Museum*, exhibited at MOBIA March 5 – July 13, 2008.

First published jointly in 2010 by GILES
An imprint of D Giles Limited
4 Crescent Stables. 139 Upper Richmond Road, London SW15 2TN, UK
www.gilesltd.com

and Museum of Biblical Art
1865 Broadway (at 61st Street),
New York City,
NY 10023, USA
Phone: 212-408-1500
Fax: 212-408-1292
info@mobia.org
www.mobia.org

Library of Congress Cataloging-in-Publication Data
Perspectives on medieval art : learning through looking / edited by Ena Giurescu Heller and Patricia C. Pongracz ; with an essay by Thomas Cahill and contributions by Dirk Breiding ... [et al.].
     p. cm.
  Includes bibliographical references and index.
  Selection of papers presented at the symposium Seeing the Medieval: Realms of Faith/Visions for Today, held May 30–31, 2008, organized by Fordham Center on Religion and Culture and the Museum of Biblical Art.

ISBN-13: 978-1-904832-69-0 (hc. : alk. paper)
ISBN-10: 0-9777839-5-2 (pbk. : alk. paper)
  1.  Civilization, Medieval--Study and teaching--Congresses. 2.  Middle Ages--Study and teaching--Congresses. 3.  Art, Medieval--Study and teaching--Congresses.  I. Heller, Ena Giurescu. II. Pongracz, Patricia. III. Museum of Biblical Art. IV. Fordham University. Center on Religion and Culture.
  CB351.P423 2009
  909.07--dc22

                         2009018830

ISBN (hardcover): 978-1-904832-69-0
ISBN (softcover): 978-0-9777839-5-3

This volume was edited by Dr. Ena G. Heller, Executive Director of the Museum of Biblical Art and Patricia C. Pongracz, Curator-at-Large.

With an essay by Thomas Cahill and contributions by Dirk Breiding, Margot Fassler, Ena G. Heller, Robin M. Jensen, Kathryn Kueny, C. Griffith Mann, Mary C. Moorman, Patricia C. Pongracz, Xavier John Seubert, and Nancy Wu.

Volume Design: Anikst Design, London
Produced by D Giles Limited, London
Printed and bound in China

All measurements are in inches and centimeters; height precedes width.

Major support for *Perspectives on Medieval Art: Learning through Looking* has been provided by the Henry Luce Foundation.

Front cover illustration: *The Procession of Pope (Saint) Gregory the Great for the cessation of the plague in Rome* (left half). Illuminated miniature from the *Très Riches Heures du Duc de Berry: The Penitential Psalms*, 1416. Ms. 65, f.71 verso. Photo: R.G. Ojeda.  Réunion des Musées Nationaux / Art Resource, NY.

Inside cover illustration: Diptych with the *Nativity, Adoration of the Magi, Crucifixion, and Last Judgment*, Flanders or northeastern France, *ca.* 1375–1400. Ivory, 6 ⅝ × 3 ⅛ in. (16.8 × 8 cm). The Walters Art Museum, Baltimore (71.201, acquired by Henry Walters, 1925).

Back cover illustration: The Workshop of the Master of Flémalle. *Annunciation* Triptych (Mérode Altarpiece). South Netherlands, Tournai, *ca.* 1427–1432.
Oil on oak panel, overall (open) 25 ⅜ × 46 ⅜ in. (64.5 × 117.8 cm). The Metropolitan Museum of Art, The Cloisters Collection, 1956. (56.70a-c).
Image © The Metropolitan Museum of Art.

# Contents

Foreword      7
*Ena Giurescu Heller and Patricia C. Pongracz*

Why the Medieval Matters      11
*Ena Giurescu Heller*

The Middle Ages in Life and Art      31
*Thomas Cahill*

**1    Teaching Medieval Art in Museums and on the Web**

From the Lecture Hall to Museum Gallery:
Teaching Medieval Art Using Primary Objects      77
*Patricia C. Pongracz*

Teaching Medieval Architecture at The Cloisters      93
*Nancy Wu*

Cataloguing Medieval Manuscript Fragments:
A Window on the Scholar's Workshop, with an Emphasis
on Electronic Resources      109
*Margot Fassler*

**2    Reading Medieval Liturgical Objects: Perspectives from
Different Fields of Study**

The Living Past: Form and Meaning in a Late Medieval
Eucharistic Chalice from the Walters Art Museum      129
*C. Griffith Mann*

Liturgical Instruments and the Placing of Presence      137
*Xavier John Seubert*

What the Eucharist Dove Teaches: Protestant
Theology Students and Medieval Liturgy                147
*Robin M. Jensen*

A Theological Reading of Medieval Eucharistic Vessels
as Emblems of Embrace                                157
*Mary C. Moorman*

**3   Broadening the Perspective**

Arms and Armor: a Farewell to Persistent Myths and
Misconceptions                                      167
*Dirk H. Breiding*

The Cure of Perfection: Women's Obstetrics
in Early and Medieval Islam                         187
*Kathryn Kueny*

Notes                                               198

Suggestions for Further Reading                     217

Contributors                                        219

Index                                               222

# Foreword

In the spring of 2008, the Fordham Center on Religion and Culture and the Museum of Biblical Art (MOBIA) invited a group of scholars to consider the Middle Ages, in particular the relevance of this period to today's world. Over the course of a two-day symposium entitled *Seeing the Medieval: Realms of Faith/Visions for Today*, scholars addressed topics ranging from "Why the Medieval Matters," to "Life and Art in the Middle Ages," to discussions of particular works of art on display at MOBIA in the exhibition *Realms of Faith: Medieval Art from the Walters Art Museum* (March 5–July 13, 2008). This group of historians of law, religion, art, music, Christian worship, theology and art, and museum curators gathered to consider issues and works of art from their specific disciplines. A selection of those papers is presented here.

The diversity of expertise informing this volume underscores the richness of medieval culture and the interdisciplinary approach the study of the Middle Ages demands. The essays included here address questions such as: how do we present the Middle Ages accurately and without compromising scholarly integrity to twenty-first century museum-goers and students? How do we contextualize as fully as possible medieval objects in lectures and exhibitions? How do we make accessible to a general public objects that even specialists have difficulty approaching? And how do we do this in an engaging way—a point emphasized by symposium participant Charles Reid, who commented:

> What you have to do is exercise your imagination, try to recreate the thought world, and how the different concepts fit into the larger medieval thought world. That's the imaginative leap you have to take as part of this exercise.

How do we help our audiences make this imaginative leap? We offer this collection of essays as but one way to help inform the readers' imaginations. Our hope is that the reader finds models in the approaches presented here, so that he or she can continue to explore the mysteries of the Middle Ages in all their complexity. The thematic core of the volume is to show the many different interpretations engendered by any one object or collection of objects. Through the case studies offered here, we hope to show just how much we can learn through the juxtaposition of various interpretations from different fields of study. This approach puts front and center the polyvalent character of medieval objects and the need to examine them from multiple areas of expertise in order to appreciate or understand them. The readings included here encourage the secular academy, museums and theological seminaries to work together in a shared intellectual pursuit: the

8    reevaluation of the active way in which art shaped and influenced medieval devotional practices and vice versa.

To that end, the volume is introduced by two essays that discuss medieval culture and its relevance today in broad terms. Section I brings the Middle Ages into the classroom demonstrating how objects can be used to enhance, illuminate and explain aspects of medieval culture. The essays in Section II address a selection of objects displayed in *Realms of Faith* from the perspective of different fields of study. Together they show how a multidisciplinary approach can enhance our understanding of the objects' original function and symbolism. Finally, Section III broadens our perspective by including aspects of medieval culture that had not been covered directly by the exhibition. The essays point the way for further research and offer but two models of other interpretive approaches.

The exhibition and symposium upon which this volume is based were the collective work of many talented and committed people. Our thanks go first to the Walters Art Museum and its director, Gary Vikan, for lending their treasures to MOBIA in the exhibition that created the background for the symposium. Georgi Parpulov, then Mellon Fellow at the Walters, selected the objects and conceptualized the exhibition around the three distinct "Realms of Faith." At MOBIA, Curators Eric Ramirez-Weaver, and Paul Tabor, Curator of Education Dolores de Stefano, and Curatorial Intern Michelle Oing all contributed to researching and interpreting the artworks, and creating the broader dialogue with the public through didactics and educational programs.

The symposium was MOBIA's second successful partnership with the Fordham Center on Religion and Culture. Our thanks go to the Center's co-directors, Peter Steinfels and Margaret O'Brien-Steinfels, for co-organizing and co-hosting the two days of engaging conversations during *Seeing the Medieval: Realms of Faith/Visions for Today* (May 30–31, 2008). We would also like to extend our thanks to all the participants in the symposium: Dirk H. Breiding, Thomas Cahill, Margot Fassler, Robin M. Jensen, Kathryn Kueny, C. Griffith Mann, Mary C. Moorman, Francis Oakley, Charles Reid Jr., Nina Rowe, Xavier John Seubert, Laura Weigert, and Nancy Wu. Their contributions and the discussions that ensued informed the editors of this volume at every step, and made our job so much easier.

The volume itself is a testimony to the teaching model it hopes to inspire, as it was written by a diverse group of scholars who work in different fields and different academic and museum environments: their collective wisdom and expertise create the multi-faceted lens that makes the Middle Ages come to life for a general public. We are deeply grateful to them, for we have learned something

new from every one of their essays: Dirk H. Breiding, Thomas Cahill, Margot Fassler, Robin M. Jensen, Kathryn Kueny, C. Griffith Mann, Mary C. Moorman, Xavier John Seubert, and Nancy Wu. From written word to printed book is a long and difficult journey; we are grateful for the expertise of MOBIA staff Michelle Oing and Ute Keyes and our publishing partners at D Giles Limited for making the journey seem effortless.

Last, but most certainly not least, our deep gratitude goes to the Henry Luce Foundation, whose generous support made both the symposium and the book a reality. The Luce Foundation has been an invaluable supporter of MOBIA through the years, and has helped us realize dreams small and large. Special thanks go to Michael Gilligan, President of the Luce Foundation, one of the earliest champions of MOBIA, and to Lynn Szwaja, Program Director for Theology, who helped us think through the concept for symposium and volume from the earliest stages. This is our second publication that is due to the unique interest of the Henry Luce Foundation in educating the general public, as well as theological and secular academic circles, in the interdependency of art and religion. Our first collaborative volume, *Reluctant Partners: Art and Religion in Dialogue,* was used as a textbook by both colleges and theological seminaries; we hope that *Perspectives on Medieval Art* will serve a similar function.

We have conceived this volume as a springboard to further learning. We hope that it will inform and excite, will pose questions and offer avenues of research—and will remind readers that the Middle Ages matter, and that learning about them will enrich our lives.

Ena Giurescu Heller
Patricia C. Pongracz

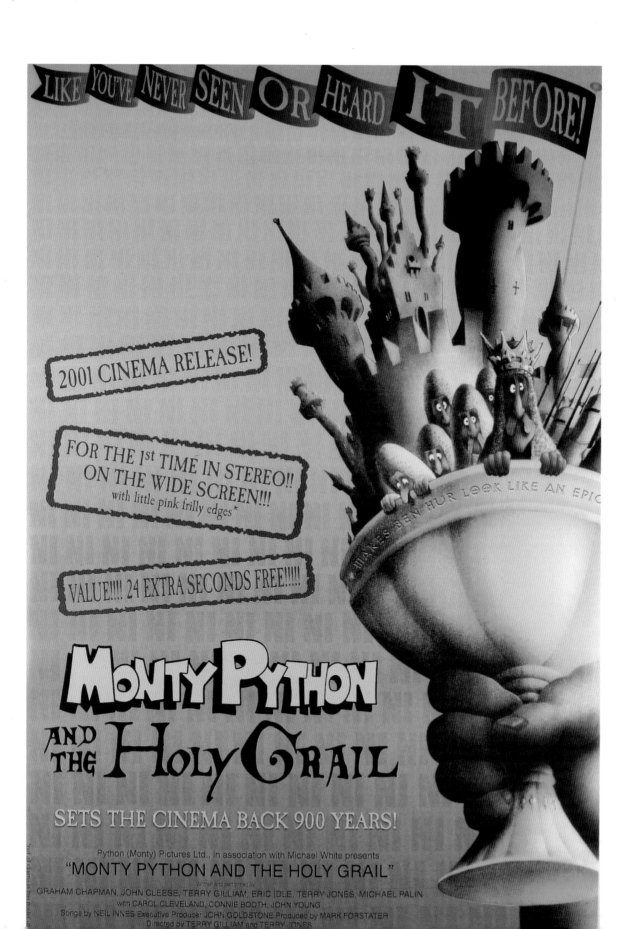

# Why the Medieval Matters

Ena Giurescu Heller

...all the problems of the Western world emerged in the Middle Ages.
   Umberto Eco

As a part-time medievalist, I start from a completely biased perspective: the medieval does matter. The Middle Ages are an essential stepping stone in the evolution of modern western society, and without medieval art our understanding of images, and more generally visual culture, would be substantially different. Yet I realize that not everybody feels that way, and that for many of us today the negative stereotypes about the medieval period tend to outweigh the role it has played in our collective history. The problem is, as a society we do not know very much about the Middle Ages, and we have trouble differentiating among history, legend, and myth.

Modern technology has only compounded the problem: when I googled "Holy Grail," the first hit was a definition and short history of the grail in Wikipedia (a notoriously inaccurate source of information), followed by a description of the 1975 film *Monty Python and the Holy Grail* (fig. 1). The *Catholic Encyclopedia* was a distant third on the list of relevant resources.

Indeed, many of us take our knowledge of the Middle Ages from Monty Python and Indiana Jones, from childhood tales (and movies we saw as adults) of knights in shining armor and princesses in need of rescuing.[1] When I started thinking about whether the medieval, and in particular medieval art, should matter to us in the early twenty-first century, I performed a test of sorts, albeit an anecdotal one. I asked colleagues, friends and family what is the first thing that comes to mind when they hear the word "medieval." Other than the art-historically conditioned answers including "cathedrals," "stained glass," and "relics," most responded with "knights in shining armor, princesses, and castles," with some variation in their order, and for the younger generation, the occasional addition of "romance" and "Heath Ledger" (by virtue of his star-making role in 2001's *A Knight's Tale*). A close second was the answer "torture." Indeed, equally many people take their cues about the Middle Ages from tales of bloody crusades, the Spanish Inquisition (which only the incomparable film director Mel Brooks could turn into comedy) and torture—all of which led to modern usage of the term "medieval" to equate retrograde or backwards at best, and cruel, inhuman or abhorrent, at worst. In recent years this usage has surfaced with some frequency in the mass media, referring particularly to the war in Iraq, as in the headline "Why CIA abuse is medieval madness" for a story describing prisoner abuse (equated with "medieval torture")

Fig. 1
*Monty Python and the Holy Grail*, 2001. Poster to promote the 2001 re-release of the film *Monty Python and the Holy Grail*, 1975, directed by Terry Gilliam and Terry Jones.

**12**    at Abu-Ghraib.[2] Acknowledging the truly abhorrent treatment of prisoners (so unbelievable for the "civilized" twenty-first century we had to mentally place it in the past), is this fair to the Middle Ages?

My admittedly biased answer is no, it is not fair. And I am in good company—not only all the distinguished writers of this book, whose essays are as many reasons why we should know and love the Middle Ages, but also many others, scholars and writers and artists, for whom the medieval period represents an important legacy and creative force, an inspiration and a fascinating field of study. Umberto Eco found it "not surprising that we go back to that period [the Middle Ages] every time we ask ourselves about our origin." He went on to write:

> We are dreaming of the Middle Ages, some say. But in fact both Americans and Europeans are inheritors of the Western legacy, and all the problems of the Western world emerged in the Middle Ages: modern languages, merchant cities, capitalistic economy (along with banks, checks, and prime rate) are inventions of medieval society. In the Middle Ages we witness the rise of modern armies, of the modern concept of the national state, ...even our contemporary notion of love as a devastating unhappy happiness. I could add the conflict between church and state, trade unions, ...the technological transformation of labor.[3]

If indeed we owe most of our modern western selves to the Middle Ages, why do we find them so elusive, different, incomprehensible, foreign – in one word, "medieval"? I will try to answer this question from the vantage point of art, specifically religious art (which was the premise of the exhibition and symposium that led to this publication). One possible answer is that our understanding of and response to medieval religious art is completely different (antithetical, really) to the response of its contemporaries.

In the twelfth century, Hugh of St. Victor wrote about how to properly look at the decoration of churches:

> The foolish man wonders only at the beauty in those things; but the wise man sees through that which is external, laying open the profound thought of divine wisdom.[4]

The frescoes and stained glass adorning the walls and windows of medieval churches, the statues in niches, the altarpieces and liturgical implements brought

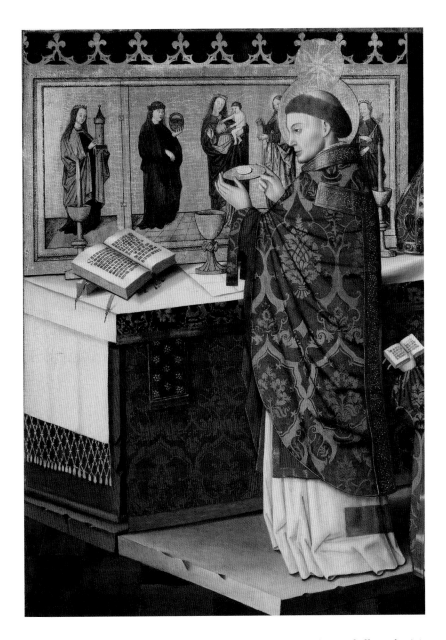

Fig. 2
Franconian School.
*Miraculous Mass of St.
Martin of Tours*, about
1440. Tempera and gold on
canvas on panel,
36 ⅛ × 32 ¾ inches.
Allentown Art Museum,
Samuel H. Kress Collection,
1961. (1961.45).

out during Mass were neither objects of any veneration (least of all aesthetic),
nor ends onto themselves. They were tools—tools for the liturgy, and, as St. Vic-
tor points out, tools for transporting their beholders to the divine realm they
symbolize and serve. The faithful would see them only during worship, as inte-
gral elements of the service, whether they are functional objects such as the book
and chalice on the altar, and the paten held up by the celebrant (fig. 2), or im-
ages whose stories and symbols invoke the celestial realm and the deeds of those
worthy to reach it. The functions of images are summarized by St. Bonaventure
(1221–1274) as follows:

> In fact they [images] were introduced for a triple reason, namely, because of
> the ignorance of humble people, so that they who cannot read the scriptures
> can read the sacraments of our faith in sculptures and paintings just as one

would more manifestly in writings. They are likewise introduced because of the sluggishness of feelings, namely so that men who are not stimulated to devotion by the things that Christ did for us when they hear about them are excited at once when they become aware of the same things in statues and pictures, as if present to the body's eyes.... Hence it has been established by the grace of God that images appear especially in churches, so that, seeing them, we will be reminded of the benefits bestowed on us and of the worthy deeds of the saints.[5]

From the outset, then, the modern point of view is distinct—and distinctly different. Museums take these objects completely outside of their intended context and present them first and foremost as art (whose appreciation is primarily, if not exclusively, aesthetic); but even in those cases where religious medieval art is preserved in situ, today we experience it differently than its original beholders on several distinct levels.

Let us use a specific example: say we are visiting the Franciscan church of Santa Croce in Florence. Inside the church, we stop to look in more detail at the Baroncelli Chapel at the end of the transept (fig. 3).[6] This chapel, which was added to the existing church sometime in the late 1320s and early 1330s, is a rare example of an intact fourteenth-century ensemble, which includes not only its architecture (and sculptural decoration) but also the frescoes, stained glass, and even altarpiece. And although the art and architecture date from the fourteenth century, our experience of the space is remarkably different than it would have been at the time.[7] We start with the reason we are there, tourism (a concept foreign to the Middle Ages, when the only travel to such sacred sites was in the context of pilgrimage—travel motivated by faith rather than intellectual curiosity or a desire to travel for its own sake).[8] Thus we perceive the chapel primarily as art, and during our visit we receive rather different information from our hosts—guides and teachers instead of priests and friars.

Upon reaching the entrance into the chapel and taking in the startlingly beautiful interior covered in a mantle of color (fig. 4), we learn about the history of the space, built by members of the Baroncelli family and dedicated to the Virgin Annunciate. Accordingly, the iconography of the frescoes by Taddeo Gaddi and of the altarpiece, by the patriarch of Renaissance painting, Giotto, celebrate the Life of the Virgin. We learn about the relationship between teacher (Giotto) and student (Gaddi), and about particular innovations by Gaddi in the handling of light and perspectival space. We take some pictures and move on, content to know

Fig. 3
Interior view of Santa Croce, showing the Baroncelli Chapel on the left, Florence, Italy. Foto: Kunsthistorisches Institut in Florenz -Max-Planck-Institut.

Fig. 4
*following spread*
General view of the Baroncelli Chapel in Santa Croce, Florence, Italy. Scala/Art Resource NY.

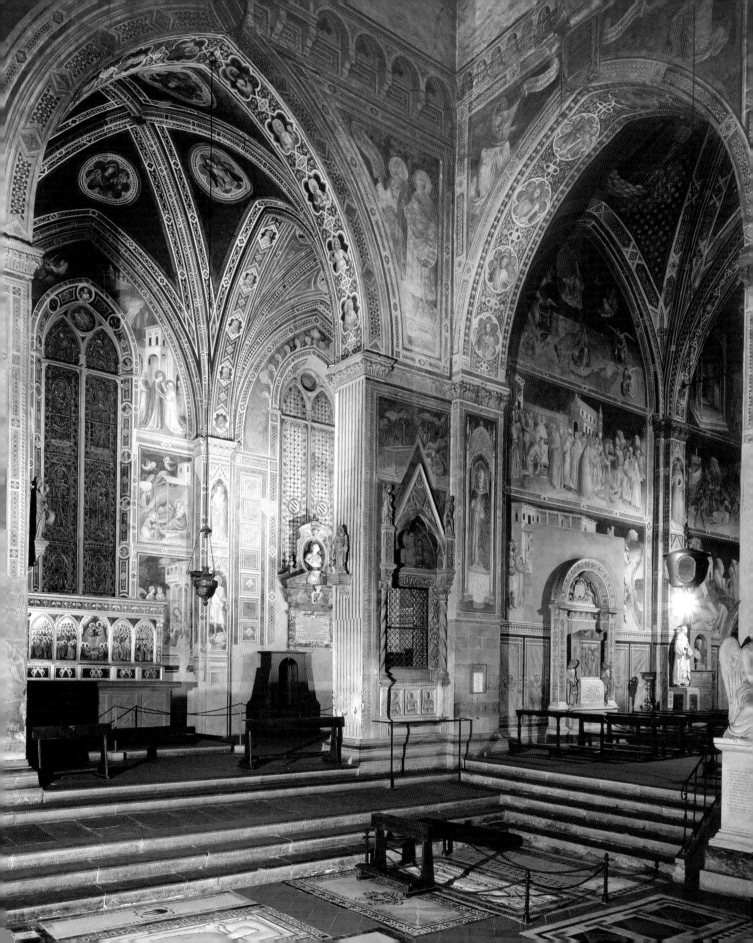

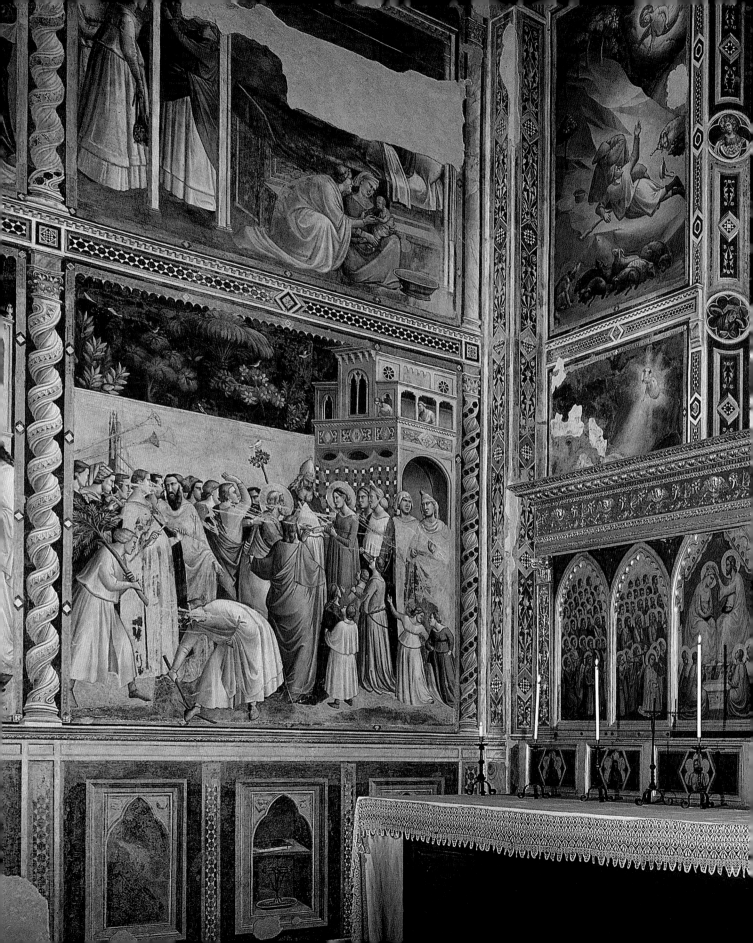

18 some basics about a wonderful—and wonderfully preserved—exemplar of mid-fourteenth-century Florentine art, to have received a glimpse into the medieval world of architecture, painting, and patronage.

The experience of a fourteenth-century beholder would have been very different. On regular days, worshippers in the church could not even enter the Baroncelli Chapel as the now long gone *cancello* or wrought iron gate that spanned its entrance would have been locked.[9] Only rarely would the select few (i.e. the Baroncelli family and their peers) have been allowed access, on the occasion of funerals or votive Masses celebrated in the chapel. It would be in an atmosphere of worship, then, that fourteenth-century beholders would take stock of the interior of this beautifully decorated space. They clearly would not have thought about the perspectival skill of the painter, or identified innovations in the iconography—except perhaps for the occasional boasting by the patrons. The art was there not for its own sake but to create an environment for worship. Contemporary documents also treat the works in various media as integral parts of what was considered to be the "honorable" decoration of a funerary chapel at the time—which really meant a space decorously embellished as a proper environment for burials and Masses for the dead. Finally, what contemporary sources (both documentary and visual) reveal is that the very participation in worship was often much fuller, and more fully sensory than in modern times. The contact with sacred personages, their relics, even objects that once belonged to them, was too much for many an ordinary human, as we are reminded in numerous medieval illuminations depicting people fainting and needing to be held up (fig. 5). The liturgy itself could have similar effects, as attests a text dating from the fourth century:

> At the beginning of the reading [of the Gospel] the whole assembly groans and laments at all the Lord underwent for us, and the way they weep would move even the hardest heart to tears....It is impressive to see the way all the people are moved by these readings, and how they mourn. You could hardly believe how every single one of them weeps.[10]

In the remainder of this essay, I would like to illustrate only two of the culture-changing legacies of the Middle Ages with respect to art. The first derives from the intensely symbolic character of medieval art: more often than not, images in the Middle Ages, while being part of a narrative or decorative scheme, also had a symbolic meaning, usually connected with the predominant Christian faith (but also

Fig. 5
*The Procession of Pope (Saint) Gregory the Great for the cessation of the plague in Rome* (left half). Illuminated miniature from the *Très Riches Heures du Duc de Berry: The Penitential Psalms*, 1416. Ms. 65, fol. 71 verso. Photo: R.G. Ojeda. Réunion des Musées Nationaux / Art Resource, NY.

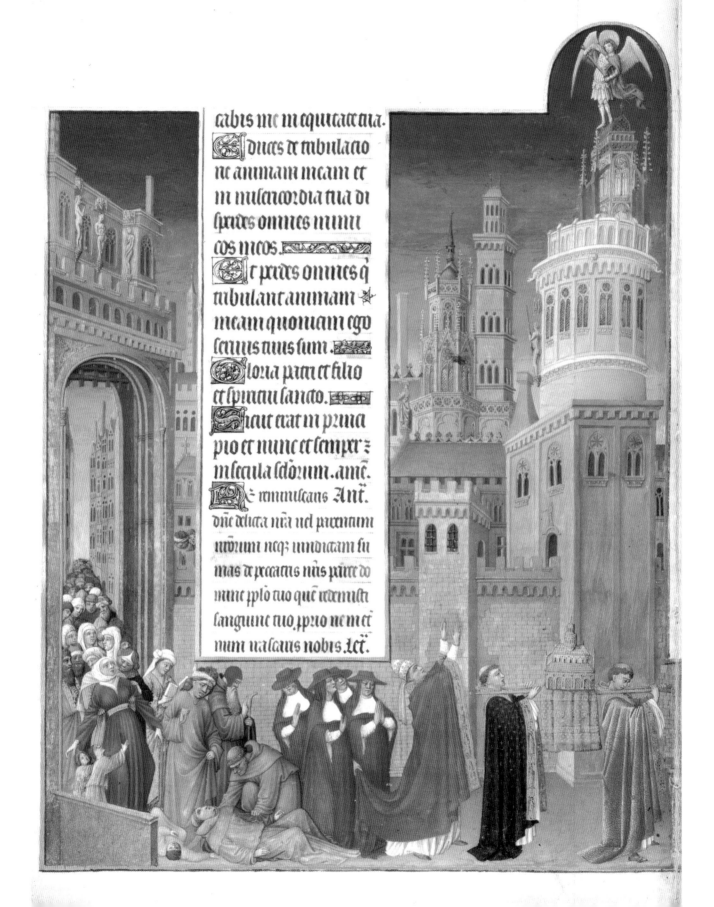

cabis me in equitate tua.
Dues de tribulacio
ne animam meam et
in misericordia tua di
spades omnes inimi
cos meos.
Et pdes omnes q
tribulant animam
meam quoniam ego
seruus tuus sum.
Gloria patri et filio
et spiritui sancto.
Sicut erat in prin
pio et nunc et semper z
in secula sclorum . amē.
Dz remuiscans Ant.
dñe delicta nra uel parentum
nrorum neqz uindictam su
mas de pccatis nris parce do
mine ipulo tuo quē redemisti
sanguine tuo ppno ne in et
num irascaris nobis. Lct.

20

with various other beliefs of the times). According to St. Germanos, patriarch of Constantinople (715–30), "the church is an earthly heaven in which the supercelestial God dwells and walks about."[11] It follows that everything inside the church, from wall paintings to liturgical implements, and from furnishings to vestments, is there to serve a higher purpose—and to lift our spirit toward it or, in other words, to symbolize it. It is through symbolism that the visible is connected with the invisible—and decoding it is essential to the modern understanding of images.

I will use but one example to illustrate how symbolism is part and parcel of a medieval work of art, and how understanding it makes the work both more accessible and more fascinating. The work is *The Unicorn at the Fountain,* the second tapestry in the unicorn series (ca. 1495–1505) now in the collection of The Cloisters in New York City (fig. 6).[12] In this tapestry men, animals, and plants surround a central fountain into which the protagonist of the story, the unicorn, dips his horn. The full narrative depicts the hunt for the unicorn; this episode explains why the hunters were trying to capture the beast. In medieval times, the unicorn was believed to be a real (albeit admittedly rare) animal whose horn possessed miraculous powers: here he purifies the water that had been poisoned, according to legend, by serpents. Yet the Hunt for the Unicorn is much more than a chivalric tale of hunting a beast whose horn would not only be a rare trophy, but could also protect its owners from poisoning and other evils. From the early Christian centuries, the unicorn becomes a symbol of Christ; as the story unfolds, details are added, transformed or reinterpreted to fit the Christian narrative of sacrifice and redemption.[13] The unicorn is known to be extremely fierce, and cannot be taken by ordinary hunters; the only way to capture him is with the help of a virgin maiden. Attracted by her beauty and purity of heart, the beast will come to rest his head in her lap; and at that moment the hunters can strike and kill him. This parallels the story of the Son of God who came to earth and became human through the womb of the Virgin Mary, only to be sacrificed for the salvation of humankind. In the story of the unicorn, thus, the sacrifice is equally necessary—and yet in the last tapestry in the series, after the killing, we see the beast alive again, a symbol of the resurrected Christ. Thus reads a ninth-century text, one of the popular bestiaries detailing the characters—real and symbolic—of animals real and imaginary:

> [the unicorn] is a small animal, like a kid, but exceedingly fierce...men lead a virgin maiden to the place where he most resorts and they leave her in the forest alone. As soon as the unicorn sees her, he springs into her lap and embraces her. Thus he is taken captive.... In this way Our Lord Jesus Christ, the

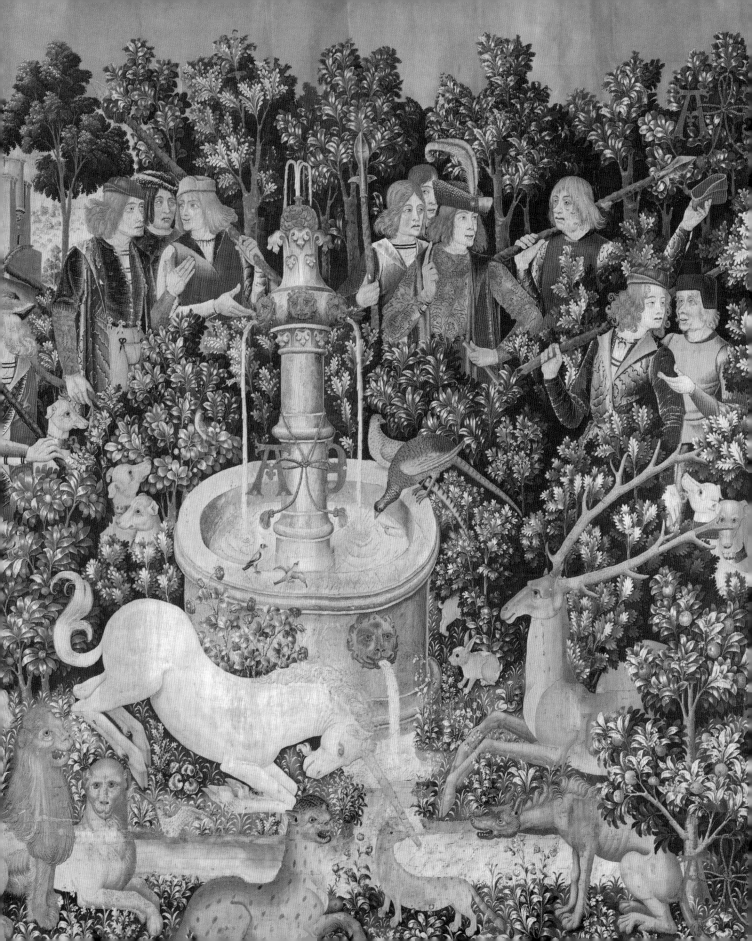

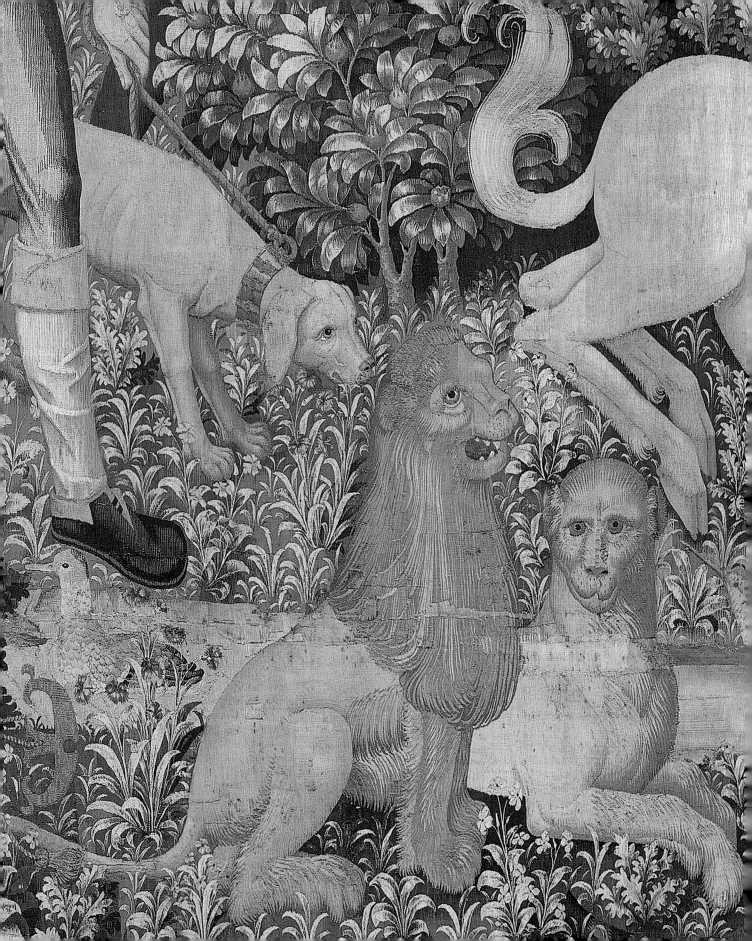

spiritual unicorn, descended into the womb of the Virgin and through her took on human flesh. He was captured by the Jews and condemned to die on the cross. Concerning him...Zacharias says, "He hath raised up a horn of salvation for us in the house of his servant David" (Luke 1:69).[14]

This is the general plot. Yet looking at details in the scene of the Unicorn at the Fountain, we begin to unveil many other layers of its complex and truly fascinating symbolism. It is almost as if no detail of the composition were accidental. Around the back of the fountain there are twelve hunters (the twelve Apostles?) with their hounds; in front of it, alongside the unicorn, we see two lions, a stag, a panther, a weasel, and two rabbits. On the rim of the fountain perch goldfinches and pheasants. It may seem that all these animals are there simply to drink the purified water, attesting to the unicorn's powers. Medieval bestiaries suggest, however, that they all have symbolic meanings; and presently their symbolism, as well as that of plants, weaves in and out of the Christological interpretation of the hunt of the unicorn, adding interpretive richness.[15] Most interestingly, parallel meanings sometimes come out of pre-Christian traditions and mythologies. A few examples will suffice here: the pomegranate that crowns the fountain is linked by a number of medieval writers to the blood of Christ (making it a symbol of the Crucifixion), yet it also has a more ancient history as a pre-Christian symbol of fertility (making it an emblem of resurrection and immortality even in pagan mythologies). The lion has an even larger number of symbolic meanings (fig. 7). The king of the jungle, known for his strength and leadership, he stands for Christ primarily by virtue of a popular medieval legend according to which the lion's cubs are born dead and brought back to life by their father on the third day (just as Christ was resurrected three days after the Crucifixion through the will of his Father). But the lion also stands for watchfulness in several different mythologies; in the Christian Middle Ages, a widely spread belief held that lions always sleep with their eyes open, lest someone think they are not always on the alert (this led, in art, to placing lions on either side of the entrance to churches, guarding as it were the house of good from any potential evil). Additionally, the lion is a symbol of fidelity, mercy and courage. Plants and flowers also do their part to emphasize (and emphasize yet again) the main idea of the tapestry, the confrontation of good and evil, of Christ and Satan, of virtue and vice: the white campion seen immediately to the left of the lion's mane, near the foot of one of the hunters, was a plant of evil—matched with goblins and death (hence its frequent inclusion in scenes of the Last Judgment). On the other hand, sage was associated with salvation (as its

Figs. 6 and 7
*previous page and detail*
*The Hunt of the Unicorn*,
*ca.* 1495–1505. Wool warp, wool, silk, silver, and gilt wefts, 145 × 149 in. (368.3 × 378.5 cm). South Netherlandish. Gift of John D. Rockefeller Jr., 1937 (37.80.2). Location: The Metropolitan Museum of Art, New York, NY, U.S.A. Image copyright © The Metropolitan Museum of Art / Art Resource, NY.

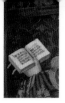

very name, derived from the Latin verb *salvare*, "to save," implies).

These select examples, which can be multiplied by the hundreds in medieval art, remind us how our modern reading of images takes its cues from the multilayered meanings offered by the visual in medieval times. Multiple interpretations, sometimes contradictory, different vantage points, symbolism, deconstruction—all these seemingly modern notions find their roots in the pre-modern period, the period that has given us the visual and interpretive skills we now use to navigate our once-again predominantly visual culture.

This brings me to another long-lasting legacy of medieval art: in it are rooted some of our society's stereotypes and preconceived notions, so familiar we no longer notice them, yet deep enough we perpetuate them. One of them concerns the representation of outsiders, outcasts, strange creatures and so forth; in other words, "the other." In the western medieval pictorial language, they are usually conceived in opposition to representations of the Christian faithful, and often cast as the enemy. They include both real and imaginary characters, human and sub-human, from the depiction of evil (devils, demons and their relatives) to deformity. Deformity, in medieval terms, could be either biological (often interpreted to reflect vice and evil), or the absence of the "true" faith in a person.[16] Take, for instance, the Jews, consistently depicted as physically unattractive, often repellent, in clear contrast to the physical beauty of sacred characters.[17] A thirteenth-century miniature of *Christ before Caiaphas* from a Book of Hours epitomizes this contrast, often found in those scenes from the Passion of Christ where he is confronted with his tormentors and executioners (fig. 8). The crooked, beak-like noses of Caiaphas and his retinue, their goat-like beards, bulging eyes and evil smirks and frowns, are common in medieval representations of Jews. The goatish beards are elsewhere joined by horns—as Jews were linked to this particular beast in several different ways. Sometimes Jews are shown riding a goat (a symbol of the devil), and medieval texts mention a certain "Jewish odour" which resembles that of a goat and only disappears when one is baptized.[18] Such images were fueled by widespread anti-Semitism, which deepened as the Middle Ages progressed; starting with the twelfth century it became manifest at all levels, from official decrees limiting Jewish rights and institutionalizing their persecution to popular hatred and fear. The Fourth Lateran Council of 1215 legislated that Jews need to be differentiated by their dress, lest they socialize with Christians; half a century later, in 1267, Pope Clement IV extended the authority of the Inquisition specifically to prosecute Jews (so they do not influence, or "pollute," their fellow Christians).[19] In addition to official church decrees, Christian polemical literature against Judaism was rather

Fig. 8
*Christ before Caiaphas*.
Illuminated miniature
from the Salvin Hours,
*ca.* 1275. London, British
Library, Add. MS. 48985, fol.
29r. Image © The British
Library.

desideratam nobis tue propitiationis ha
bundantiam multiplicatis intercessori
bus largiaris. p̄ <del>Ad primam</del>

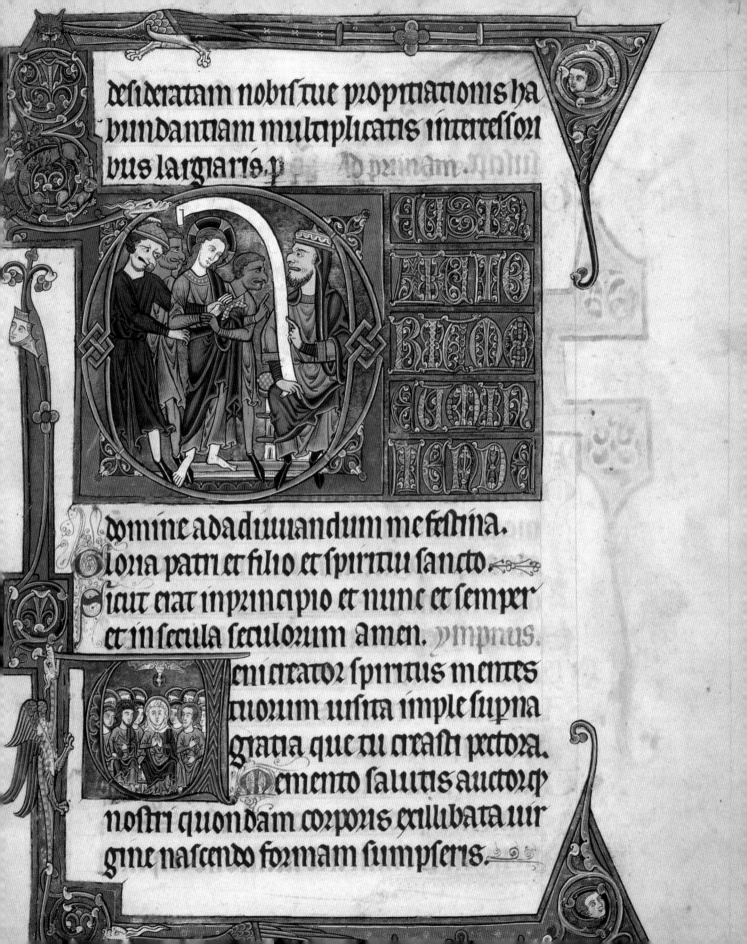

domine ad adiuuandum me festina.
Gloria patri et filio et spiritu sancto.
Sicut erat in principio et nunc et semper
et in secula seculorum amen. ympnus.
Veni creator spiritus mentes
tuorum uisita imple supna
gratia que tu creasti pectora.
Memento salutis auctor quod
nostri quondam corporis exillibata uir
gine nascendo formam sumpseris.

prolific in medieval times, including historical chronicles, royal documents, canonist texts, as well as anti-Semitic tracts, poetry, and drama. A late fifteenth-century anti-Semitic tract circulated describes the Jews in the following manner:

> There is no people more wicked, more cunning, more avaricious, more impudent, more troublesome, more venomous, more wrathful, more deceptive and more ignominious.[20]

These beliefs, officially sanctioned or simply fueled by popular paranoia and myth, influenced depictions of Jews in art. One of the oldest extant caricatures, in a Jewish Receipt Roll dating from the early thirteenth century, has a Jewish resident of Norwich depicted as a three-headed monster surrounded by horned characters, half-human, half-demon (fig. 9). In the foreground, a devil figure also sporting the now familiar goatee is touching the nose of another Jew, in a gesture that could be interpreted as familiarity; additionally, Jews and demons share the same physiognomy. These stereotypes are unfortunately long-lived, and not exclusive to medieval society. We still feel their burdensome legacy today. From the pioneering, minute-long *Cohen's Advertising Scheme* of 1904 to Alec Guinness's masterful portrayal of Fagin in the 1948 screen adaptation of Charles Dickens's *Oliver Twist*, Jewish stereotypes of the "scheming merchant" and arch-thug are present in the preeminent visual medium of the twentieth century, film. Biblically inspired movies, in turn, picked up the medieval depictions of Jews in the context of the Christological narrative—the priests who decide the fate of Jesus are as ugly as they are evil. Watching these movies we are again reminded that pictures are worth a thousand words.

I use the case of medieval Jewry here simply to illustrate the wider issue—still present in modern society—of stereotyping certain outsider groups (the definition of outsiders being established, throughout history, by the majority and/or by the rulers). These groups included Muslims and lepers, prostitutes and the lame, Ethiopians and other "rejected social groups."[21] Defining "the other" in opposition to the majority on all levels, from appearance and dress to belief and behavior, has led to the concept, still alive and well in the twenty-first century, of the clash of civilizations, of "us versus them." Now again, this opposition—this medieval stereotype—refers to enemies both real (as in post-9/11 political rhetoric invoking the crusades) and imaginary. The ever-more imaginative monsters of modern horror film notwithstanding (which, it should be pointed out, take more than one cue from their medieval predecessors), why is it that aliens, even those friendly

Fig. 9
Isaac of Norwich (centre), Moses Mokke and the Jewess Abigail tortured by demons. Miniature from a Jewish Receipt Roll of 1233. London, Public Record Office, Jewish Record Office, E401, 1565, 17.

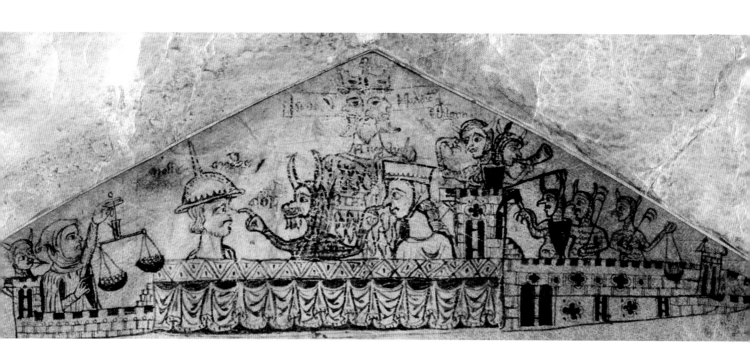

28

*"He's illuminating something called 'The Book of Billable Hours.'"*

and capable of love like E.T., are never pretty? Or remotely resembling humans? I believe it is because they follow the medieval stereotyping of the other, which needs to be different from us in every possible way.

Our world today continues to be filled with both symbols and stereotypes: as we are fascinated by the former we do not seem to be able to get rid of the latter. Together, they define a rich visual world whose decoding needs help. The help this volume offers, the help that I believe all of us need, is a better understanding of the culture and art of the Middle Ages. It is an understanding of our historical legacy, ultimately leading to a better understanding of our society today. And connecting that apparently remote period of history with our lives today, realizing how much

Fig. 10
Lee Lorenz, "He's illuminating something called 'The Book of Billable Hours.'" Cartoon from *The New Yorker*, April 9, 2001. Image copyright © *The New Yorker*.

of who we are today was shaped by whom we fought back then, makes the period come to light. In order to promote knowledge of the Middle Ages, and in particular of their art, without being apologetic, those of us who labor in this field need to do a better job at inspiring, at making the medieval world appear more alive, more interesting, more relevant. And yet we continue to be on the defensive, as I realized the other day when I was browsing the College Board website giving advice to high school students fishing for the right major in college. In the section dedicated to "Medieval and Renaissance Studies," we read about how that period teaches us about the roots of our present society, about the importance of history and the beauty of opening windows onto the past. All good. And then comes the pitch—the beauty of medieval studies is that you can see yourself as an "Indiana Jones of culture, an adventurer as well as an archaeologist." Do we really need Harrison Ford to attract our children to the study of the Middle Ages?

As I said in the beginning, I write from a biased perspective. In my view, if Harrison Ford can help, let him. Or Monty Python. Any entry into the fascinating world of the Middle Ages is better than no entry at all, as long as it leads to actual learning—beyond myths and preconceived notions. After all, sneaking in would be approved of by many a medieval bard: the Middle Ages were also characterized by playfulness (which in turn may have given us modern humor, so brilliantly captured, with medieval flair, by *The New Yorker*—see fig. 10), as Tom Cahill illustrates so eloquently in the following essay. For him, as for me—and all the contributors to this volume—the medieval matters.

# The Middle Ages in Life and Art
Thomas Cahill

I have spent the last few years of my life in the Middle Ages. What I found there I have memorialized to the best of my ability in my new book, which is entitled *Mysteries of the Middle Ages: The Rise of Feminism, Science, and Art from the Cults of Catholic Europe.*[1] When all's said and done, what stands out for me from all of my reading, looking, and vicarious experience of other people's lives are two qualities that especially characterize medieval cultural life. These are playfulness and a heightened sense of the visual.

The spirit of the Middle Ages, whether glimpsed in the stories in stained glass or the stories of the rough-hewn mystery plays, is full of humor, playfulness, and bounce—in a dance of comic profundity unavailable in earlier ages. If the whole of the Bible's bizarrely positive texts go into this new sensibility, if all the outlandish traditions of Judeo-Christian life may be said to contribute to it, it is the idea of Incarnation that especially makes the difference. If God has taken human flesh, classical pessimism can be transformed into Christian optimism. If this human God has suffered, died, and risen again, life is not tragedy but—a comedy. And if these things are so, a certain playfulness, a certain lack of ultimate seriousness, even a certain silliness, is in order.

Think for a moment of the first medieval texts, composed by Irish scribes in the early Middle Ages. Think of the beautiful pages, the playful presentation of letters of an alphabet that the scribe has just recently learned. Think of the margin of the page, filled with sprays of foliage and flowers. Notice the goofy little medieval faces peering through the shrubbery. From those faces and bodies shines the innovative medieval spirit—the spirit of fun, the spirit of children happily transgressing the strict norms of the serious classical text the scribe has copied out. Take, for instance, a page from the Book of Kells (fig. 11). The words are a list from Luke's Gospel, the genealogy of Jesus—the usual Biblical series of who begat whom. In the lower left the scribe has given us a jaunty picture of himself with the tools of his trade. He's no beauty, nor does he bother to idealize himself. But the genealogy of Jesus reminds him that he too is capable of generativity. He would like you to know that, so he has pulled out his own organ of generativity, which you may barely be able to see rising just below his brush. It's not much to brag about, but there it is. As I said: playfulness and lack of ultimate seriousness, even in dealing with the sacred text of the holy Gospel.

Hildegard of Bingen (1098–1179), the Sybil of the Rhine, was a German abbess of extraordinary abilities (fig. 12). She was a visionary, a healer and herbalist, a gifted musician and composer, and a church reformer, who corresponded brusquely with emperors and popes. Fire from heaven is illuminating Hildegard just prior to

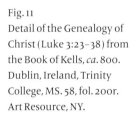

Fig. 11
Detail of the Genealogy of Christ (Luke 3:23–38) from the Book of Kells, *ca.* 800. Dublin, Ireland, Trinity College, MS. 58, fol. 200r. Art Resource, NY.

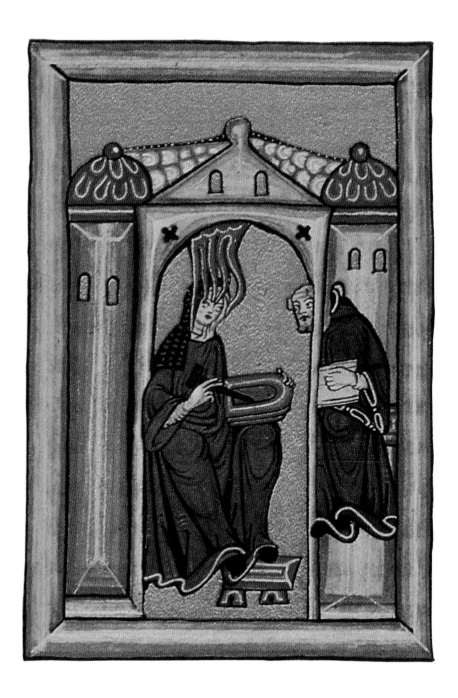

Fig. 12
Inspired by heavenly
fire, the German nun and
mystic Hildegard of Bingen
begins to write down her
visions. Miniature from
her *Scivias* (Know the Ways
of the Lord), 1165. From
a facsimile of the Codex
Rupertsberg (original lost
during World War II). Erich
Lessing/Art Resource, NY.

Fig. 13
*opposite page, left*
Man cannot hide from
God, who sees all from his
high mountain. Miniature
from Hildegard of Bingen,
*Scivias* (Know the ways
of the Lord), 1165. From
a facsimile of the Codex
Rupertsberg (original lost
during World War II). Erich
Lessing/Art Resource, NY.

Fig. 14
*opposite page, right*
St. Hildegard of Bingen
and the Four Seasons.
Miniature from her *De
operatione Dei, ca.* 1200.
Lucca, Italy, Biblioteca
Statale, Codex Latinum
1942, fol. 38r. Scala/Art
Resource, NY.

Fig. 15
*following page*
West façade of the
Cathedral of St. Peter,
Trier, and (right) the
Liebfrauenkirche. Original
building from the 4th
century CE; extended in
Romanesque style to a
three-nave church from
1037. Photographed in
2000. Photo: akg-images/
Schuetze/Rodemann.

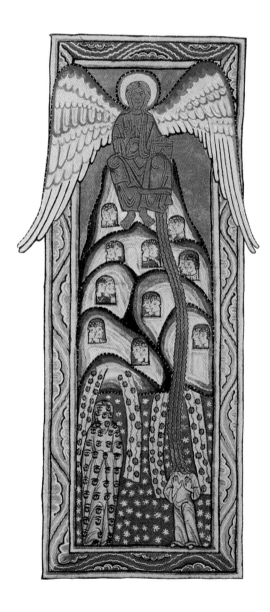

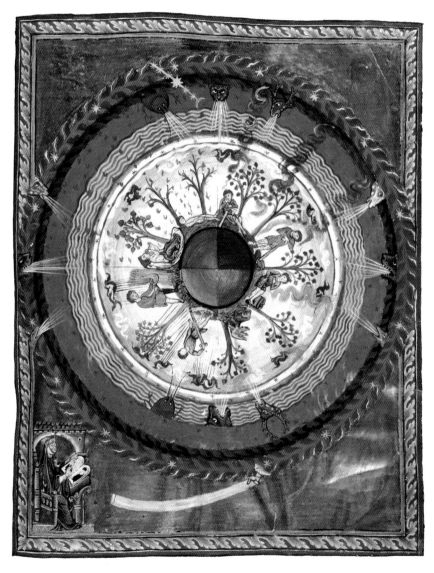

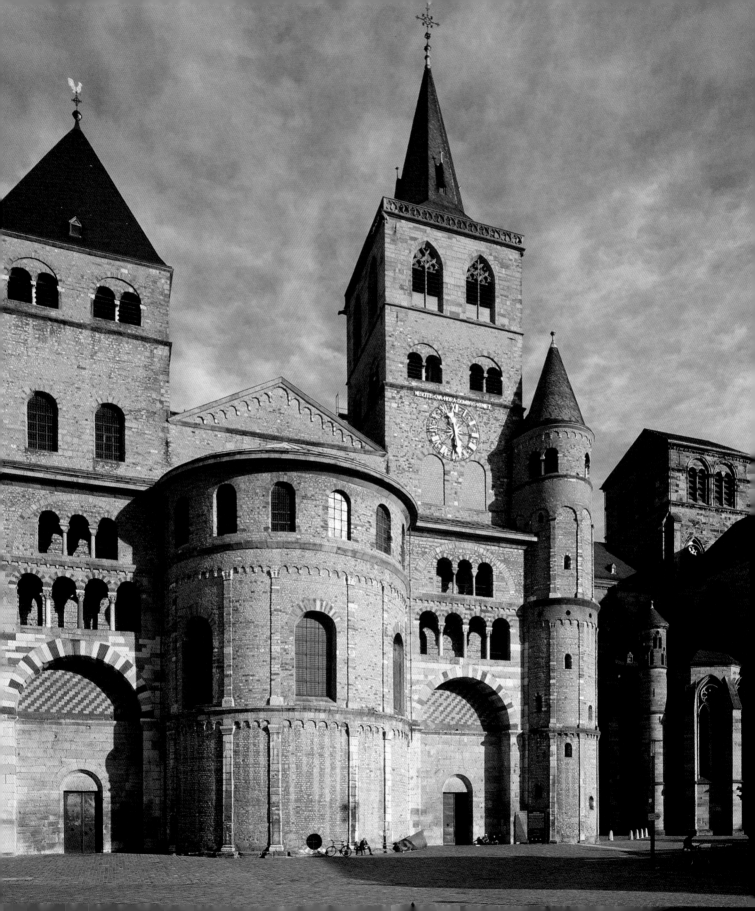

her writing down her vision. Her secretary, Volmar, waits in the wings. He was the perfect assistant, hardworking, detail-oriented, self-effacing, intelligent, discerning, loyal as a dog, someone who could anticipate her needs before she articulated them—what every abbess needs. Volmar was also an excellent editor, since Hildegard had far too much to do to be concerned with the niceties of Latin prose. Hildegard almost certainly approved of this illustration; she may even have made it. In images such as these human beings may have dignity, but they are never overly august, never titanic in proportions, always humbly life-size. Hildegard the famous seer never pretends to be more than a human being.

Hildegard's First Vision in her first book, called *Scivias* (fig. 13), reads:

I saw a great mountain the color of iron and enthroned on it One of such great glory that it blinded my sight. On each side of him there extended a soft shadow, like a wing of wondrous breadth and length. Before him, at the foot of the mountain, stood an image full of eyes on all sides, in which, because of those eyes, I could discern no human form. In front of this image stood another, a child wearing a tunic of subdued color but white shoes, upon whose head such glory descended from the One enthroned upon that mountain that I could not look at its face. But from the One who sat enthroned upon that mountain many living sparks sprang forth, which flew very sweetly around the images. Also, I perceived in this mountain many little windows, in which appeared human heads, some of subdued colors and some of white.

Though the symbolism is difficult and obscure, Hildegard carefully explains the meaning of each symbol. I use this image here to point to the second quality that for me characterizes medieval life: a heightened sense of the visual. Another vision of Hildegard's is the Mandala of the Seasons, her vision of the earth's teeming fecundity and human cooperation with nature (fig. 14). Note Hildegard's picture of herself in the lower left. It is a typical medieval portrait; small, even insignificant before the grand and sacred sweep of the cosmic drama—very different from the far more egotistical portraits of the Renaissance.

Hildegard preached on the need for church reform to capacity crowds in the Romanesque cathedral of Trier (fig. 15). Beside it is the graceful church of the Virgin Mary, one of the very earliest examples in Germany of Gothic architecture. The artistic impulse of medieval people was surely impelled forward in part by widespread illiteracy, so that glorious stained-glass windows in churches like these came to be called "The Bible for the Poor"—that is, the Bible of the Illiterate.

But this almost universal artistic impulse was impelled forward by the spirit of Incarnationalism as well. In their combination of Christian faith and barbarian custom, medieval people brought about a new sensibility, which is rightly called Incarnationalism. Incarnationalism refers to the significance of God becoming man, of God taking on human flesh, of God becoming one of us, of God forever on the side of humanity. In the West, this new sensibility brought about the eradication not only of crucifixion but of so many cruel Roman practices, such as gladiatorial combat and public torture as mass entertainment. The Romans stopped feeding criminals to wild beasts in the arena; they ceased using human torches to light their evening frolics. Instead they began to celebrate Christmas, the feast of the God-Man's birth, employing many merry pagan customs to enhance their celebration.

It is impossible to offer here a thorough evaluation of these cultural changes. But the Introduction to *Mysteries of the Middle Ages* traces the course of how the unbending ancient Romans turned into the life-loving modern Italians. Truth was now to be found not just in the higher thoughts of meditative philosophers but by everyone in the ordinary events of their daily lives, made holy by this Incarnation. Truth was to be found in human flesh, an idea that would have scandalized the ancient Greeks.

Let's turn to Italy. The earliest surviving depiction of the *Virgin and Child* is a quickly daubed, now fading second-century fresco from the Roman Catacomb of St. Priscilla (fig. 16). The figure to the left is a prophet, either Balaam or Isaiah, each of whom was thought to have prophesied that Christ would appear as a star or light. Above the Madonna's head is a star to which the prophet is pointing. Despite the poor state of preservation, we can discern that the Madonna is seated, that she wears a short-sleeved tunic and is tenderly bent toward the baby offering her breast. Here, close to the beginning of her Roman cult, the Virgin is shown as the Virgin of Christmas—as Mother, affectionate and nurturing. Her connection to the divine is a connection so ordinary, so quotidian, so human as to be almost bathetic. Like all mothers, she comforted the child in her arms, offered her breasts to his sucking lips, wiped his little bum—actions repeated so often they constituted the most visible and unremarkable work performed in the ancient world (or in ours, for that matter).

This early exaltation of Mother and Child already demonstrates the innovative Christian sense of grace, no longer something reserved for the fortunate few—the emperors and their retinues—but broadcast everywhere, bestowed on everyone, "heaped up, pressed down, and overflowing," even on one as lowly and negligible

Fig. 16
Virgin and Child with a prophet and a star. Fragment of an Early Christian fresco from the Catacomb of St. Priscilla, Rome, Italy, 2nd century CE. Scala/Art Resource, NY.

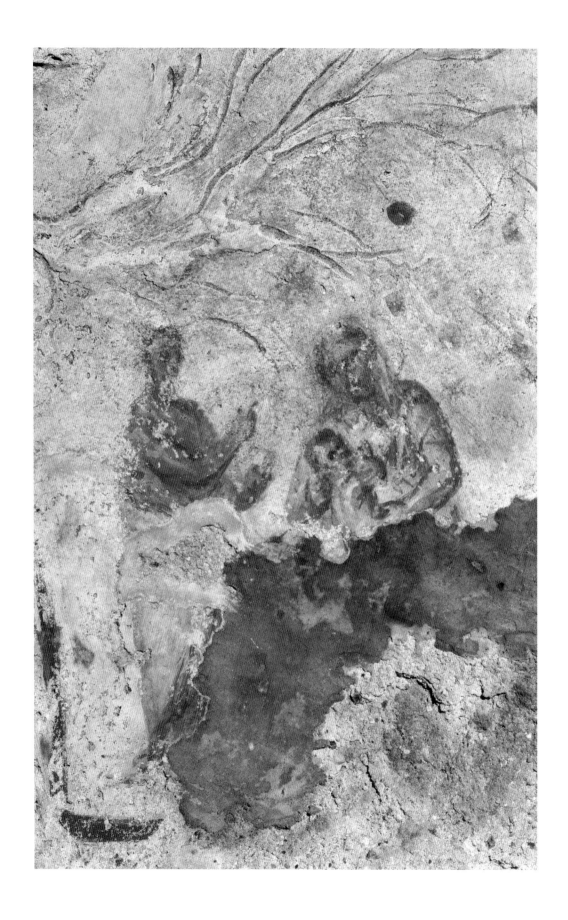

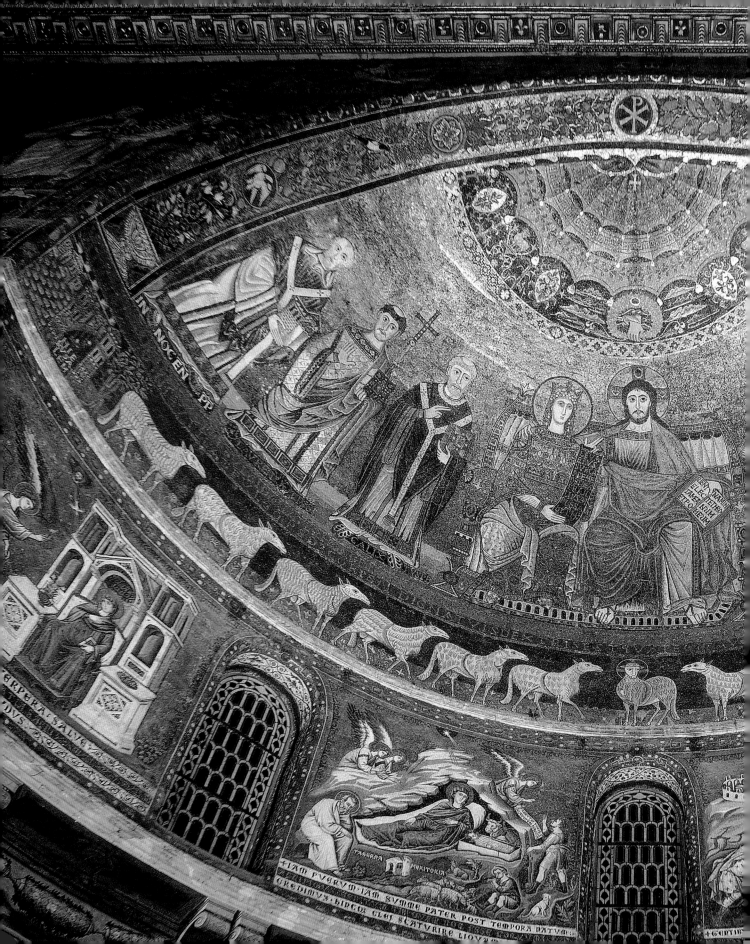

Fig. 17
Apse mosaic in the church of Santa Maria in Trastevere, Rome, Italy, mid-12th century. Scala/Art Resource, NY.

40 as a nursing mother. In the words of a famous Latin hymn, "God...is born from the guts of a girl." For even the most ordinary people in their most ordinary actions can serve as vessels of God's grace. Though awarding them equal political status with society's leaders would have been unthinkable, their values as persons was newly absolute, for, as Hildegard insisted, "they are all loved by God."

The worship of this Virgin of Virgins culminates in Rome in the magnificent Basilica of Santa Maria in Trastevere, the earliest church dedicated exclusively to Mary (soon after Christianity's legalization in the fourth century) on the site of a remembered miracle, the sudden eruption of a healing fountain of oil at the very moment—or so legend had it—that Jesus was born in Bethlehem. The shimmering twelfth-century mosaic apse of Santa Maria (fig. 17), ornamented with prophets, apostles, saints, and symbolic sheep, gives us at its very center the Throne of Mercy, on which are seated Christ and Mary, welcomed into heaven after her death by her son, who had preceded her.

Up to this moment, Western art had imitated all the staid solemnities of the Greeks, and it is often impossible for a layman to tell a Roman image from an Eastern ikon. Mary of Trastevere is adorned as a Byzantine empress, elaborately crowned, decked out in golden, bejeweled garments. The gravity of her expression is tempered somewhat by the rounded oval of her face, shown to us not starkly straight-on but in a three-quarters' view, turning toward her son. But Jesus is patently Italian, not Greek. The set of his figure, though dignified, is easy, informal, radiating affection. His broad naked feet are planted solidly on the floor in clear contrast to his mother's dainty slippers. His happy face is close to cartoonish, contented, playful, amused, *capriccioso*, almost mouthing "Mamma"; and since this is a moment of sublime felicity, his right arm is extended across his mother's back, his right hand tenderly cupping her shoulder (fig. 18).

This tremendous movement—the Son of God hugging his earthly mother!— had never been seen before. Hildegard had dreamed of such a thing, calling Christ her "sweetest hugger," but now a visual artist, we don't know who, shows it spectacularly above a pontifical altar. Anatomically, kinetically, instinctively, this is an entirely novel moment in the history of sacred art and the beginning of a characteristically Italian contribution. By this single gesture, Western art is freed from its Eastern enchantment. The long tradition of representing spirit by super-serious faces and two-dimensional, stick-figure human bodies, starved, denatured, aloof, and devoid of movement, is about to give way, as Western Europeans discover a new embodiment, a new earthiness, a new bounce—a new kind of heaven. And if saints can hug, so can we.

Fig. 18
Detail showing *Christ Enthroned and the Crowned Virgin*, mid-12th century. Mosaic from the apse conch in the church of Santa Maria in Trastevere, Rome, Italy. Scala/Art Resource, NY.

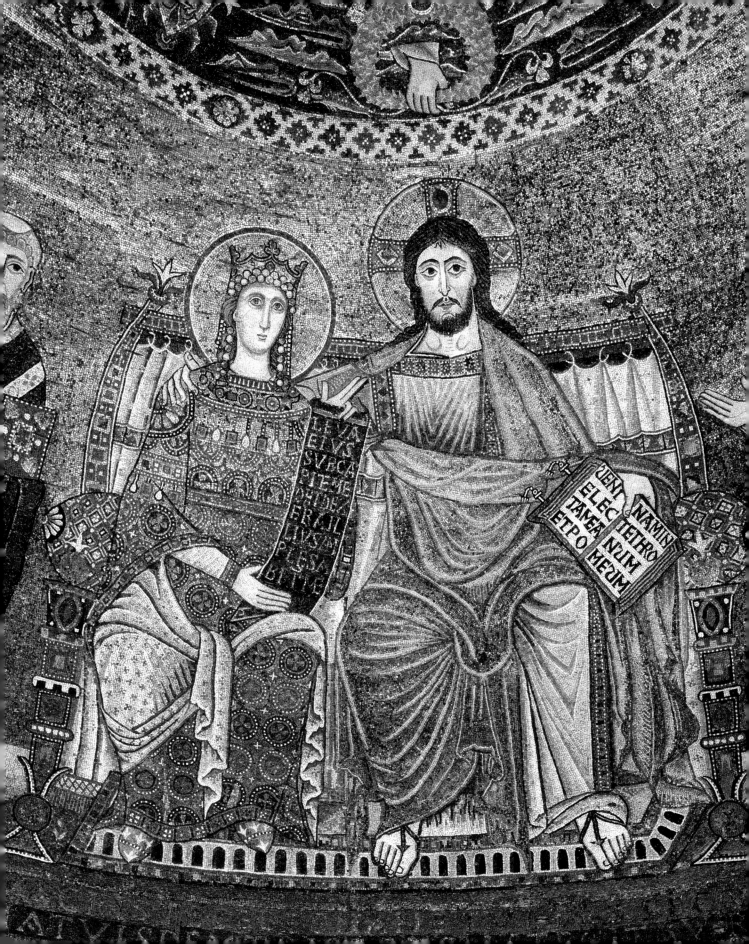

42      Art in the Middle Ages was a common enterprise, an endeavor of a whole community. Everyone who was able to walk and move wished to participate in the building of the cathedral at Chartres (fig. 20). The people of the town were joined by many others—"old people, young people, little children," "often a thousand persons or more"—who came from much farther afield to transport all necessary materials to the plain of Chartres. As a twelfth-century letter informs us, each person, before participating, had

> been to confession, renounced enmities and revenges, and reconciled himself with his enemies.... Powerful princes of the world, men brought up in honor and in wealth, nobles, men, and women, have bent their proud and haughty necks to the harness of carts, and, like beasts of burden, they have dragged to the abode of Christ these wagons, loaded with wines, grains, oil, stone, wood, and what is necessary for the wants of life or for the construction of the church.[2]

And all this is accomplished "in such a silence that not a murmur is heard, and truly if one did not see the thing with one's eyes, one might believe that among such a multitude there was hardly a person present."

     Chartres is replete with images of Mary in sculpture and stained glass, in hidden nooks and wide bays. One in particular has held the attention of millions of pilgrims down the centuries, *Notre Dame de la Belle-Verrière* (Our Lady of the Beautiful Stained Glass), a late twelfth-century window in the choir next to the south transept (fig. 19). "A strange and uncanny feeling seems to haunt this window," wrote Henry Adams. The lines of the face have little in common with the residual severities of the Virgin in the apse of Santa Maria in Trastevere. Instead of light glistening on mosaic tiles, here light shines through colored glass. The self-dramatizing Greco-Italian faces of Trastevere have been replaced by the faces of a sweetly sensible Frenchwoman and her placidly solemn child. But there is continuity in the merriment. Like the Christ of Trastevere, the Virgin Mary smiles, if more broadly. As he was happy to be reunited with his mother, she, a royal but very earthly woman, is even happier to be the mother of her son.

     Before leaving France and returning to Italy for the remainder of the essay, let's have a brief look at one more Frenchwoman. This is Eleanor of Aquitaine, as depicted on her tomb in Fontevraud Abbey (fig. 21). She had been queen of France, and then of England. Having married Louis of France at fifteen, in her early twenties she tired of Louis, who wasn't much fun, and managed to get an annulment.

Fig. 19
*Notre Dame de la Belle-Verrière* (Our Lady of the Beautiful Window), late 12th century. Stained glass reset in the south choir, Chartres Cathedral, France. The Art Archive/Gian

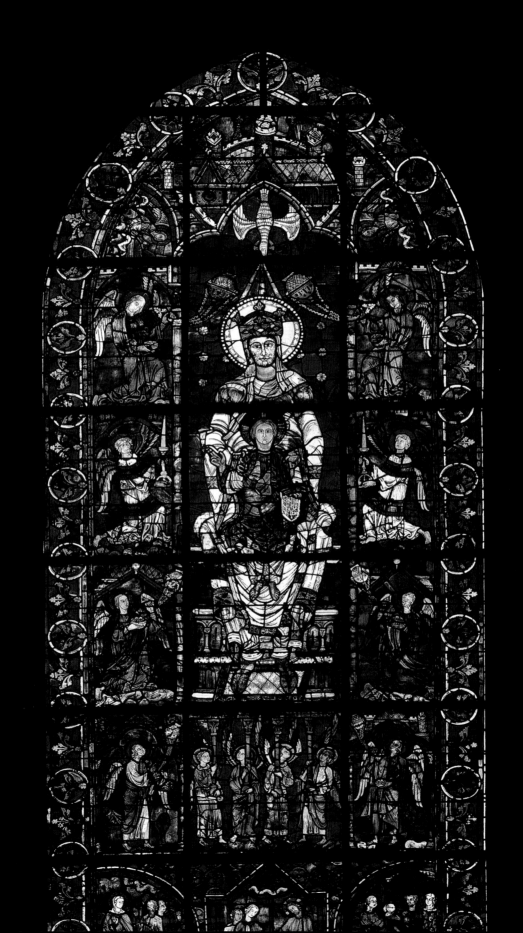

Fig. 20
Notre-Dame Cathedral,
Chartres, France, rebuilt
after 1194. View from the
south-east. Alinari/Art
Resource, NY.

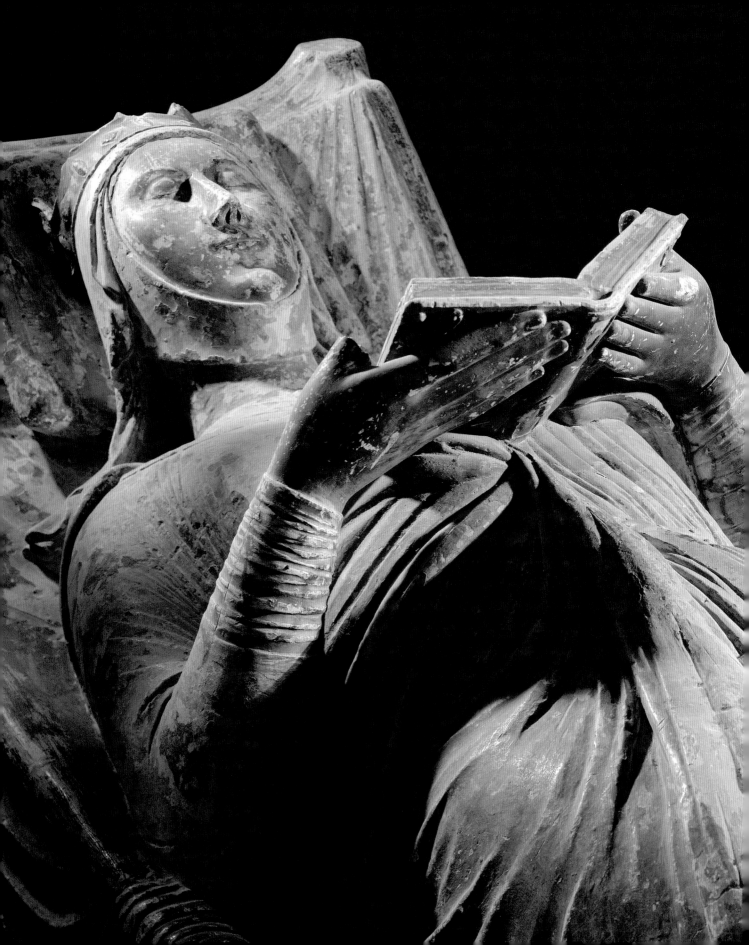

She then married a real catch, Henry II, king of England and much of France. Eleanor was eighty-two when she died, a very great age for any medieval person, particularly for a woman who had borne ten children. Eleanor was quite a dish, widely celebrated as the most beautiful woman in Europe, and even in her eighties she retained her beauty, though I'm sure the chinstrap helped a bit. She is, along with Hildegard, one of my main examples of the new importance of women and the new freedom exercised by them in the high Middle Ages. It's appropriate that Eleanor is depicted as a reader, for she loved to read in both Latin and her native Provençal. She had an excellent education, thanks to her wise father, and she became a uniquely generous patron to poets and musicians.

What kind of books did women like Eleanor read? They were especially attracted to the romantic stories surrounding the legend of King Arthur and his court of Camelot. And they loved books that offered keys to the hidden symbolism of creation. An example of this belief in hidden symbolism may be found in the use the unicorn was put to (fig. 22). The unicorn was believed to purify water with his horn and could be captured only if he lay his head in the lap of a virgin. He is, of course, Christ, who lays his being in the womb of the Virgin and cleanses the world of its impurities. Another example was the story of the pelican, who was believed to tear her breast with her beak to feed her young. She, too, was Christ, who nourishes us through excruciating but self-inflicted suffering. Both stories were told and retold in the illustrated books called "bestiaries," which purported to explain the symbolic significance of all God's creatures. But this was not all: the mysterious bear, the mysterious lion, and even the lowly ant (whose economic thrift is a lesson in how to conduct our lives)—all these and many more natural phenomena presented themselves to the medieval observer first of all as God's creations, as gifts descended from heaven to us below. Medieval imagination speculated about what they were there for—in often simple, childlike ways, but increasingly as time went on by more penetrating methods, even with genuinely scientific interest.

The twelfth-century apse of the upper church of San Clemente is my favorite thing in all of Rome (fig. 23). I urge you to go there, as no reproduction can do it justice because of the uneven and unpredictable ways in which light is reflected off gold mosaic. The central image is of the crucified Christ, mildly accepting his suffering and death, his face full of peace. Perched on the four extremities of the dark red-rimmed cross are twelve white doves, symbolic apostles, rapt in contemplation though about to fly off to the ends of the earth. Jesus's mother Mary and the Beloved Disciple stand in mourning beneath the arms of the cross. But spiraling forth from the foot of the cross, where it is watered by the blood of Christ, a stupendous acanthus

Fig. 21
Tomb of Eleanor of
Aquitaine, wife of Henry
II and mother of Richard
I, Coeur-de-Lion, 13th
century. Limestone.
Fontevraud Abbey, France,
Tombs of the Plantagenet
Kings. Erich Lessing/Art
Resource, NY.

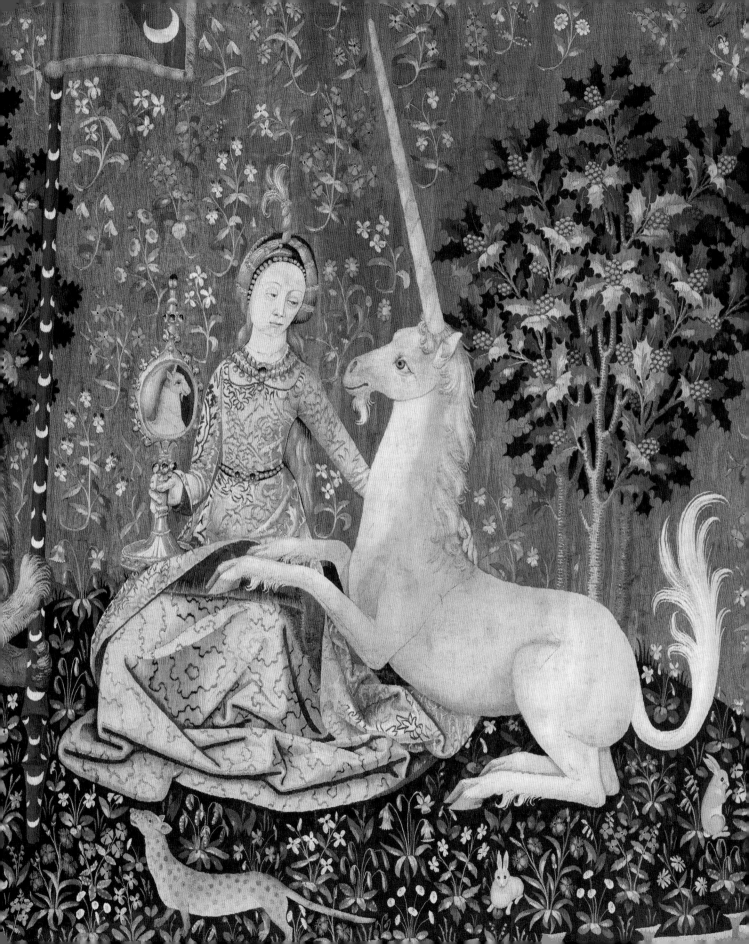

bush curls outward and upward, encircling nearly a hundred different images. These include flowers of many varieties, an oil lamp, a basket of fruit, beasts wild and tame, and people of all kinds involved in all kinds of labor. Each figure has a special meaning: a caged bird, for instance, represents the Incarnation, whereas wild ones flying upward are the souls freed by death on their way to union with God. The humility of many of the figures is meant to remind us that not only have we been redeemed, but so has the whole world and everything in it. The spiraling branches of the acanthus embrace even two pagan Roman gods, baby Jupiter, formerly king of the Gods, and baby Neptune, formerly king of the deep, who rides a slippery-looking dolphin. Even the ancient pagans have been redeemed, and their mythologies are usable by us, so long as we reduce them to less fearful and more apposite dimensions.

Most tender of all are the depictions of ordinary medieval life, shepherds with their flocks and herds, farm children helping their parents, a lord and a lady watching the proceedings, a tonsured monk giving food and water to a colorful bird, and a bosomy lady in white, wearing flowing sleeves and an enormous brooch while feeding her excited hens (fig. 24). This is a portrait of a local of the artist's time, I am sure, perhaps a lady who kept hens across the street from the church. With her extravagant sense of herself—who feeds hens in a white gown with flowing sleeves, surmounted by an heirloom brooch?—she can only have been somebody the artist knew.

One soon notes that many of the details in the mosaic are of creatures nourishing creatures or of creatures taking nourishment on their own, as in the case of the two stags drinking directly from streams that flow from the root of the acanthus. "As the hart panteth after the water brooks, so panteth my soul after thee, my God," we are meant to recall in the words of Psalm 42.

To appreciate the impact of this mosaic it is nearly necessary to attend a Mass celebrated at the altar below the apse. As the ritual of the Mass unfolds beneath the cosmic wildness of the apse, we reflect that we are all caught up in the universal mystery of Christ, who has redeemed us and all of creation, even the humblest humans and the humblest things, so that he might come to us as bread. He is the great Nourisher of whom all the others are but earthly examples.

The apse of San Clemente is part and parcel of the innovating art of Italy that will soon spread throughout Europe. It is a playful and celebratory reaction against the static Byzantine formalism that had preceded it. Compare it to a typical depiction of Christ in an eleventh-century Greek mosaic from Daphni (fig. 25). How imposing, how terrifying, how different from the Christ of San Clemente,

Fig. 22
Illustration of the sense of sight, from the *Lady with the Unicorn* series, detail, 1484–1500. Wool and silk. Woven in the Netherlands based on cartoons made in Paris. Paris, France, Musée National du Moyen Age—Thermes de Cluny, CL 10836. Photo: Franck Raux. Réunion des Musées Nationaux/Art Resource, NY.

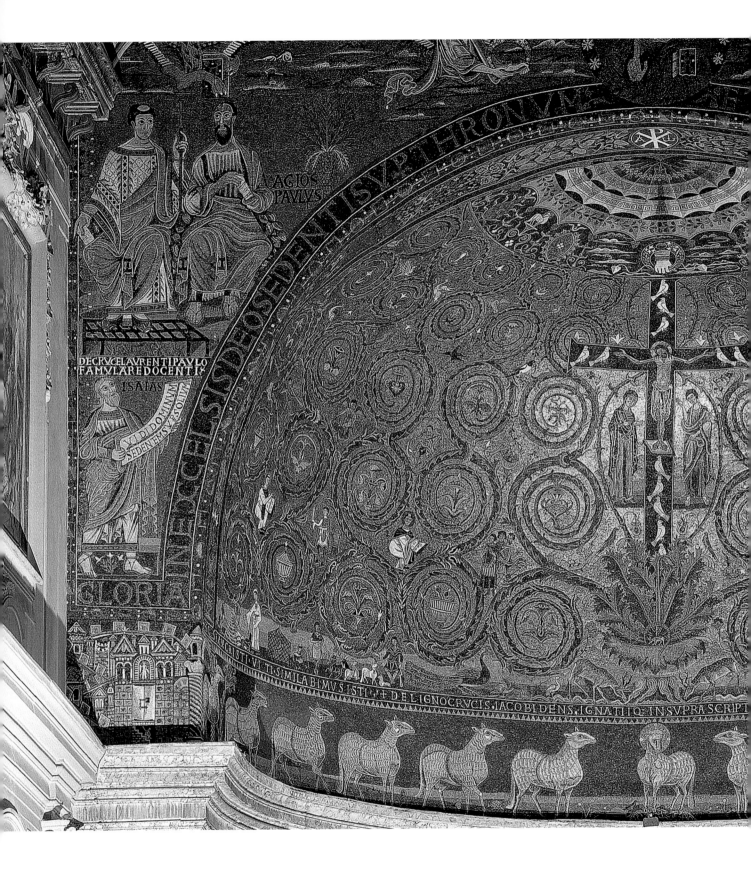

Fig. 23
Mosaic of the apse from
the Upper Church of San
Clemente, Rome, Italy,
12th century. Photo:
Luciano Romano. Scala/Art
Resource, NY.

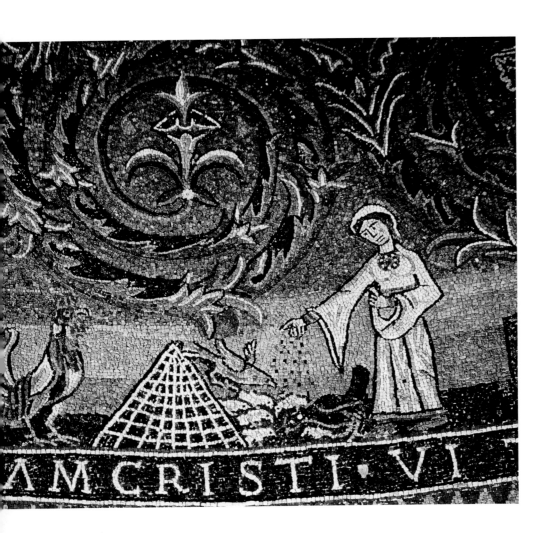

AM CRISTI · VI

Fig. 24
Woman feeding chickens,
detail of the apse mosaic in
the Upper Church of San
Clemente, Rome, Italy, 12th
century. The Art Archive/
San Clemente Basilica,
Rome/Alfredo Dagli Orti.

Fig. 25
*opposite page*
*Christ Pantokrator*,
Byzantine, 11th century.
Mosaic in the dome of the
Monastery Church of the
Dormition, Daphni, Greece.
Erich Lessing/Art Resource,
NY.

Fig. 26
*following page, left*
Giotto di Bondone,
*Crucifixion*, 1302–6.
Fresco, 72 ⅞ × 78 ¾ in.
(185 × 200 cm). Padua, Italy,
Scrovegni Chapel. Scala/
Art Resource, NY.

Fig. 27
*following page, right*
*Crucifix of St. Damiano*,
Romanesque, 12th century.
Tempera on linen. Assisi,
Italy, Santa Chiara. Scala/
Art Resource, NY.

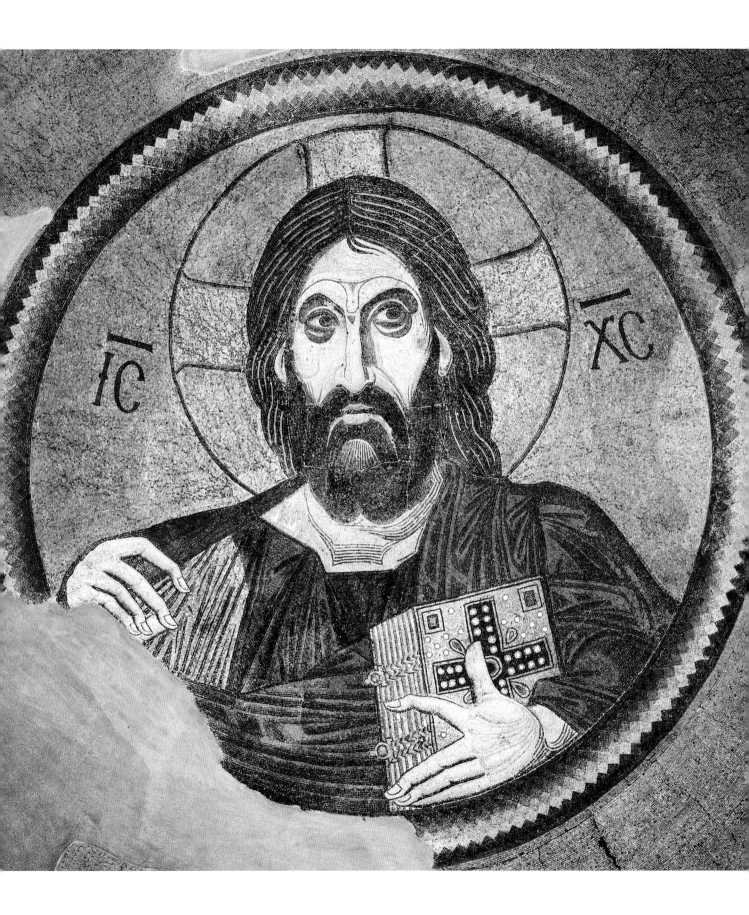

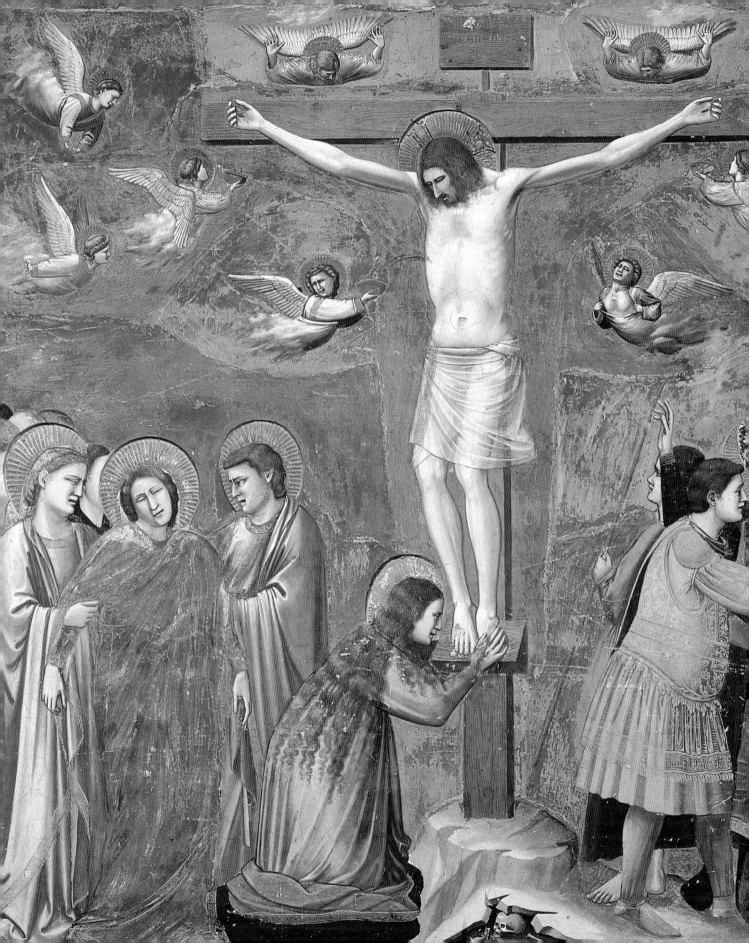

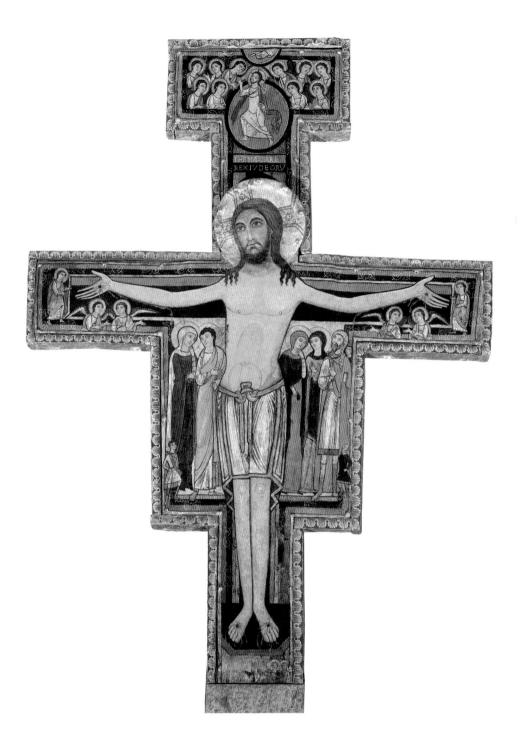

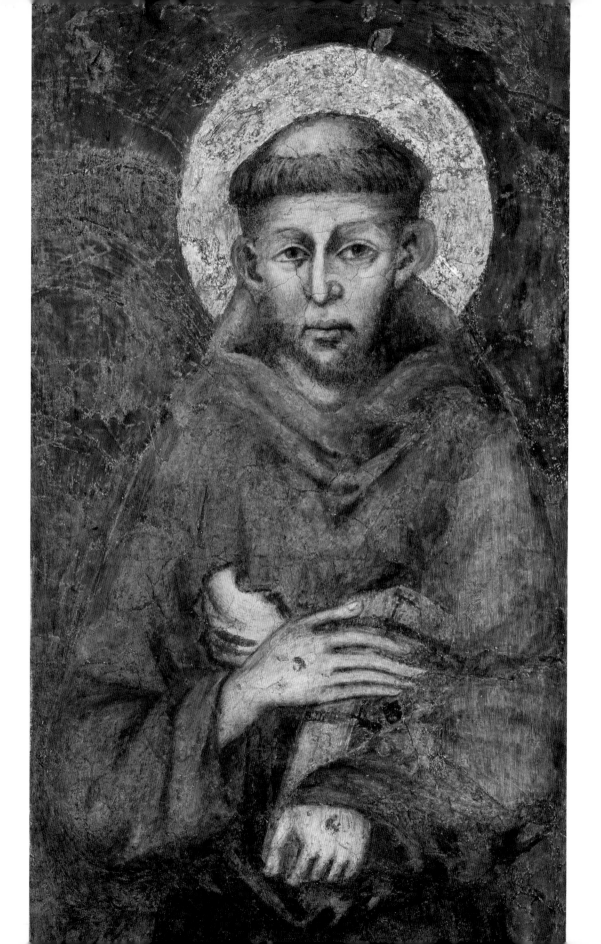

surrounded by his busy, happy brothers and sisters. This was the tradition that artists of twelfth- and thirteenth-century Italy found they had to depart from if they were to be true to their understanding of the nature of Christ and the true spirit of the Gospel.

The utter overturning of the earlier tradition is illustrated by Giotto's great *Crucifixion* in the Scrovegni Chapel, Padua (fig. 26). This is not a harsh god surrounded by gold; this is a good man dying on a cross, surrounded by his few suffering friends. That's all. It's as if Giotto even said to himself, "Don't show off, *artista*. Don't even reach for anything like gory sensationalism. Pity, that's all. Pity and profound reverence for human suffering. And silent contemplation." However innovative, however magisterial his work becomes, Giotto's reverent humility makes all his art into prayer. He is, in the truest sense, Franciscan.

"Franciscan," of course, means having to do with St. Francis of Assisi, and Giotto was always a faithful follower of St. Francis. The crucifix of San Damiano, made by an anonymous artist, is earlier than Giotto's masterpieces, still under Byzantine influences but already showing the innovative tenderness that was to become the hallmark of Italian art in the high medieval period (fig. 27). This is the crucifix that transformed Francis's life.

On a bright afternoon in the summer of 1205, Francis, returning from an errand for his father, took refuge from the heat in the ruined coolness of the chapel of San Damiano at the foot of the hill of Assisi. There above the cracked altar, surrounded by signs of neglect and decay, was a miraculous survival: this intact crucifix of painted linen, stretched across a wooden frame. The image on the cloth was looking directly at Francis. Then the young man thought he heard a voice gently saying, "Francis, don't you see my house is being destroyed? Go, then, rebuild it for me." Francis felt a mysterious change steal over him, a change he could never afterwards describe. "So," writes Thomas of Celano, Francis's first biographer, "it is better for us to remain silent about it, too."

Francis, previously a wastrel and irreligious layabout, loved only the same French love poetry and tales of chivalry that so attracted Eleanor of Aquitaine. Now he had found the love of his life—God, or more precisely, God revealed in Jesus—and this discovery made sense of everything else, putting all others, whether people or things, in their proper perspective. In retrospect, as one looks back over Francis's boyhood, one sees that the bolts of cloth and columns of coins in his father's fabric shop could never have held him. He required an overpowering vision to make him function properly; and it's no wonder that the stimulus of poetry and the ideal of knighthood had been the only previous things to capture

Fig. 28
Cimabue, St. Francis, detail from the *Virgin and Child with Angels, ca.* 1280. Fresco. Assisi, Italy, Lower Church of San Francesco. Scala/Art Resource, NY.

his attention or win his homage. He was in every sense of the word an extremist.

Giotto's teacher, Cimabue, painted a portrait of St. Francis, and it is an accurate likeness (fig. 28). Francis took to wearing a hooded peasant's tunic, cinched by a wide leather belt, and sandals. He lived in a hermit's cave and carried a pilgrim's staff. When a little later he noted Jesus's instructions to his disciples in Matthew's Gospel, telling them to "take no gold or silver or copper in your belts, no bag for your journey, nor two tunics nor sandals nor a staff," he would abandon his staff, go barefoot, replace his belt with a bit of rope, and divest himself of all changes of clothes. His colorless vagrant's costume would become the uniform of the early Franciscans, the world's first hippies.

But Francis's father, mortified by the mad behavior of his son, hauled him into Assisi's central square and beat him brutally in the sight of everyone. When that failed to dissuade Francis from his bizarre behavior, the father locked him in a storage room, from which he escaped with his mother's complicity. When the father discovered that Francis had sold some of the family's precious bolts of cloth to get money for San Damiano's repairs, he was overcome with rage and brought his case against his son to Guido, the exceedingly wealthy, no-nonsense bishop of Assisi. Guido conducted his court in the great piazza before the cathedral in the hearing of many witnesses.

To the amazement of all, Francis emerged from nowhere, bathed, trimmed, and elegantly outfitted in one of the plumed and patterned costumes from his abandoned wardrobe. The father began his complaint before the bishop: his son was a thief who had mortally dishonored his father, who had the right to compensation for the cloths the young man had stolen. The father was startled by the response of his son, who agreed to return all the money forthwith, as well as anything else he had from his father. Francis then ducked into the cathedral, reappearing shortly thereafter stark naked and holding his clothes in a bundle in front of him, surmounted by a purse full of coins. All these he handed to the imperious bishop, who could not mask his astonishment (fig. 29).

"Listen to me, all of you," the unashamed naked man addressed the crowd, "and understand. Till now, I have called Pietro di Bernardone my father. But because I have proposed to serve God, I return to him the money on account of which he was so upset, and also the clothing that is his, and I wish from now on to say only 'Our Father, who art in Heaven' and not 'My father, Pietro di Bernardone.'" As Bernardone stumbled off with his bundle and purse, Bishop Guido descended the steps of the cathedral and covered the naked man with his enormous cloak. Symbolic gesture, Francis's natural language, was the profound source he was able to call on throughout his life.

Fig. 29
Giotto di Bondone, *St. Francis Renounces All Worldly Possessions, ca.* 1300. Fresco, 106 ¼ × 90 ½ in. (270 × 230 cm). Assisi, Italy, Upper Church of San Francesco. Erich Lessing/ Art Resource, NY.

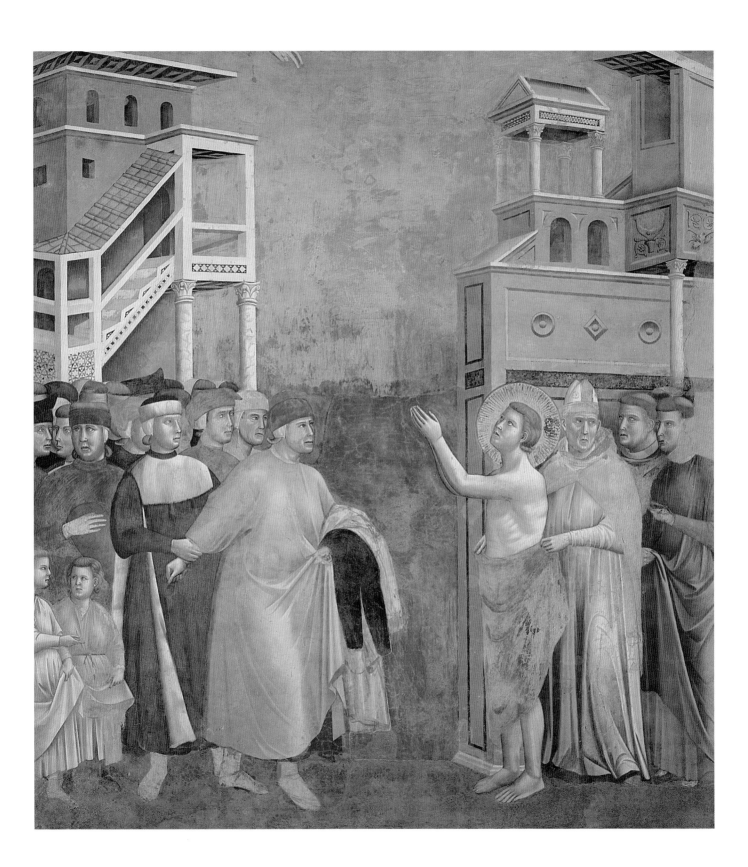

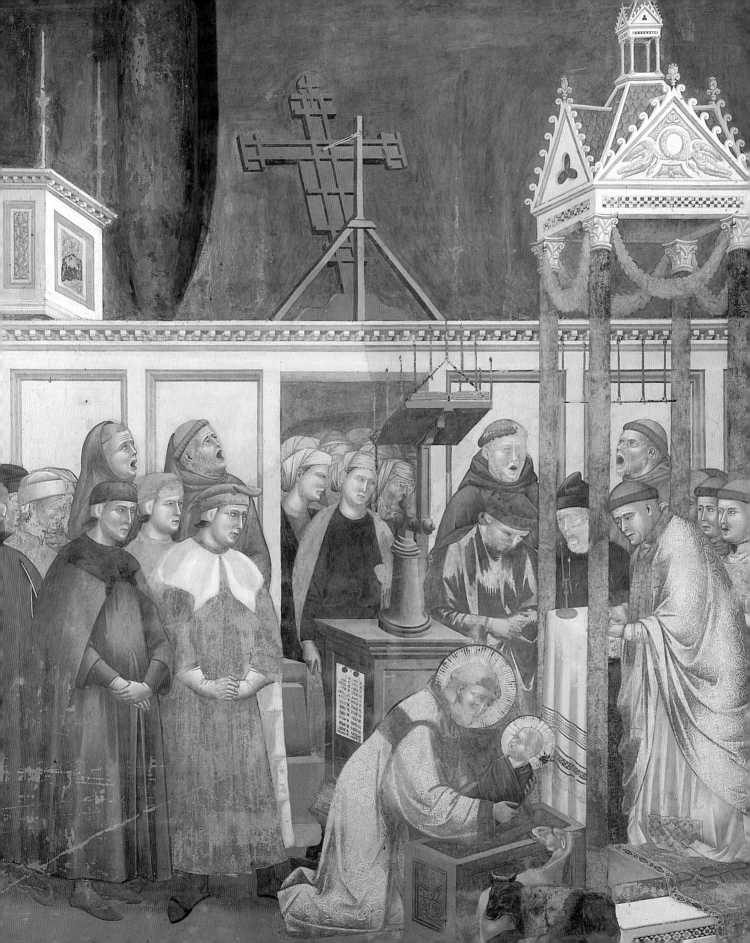

Francis even invented the *presepio* or Christmas *crèche*, insisting that real animals be led into the church and real hay be laid out. Giotto's dramatization of the scene includes awfully small animals next to the manger (fig. 30). Few people at the time understood the implications of what Francis was doing. "I wish to make a memorial of that child who was born in Bethlehem and, as far as possible, behold with bodily eyes the hardship of his infant state, lying on hay in a manger with the ox and the ass standing by."

This archetypal tableau, presented to the people of Greccio in the vale of Rieti on Christmas night in the year 1223, announced the end of the ikon and the beginning of realism. No more would the visual artist make a kind of Christian idol to be bowed before and held in awe. No more would traveling companies offer merely symbolic dramas with actors brought onstage to illustrate virtues and vices, as in the medieval drama *Everyman*—who is never any particular man. The wholly new question to be asked was historical, emotional, particular, and human: *what would it have been like to have been there?* This question, never asked before, was still being asked at the end of the Second World War by men like Vittorio De Sica and Roberto Rossellini as they set aside fancy-dress filmmaking and artificial indoor sets and went out to the broken streets, peeling stairwells, pitted walls, and piteous disorder of Rome to direct the first films of Italian Neorealism, gathering ordinary people—non-actors—to play many parts. In the town of Greccio on Christmas night in 1223 were born the arts as we still know them.

In another scene from Giotto's amazing sequence on the life of Francis in the basilica at Assisi, the exceedingly powerful medieval pope, Innocent III, sleeps in full papal regalia (lest anyone should not know he's pope), and while he sleeps he dreams that his own cathedral of St. John Lateran is falling down, held up only by...Francis, the Little Poor Man of Assisi (fig. 31). Because of this dream, Innocent decided to reverse his previous caution and give his approval to Francis's new experiment of poor people living together, begging for their living, and caring for people even poorer than they. Finally, Giotto's *St. Francis Mourned by St. Clare* depicts the woman who became his first female disciple (fig. 32). It is a pity that the face of Clare is ruined, but the stance of her body leaves no doubt as to her attitude. Francis, even dead, seems more alive than any of the grieving onlookers, and the inclination of his head to Clare's, and hers to his, resolve all ambiguity: here was a mighty friendship.

Francis often warned his followers that they should not be surprised if he turned up one day with children of his own. This was taken by pious interpreters to mean that Francis was conscious in his holy humility that even a saint could

Fig. 30
Giotto di Bondone,
*Celebration of Christmas at Greccio, ca.*1300. Fresco,
106 ¼ × 90 ½ in.
(270 × 230 cm). Assisi,
Italy, Upper Church of San
Francesco. Erich Lessing/
Art Resource, NY.

**62**

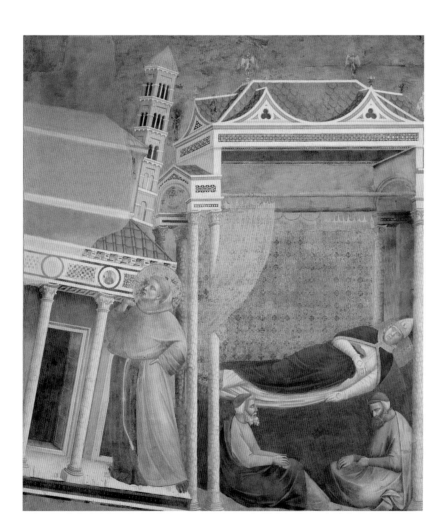

Fig. 31
Giotto di Bondone, *Dream of Pope Innocent III, ca.* 1300. Fresco, 106 ¼ × 90 ½ in. (270 × 230 cm). Assisi, Italy, Upper Church of San Francesco. Erich Lessing/ Art Resource, NY.

Fig. 32
*opposite page*
Giotto di Bondone, *St. Francis Mourned by St. Clare, ca.* 1300. Fresco, 106 ¼ × 90 ½ in. (270 × 230 cm). Assisi, Italy, Upper Church of San Francesco. Erich Lessing/ Art Resource, NY.

fall into the most despicable of sins. I rather think he meant that, though he had been given his life's commission by God and had to follow it, he was a man like other men and would much have preferred to take a wife, know fleshly intimacy, and love the children of his body. Here his bier is laid out before San Damiano, the chapel he had restored and later turned over to Clare and her sisters; and his face in Giotto's depiction still gives off an aura of the romantic masculinity that might have taken him to a far more ordinary, more obvious, more human way of life,

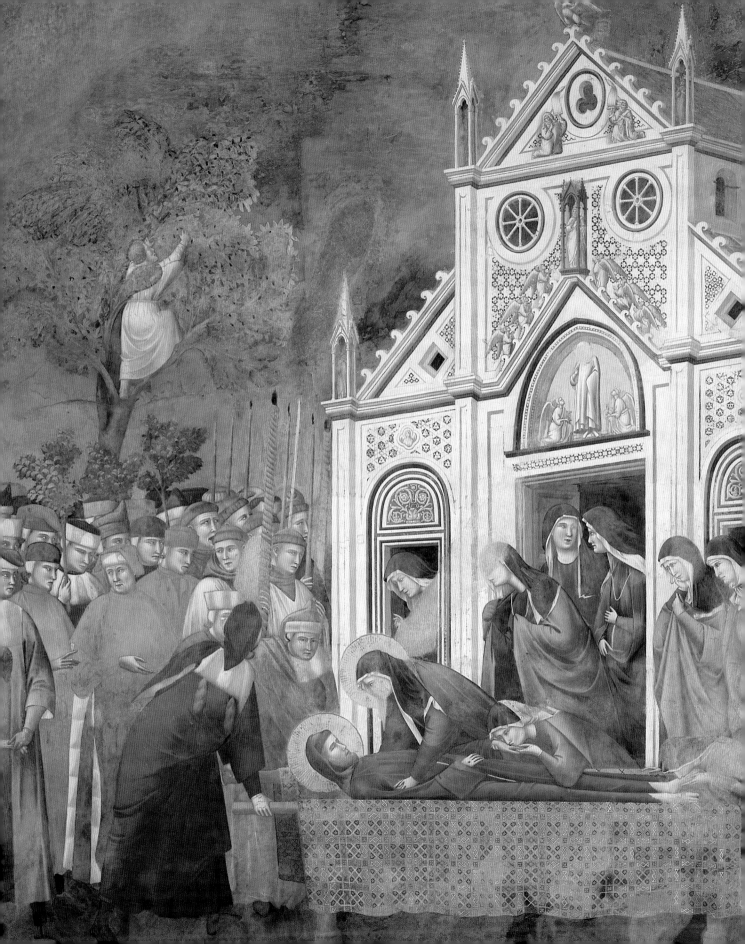

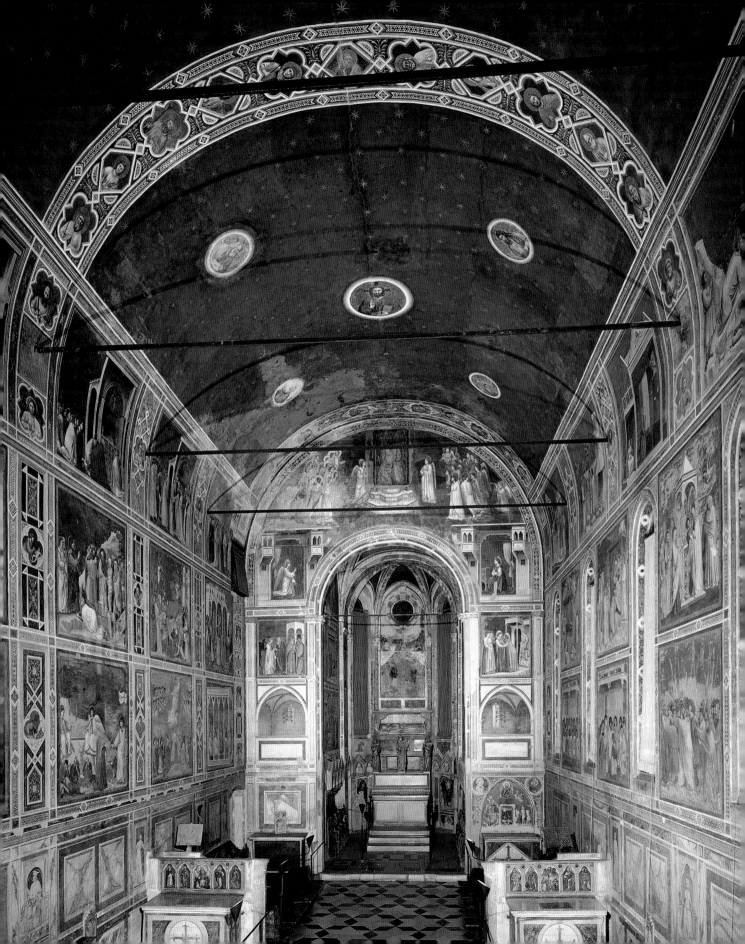

rather than weary death at forty-five. He married a concept, whom he gallantly called Lady Poverty, but he gave every evidence of being a man of tangibility, who constantly ran his fingers over the world of the senses and loved everything those fingers touched.

Giotto's supreme masterpiece, the Scrovegni Chapel in Padua, is dedicated to the moment when the Angel Gabriel announced to Mary that she was to "bear a son" (fig. 33). The walls are filled with vignettes from the Gospels and even from the apocryphal gospels. I would like to highlight three scenes. First, the *Nativity* (fig. 34). I love this composition for the solemnity of Mary's countenance. She seems to know just who she is holding. But hers is also the seriousness of a good mother on first beholding her firstborn child. Joseph, old and exhausted, has already fallen asleep. In the positioning of the stable and the foreshortening of both the ox and ass (to the left) and the arms of the shepherds (to the right), we see the first attempts to create perspective, a process that would take a generation or two more to complete successfully.

In the *Lamentation* over Jesus after his death (fig. 35), once again, as at his *Nativity*, his body is held by a woman—suggesting, I would wager, that Giotto, always a forward-looking fellow, may have been secretly in favor of ordaining women as priests! "This is his Body," the woman could be saying. The mourners are extraordinary in their individuality, but the lamenting angels in the sky are downright sensational, heavenly mourning being, it would seem, even more unabashed and over-the-top than earthly mourning.

The third scene is Judas in the Garden of Gethsemane identifying Jesus by kissing him, so that the Roman soldiers can arrest him (fig. 36). Giotto always shunned violence in his art; and this is his most violent composition, the night sky slashed by torches and brandished clubs, which must make uneasy even a viewer who has no idea what is going on. How Jesus's expression of sad regard is like his mother's expression at his birth. And how ugly Judas is, not because of his physiognomy but because of his expression, the resolute ugliness of someone cruelly set on doing evil.

Directly across the chapel is another face, the face of Giotto himself, wearing his yellow hat, painted by his assistants after his death (fig. 39). Like Judas, he is shown in profile, a revolutionary development that Giotto championed. He stands, however, among the anonymous elect at the Last Judgment. Perhaps if seen full face he would look ugly, perhaps his body if separated from those on either side of him and turned toward us would be displeasing. But Giotto's life has led him to eternal life with God. He has been saved; he is on his way into heaven, and his contentment, his beatitude, his high expectations for what comes next

Fig. 33
View of the interior of the Scrovegni Chapel, looking toward the altar. Frescoes, 1303–6, by Giotto di Bondone. Padua, Italy, Scrovegni Chapel. Scala/Art Resource, NY.

Fig. 34
*following spread, left*
Giotto di Bondone, *Nativity*, 1303–6. Fresco, 72 ⅞ × 78 ¾ in. (185 × 200 cm). Padua, Italy, Scrovegni Chapel. Alinari/Art Resource, NY.

Fig. 35
*following spread, right*
Giotto di Bondone, *Lamentation*, 1303–6. Fresco, 72 ⅞ × 78 ¾ in. (185 × 200 cm). Padua, Italy, Scrovegni Chapel. Alinari/Art Resource, NY.

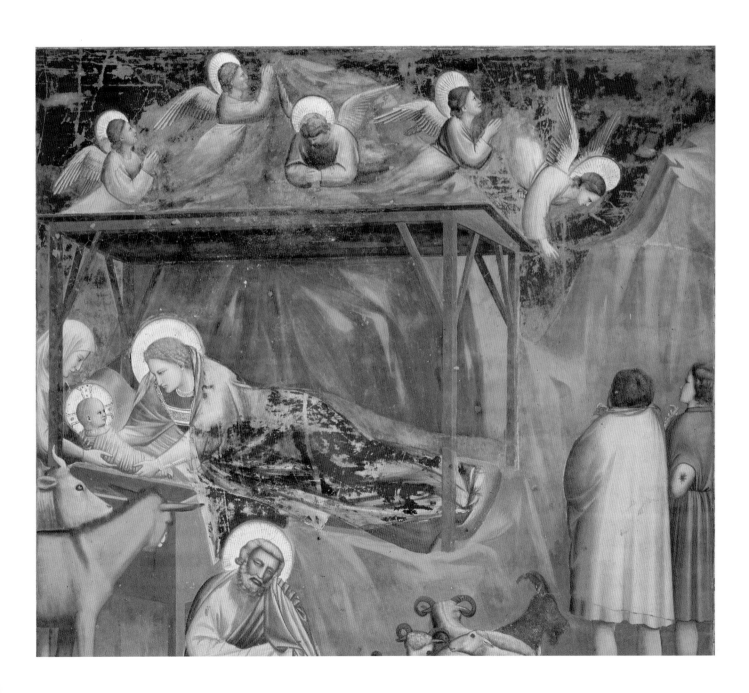

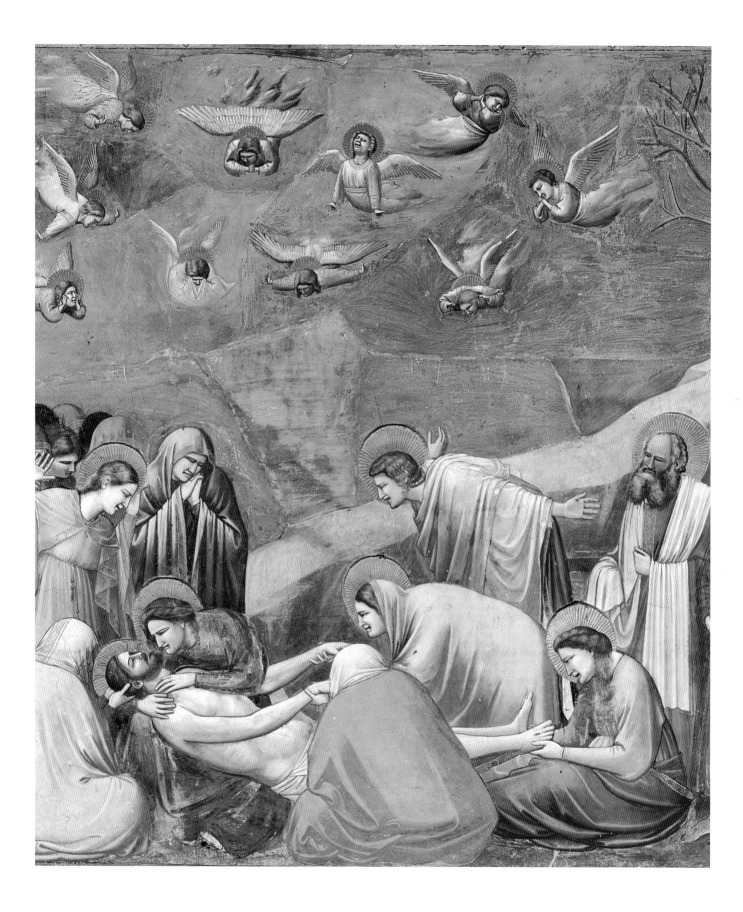

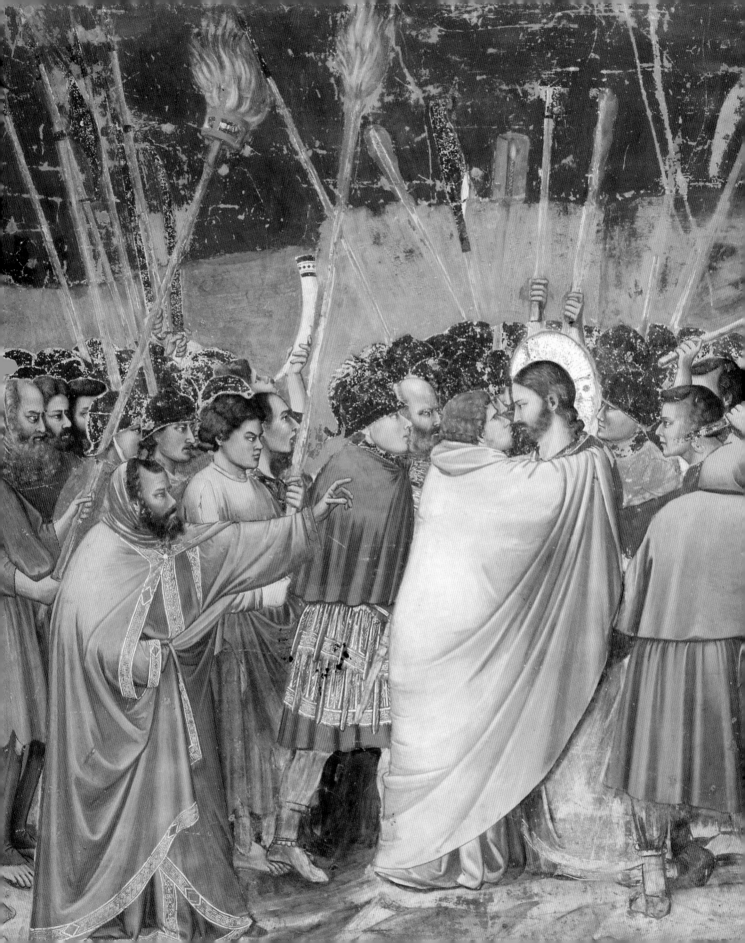

Fig. 36
Giotto di Bondone, *Betrayal
of Christ*, 1303–6.
Fresco, 72 ⅞ × 78 ¾ in.
(185 × 200 cm). Padua, Italy,
Scrovegni Chapel. Alinari/
Art Resource, NY.

Fig. 37
*Satan in Hell*, detail from the
*Last Judgment*, 13th century.
Mosaic from the cupola of
the Baptistery, Florence,
Italy. Erich Lessing/Art
Resource, NY.

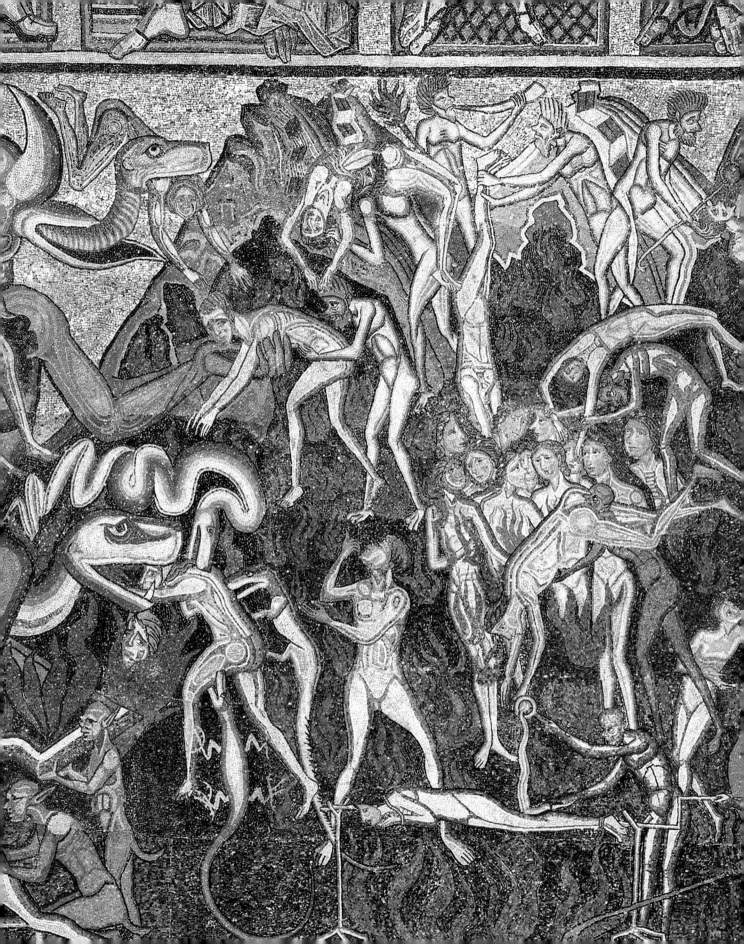

suffuse his features with a satisfying glow. The opposite of Judas's screwed-up grimace, the face of Giotto, who labored without rest and with such dedication on an immensity of works, both surviving and lost, is just sublimely relaxed.

But not everyone is going to heaven, as is seen in a mosaic found in the vault of the famous Baptistery in Florence (fig. 37). It was a scene Dante examined in childhood, and it obviously made a deep impression. This is almost exactly how he describes the lowest circle of Hell in the *Divine Comedy*.

Having started with sex, I'd prefer not to end with violence. So here is Dante himself, in the foreground, on the chapel wall of the Bargello in Florence (fig. 38). He is shown as a tall, thin, handsome man in his mid-thirties, clean shaven, dignified in rich, dark red velvet, and learned (for he carries a book). He has a strong, well-defined jaw, thin, firmly closed lips, and the aquiline nose of the ancient Romans. Many of those around him are smiling sweetly, looking here and there, as people will. Dante stares straight ahead, serious, intense, meditative, and resolute. In Dante, the playful, visual medieval imagination takes on a sobriety, a cosmic seriousness, unparalleled in literary history.

Which probably just goes to show that every period in history, no matter its most salient characteristic, also harbors the very opposite.

Fig. 39
*opposite page*
Giotto di Bondone, *Giotto among the Group of the Elect*, detail from the *Last Judgment*, 1303–6. Fresco. Padua, Italy, Scrovegni Chapel. Cameraphoto/Art Resource, NY.

Fig. 38
Workshop of Giotto di Bondone, detail of the *Last Judgment* showing Dante. Fresco. Florence, Italy, Museo Nazionale del Bargello. Scala/Art Resource, NY.

1

# Teaching Medieval Art in Museums and on the Web

For many, strolling leisurely through a museum is a pleasant and edifying way to spend a few hours. On any given day, a city's museums will be filled with schoolchildren on field trips, tourists, and locals visiting their favorite works of art. Museums welcome their various constituents and take great care to present their collections so that visitors understand at least some basics about the works on display. Yet each visit can engender different reactions, and the distinctive ways in which the material can be presented by museum professionals lead to as many learning experiences. In this section, an art history professor, a curator and a professor of music history were asked to use two museum exhibitions (one temporary, one permanent) and a specific set of objects from an exhibition (fragments from a medieval manuscript) as starting points for teaching. The essays present strategies for teaching medieval art and architecture in museum galleries and offer a model of object research that has as its aim the writing of a catalog entry or object label. Taken together, these case studies illustrate as many methods to teach, exhibit and research medieval art and architecture.

# From the Lecture Hall to Museum Gallery: Teaching Medieval Art Using Primary Objects

Patricia C. Pongracz

Perhaps one of the most difficult aspects of medieval life for the contemporary student to appreciate is a medieval person's daily interaction with images. In an age with no television, no internet, no printed materials like billboards or direct mail, the average person in the Middle Ages saw imagery much less frequently than we do today. Imagery did not dot the landscape, was not delivered to your door, and was beyond most people's means to acquire. Access to it was therefore controlled, one needed to seek it out, to visit a place where images were. And the most likely place where the average medieval person would have encountered imagery was in a church.

Access to imagery is no small consideration when viewing medieval objects like those displayed in *Realms of Faith* (on view at MOBIA during the spring of 2008; fig. 40). The fifty works on loan from the collection of the Walters Art Museum, together with the eighteen books and leaves from the Rare Scripture Collection of the American Bible Society, could have been perceived by the casual viewer as precious, isolated objects esteemed primarily for their age, materials and technical virtuosity. The artworks, most of them relatively small in scale, all of them enclosed within Plexiglas surrounds, required the viewer's close examination. Imagery was not immediately apparent when one entered the gallery; rather encased objects were (fig. 41). For contemporary viewers used to being immersed in both static and dynamic imagery every day, the medieval liturgical and decorative objects displayed could have appeared, upon first glance, rather ho-hum. Each of the sixty-eight works on display, however, could be viewed as a microcosm of medieval thought and ideology. It was MOBIA's challenge to present the works so that their full historical richness was comprehensible to the museum's constituents. Fostering appreciation required viewer engagement based on some knowledge of each object's original function, iconography, audience, patron, and regional aesthetic. MOBIA's curator at the time, therefore, took as his guiding principle the presentation of the art in as full a context as possible within a temporary exhibition setting.

The exhibition strategy was manifold: organize the objects thematically, creating an overarching narrative in which the works could be understood; present the visitor with information explaining the works' medieval context in the form of labels and wall text; program exhibition-related events (like the symposium that resulted in the present volume) to further illuminate the complex and dynamic history that occasioned the various objects' creation; and present information targeted to the museum's diverse constituency, ranging from experts in the field to educated non-specialists to children. In short, MOBIA wanted to present

Fig. 40
View of the installation of the exhibition *Realms of Faith* at MOBIA. Photo: Gina Fuentes Walker.

Fig. 41
View of the installation of the exhibition *Realms of Faith* at MOBIA, showing objects displayed in Plexiglas cases. Photo: Gina Fuentes Walker.

the works in all of their fullness making them accessible to a variety of viewers.    **81**

As the essays in this volume make clear, study of the Middle Ages in all of its complexity permits—demands really—an interdisciplinary approach. The objects displayed in *Realms of Faith* could be understood by the contemporary viewer from multiple viewpoints: as beautiful, old objects valued today for their age, workmanship and precious materials— traits validated by the works' inclusion in the Walters Art Museum's collection, as well as their very display in a museum setting (fig. 42); as objects essential to medieval liturgical drama and choreography (see fig. 66); as tangible records of a lived faith (fig. 43); as indications of medieval conspicuous consumption (fig. 44); as examples of esoteric, and sometimes quirky sacred stories (fig. 45); or as some combination thereof (fig. 46). This essay uses MOBIA's presentation of *Realms of Faith* as the background for teaching an undergraduate introductory class on medieval art.

*Realms of Faith* presented an ideal opportunity to acquaint a group of undergraduates with a range of medieval objects that underscored how faith was interwoven with daily life. A museum visit, examining actual works of art, is central to any art history course. Though much information on history, style, iconography, use, audience, production, and technique can be taught in illustrated lectures, nothing replaces experiencing a work of art in person. First-hand observation reinforces topics addressed in lecture and often dispels misconceptions about objects gleaned from those very same lectures. Take, for example, the issue of scale. Art history lectures rely on images clearly projected onto a large screen or wall. While essential for teaching visual analysis in a classroom setting, this very means of communication often results in the students' misapprehension of a work's actual size. It can be difficult to reconcile how an ornate chalice, measuring eight inches tall, would have been the especial visual purview of the celebrant holding it when it is seen so easily in lecture magnified to seven feet tall. During museum trips students consistently remark how small or large an object they have studied in class appears in actuality.

*Realms of Faith*'s manageable size (sixty-eight objects) and disposition throughout a single spacious gallery created an intimate learning environment for students new to medieval art. Students could come nose-to-nose with the works on display, examining each of them carefully at his or her own pace. The works in fact demanded this level of interaction, for most were relatively small. The exhibition, arranged thematically around the notion of medieval faith, presented the works within a clear narrative framework that allowed the objects to be understood individually while enabling the student to make connections among various objects. This curatorial

Fig. 46
Diptych with the *Nativity, Adoration of the Magi, Crucifixion, and Last Judgment,* Flanders or northeastern France, *ca.* 1375–1400. Ivory, 6 ⅝ × 3 ⅛ in. (16.8 × 8 cm). The Walters Art Museum, Baltimore (71.201, acquired by Henry Walters, 1925).

conceit, imposed on the objects for ease of interpretation, is of course not medieval. As the introductory panel to the exhibition made clear, during the Middle Ages faith and the notion of the sacred infused the activities of day-to-day life; they were not confined to a particular place or time. Yet dividing the works into three thematic categories—"Realm of Domestic Life," "Realm of Liturgical Celebration," "Realm of Private Devotion"—allowed for objects to be grouped according to function and use, while encouraging the viewer to see iconographic overlaps between categories. Taking this approach the curators sought to underscore how faith was enmeshed with daily medieval life. Defining the sections as "realms" suggested distinct, yet intermingling themes, a kind of semantic equivalent of a Venn diagram.

"Realm of Domestic Life" included ten works ranging from dishes, to decorative tiles, candlesticks, and a plaque. This section gave an interesting opportunity to explain how the sacred, or sacred symbolism, was often incorporated in domestic objects and wares, and surrounded people in their homes. For example, the ceiling tile with a hare, made in Spain around 1513 (fig. 47), permitted the student to see how even a decorative tile could have had much greater resonance for its medieval viewer. The object label explained that:

> According to the bestiary, hares are swift and timid creatures, symbolizing people who put their trust in God in exchange for his protection: "The hares are but a feeble folk, yet make they their houses in the rocks" (Proverbs 30:26). This ceiling tile accentuates the symbolic value of the bestiary story; God protects those who trust in him as the ceiling protects the domestic interior.[1]

Describing the tile's actual and spiritual function while locating the image within its literary, visual and biblical context allowed the student to consider how various sources informed a medieval viewer's appreciation of a mere tile.

Pairing the ceiling tile with a hare with another Spanish tile dating to a similar period helped define their original context further. Like the tile depicting the rabbit, the chat label for the ceiling tile with a lion's head (fig. 48) noted that this image too was drawn from the medieval bestiary, which "combined moral lessons with examples of real or fictive animal behaviors." The label made clear why a patron would want the object in his or her home, noting that the lion represented "respectable characteristics with which medieval families wanted to be identified." In its discussion of the allegorical significance of the lion in medieval Christian thought, the label enabled the student to understand the symbolic link between a

Fig. 47
Ceiling tile with a hare, Spanish (Paterna), *ca.* 1513. Painted unglazed ceramic, 13 $^{15}/_{16}$ × 17 $^{1}/_{4}$ × 1 $^{3}/_{16}$ in. (35.4 × 43.8 × 3 cm). The Walters Art Museum, Baltimore (48.2106.12, museum purchase, 1958).

ceiling tile made for a private lay residence and medieval Catholic devotion:          **85**

> In the medieval bestiary, the lion could allegorically refer to God the Father. The lion keeps its eyes open while sleeping, symbolizing God's attentive watch over his people. Another fanciful property of the lion concerned its offspring. According to the bestiary, the lioness birthed stillborn cubs, but after three days blew life-giving breath into their nostrils. This became a metaphor for the Resurrection of Jesus, who, according to the Bible, three days after his Crucifixion, walked the earth again.

The display of the tiles in proximity to one another, combined with discussion of the rich and varied sources that inspired them, permitted the student a glimpse into how something as seemingly ordinary as a tile with an animal motif could serve more than a simply decorative function. Discussion of the tile's symbolic significance—the notion that for medieval believers the lion refers to God's protective watch over them—ties this object made for domestic use to the theological and doctrinal teachings of the Catholic Church. This link suggests how the realms of domestic life and liturgical celebration could have overlapped, and presents us with an ideal transition into the core of the exhibition: the twenty-four works displayed in "Realm of Liturgical Celebration."

"Realm of Liturgical Celebration" contained the largest number of objects, a nod to just how active a patron the medieval Church was. The objects' liturgical functions and their original uses in the celebration of the Catholic Mass required discussion of certain aspects of Catholic liturgy, theology and doctrine. Absent this contextualization, the objects would be understood as materially valuable, finely wrought, but perhaps esoteric works of art. Just how difficult it is to communicate tenets of a faith, even to a community of contemporary believers, was emphasized in a recent front page *New York Times* article about the Catholic Church's reinstatement of indulgences. Writing under the byline "For Catholics, A Door to Absolution Reopened," Paul Vitello began:

> The announcement in church bulletins and on Web sites has been greeted with enthusiasm by some and wariness by others. But mainly, it has gone over the heads of a vast generation of Roman Catholics who have no idea what it means: "Bishop Announces Plenary Indulgences."[2]

Vitello reports that the petition for indulgences—"a sort of amnesty from punish-

Fig. 48
Ceiling tile with a lion's head, Spanish (Paterna), *ca.* 1490–1550. Painted unglazed ceramic, 13 ⅞ × 17 ⅛ × 1 in. (35.3 × 43.5 × 2.5 cm). The Walters Art Museum, Baltimore (48.2106.5, museum purchase, 1958).

ment in the afterlife"—was a penitential rite lost in the wake of changes spurred by the Second Vatican Council in the 1960s.[3] Vitello's article is germane to the discussion at hand for it underscores the dynamic nature of faith traditions and shows quite clearly how doctrinal changes affect understanding of ritual tradition. If "a vast generation of Roman Catholics" have no idea about a rite that fell out of practice less than fifty years ago, consider the complexity of explaining a ritual object made, in some instances, more than 1,300 years ago to a museum-goer who may or may not be familiar with the Catholic liturgy for which the objects in "Realm of Liturgical Celebration" were originally made. Where does a teacher even begin?

One way to begin is to try to provide some visual context for a medieval Mass, which *Realms of Faith* did through the display of an image of the anonymous *Mass of St. Giles* together with definitions pertaining to Catholic liturgy and the celebration of Mass (fig. 49). The image of the priest consecrating the Eucharist during High Mass at a beautifully embellished altar was used to foreground the various objects displayed throughout the gallery. And because almost half of the twenty-four objects displayed were made for liturgical use and had to do with the rituals surrounding the consecration of the Eucharist, the wall text took care to explain to the museum audience what exactly Catholics believe happens during Mass:

> During this dramatic ritual, the faithful receive the sacrament of Holy Communion by consuming the consecrated Eucharist, thereby participating in the Last Supper, the sacred meal that Jesus shared with his apostles before his Crucifixion.

> According to the Gospels, Jesus blessed bread and wine and gave it to his disciples, identifying those elements with his own body and blood. The Catholic doctrine of transubstantiation asserts that the gifts of bread and wine consecrated by the priest during Mass become the body and blood of Christ. Thus, during Communion, the sharing of Eucharist with the congregation, medieval Catholics received what they believed to be the body of Jesus, sacrificed to redeem their sins. The precious materials and ornate decoration of the Eucharistic instruments displayed here demonstrate both the sacrament's significance and the medieval worshipper's belief in its redemptive power.

Even with thoughtful and sensitive description, Mass and what the faithful believe happens during it is a difficult concept to convey to students who are completely unfamiliar with the ritual. It can be surprising to realize how even

Fig. 49
View of the installation of the exhibition *Realms of Faith* at MOBIA, showing an introductory wall defining key parts of the medieval liturgy as seen in the *Mass of St. Giles* (see fig. 75).

those students who know what Mass is, and may even have participated in it, are often unfamiliar with the doctrine and theology undergirding this sacred drama. Together, comparative image and wall text attempt to contextualize the liturgical function the objects displayed would have had for a medieval audience. Believers throughout the Middle Ages (and in the present day) would have understood the import of the miracle of transubstantiation and most likely would have interpreted that altar, in all of its finery, as a most appropriate setting for the reenactment of this most sacred meal. For believers, the altar was God's table in God's house—a point eloquently explored by Xavier Seubert in this volume. To emphasize this belief, many of the liturgical objects were displayed beneath the words of twelfth-century theologian and avid art patron Abbot Suger:

> To me I confess one thing has always seemed preeminently fitting, that every costlier or costliest thing should serve first and foremost on the administration of the Holy Eucharist.[4]

With an image of how a medieval Mass may have looked and the essential components of what took place and why defined, the student is encouraged to see the precious objects displayed as purposefully designed liturgical objects essential to the practice of codified ritual devotion. The four essays in the following section of this volume examine the rich and multiple contexts for the chalices, paten, spoon, and Eucharistic dove. Here we look at one other work featured in "Realms of Liturgical Celebration."

An excellent example of how rites and ritual are embodied in a work made expressly for their service is the gilt and engraved copper pyx made in France during the thirteenth century (fig. 50). This diminutive box could be used to communicate succinctly and powerfully how a single object fulfills multiple rites. As the chat label explained, small boxes like this pyx were made for various uses during the Middle Ages. The liturgical function of this particular box is signaled by a design element: "The medallions on its sides contain the monogram IHS, the short form of the medieval Latin *Ihesus*, or Jesus." A pyx like this would have been used to bring the Eucharist to those believers who were too sick to attend Mass, but who still wanted to partake of Holy Communion. As the label continues to explain, a second design element indicates that this box would have been used to bring communion to those who lay dying:

> This particular function is suggested by the small, hinged lid atop the pyx lid.

Fig. 50
Pyx, French, 13th century.
Gilt and engraved copper,
1 ½ × 2 ½ in. (3.8 × 6.3 cm).
The Walters Art Museum,
Baltimore (53.11, acquired
by Henry Walters).

90

This smaller lid covered a Holy Oil reservoir. It would have contained a wad of wool or other absorbent material soaked in Holy Oil to be used to anoint the believer during the Sacrament of Extreme Unction, also known as Last Rites.

The intimacy of this ritual is suggested by this pyx's small cylindrical shape. Measuring just 1½ inches high and 2½ inches in diameter (considerably smaller than the image reproduced here), this pyx would have contained just a few consecrated wafers. It would have tucked easily into a pocket for safe transport and fit comfortably in the palm of one's hand as the Eucharist was offered and Sacrament of Extreme Unction administered. The pyx's design elements, size and decoration combine to suggest the comforting power rites like those administered with the aid of this box had (and continue to have) for Catholic believers. The student would be encouraged to consider the sacramental import of this small, functional object in the Middle Ages, while being reminded that pyxes like this are still very much in use by contemporary Catholic priests and Eucharistic ministers. The details of this particular pyx thus illustrate how aspects of liturgical celebration could also take place outside of the church proper, which brings us to consideration of the final thematic category, the "Realm of Private Devotion."

As we saw in examples from the "Realm of Domestic Life," imagery commissioned by a wealthy patron for personal use had multivalent meanings that included both tacit and overt references to faith. The introductory text panel for the "Realm of Private Devotion" made this point clear for the works of art displayed:

These objects helped their pious owners reflect upon the divine mysteries of the Christian faith, such as the Virgin Birth, the Resurrection of Christ, or the empowerment of the early church on Pentecost. Equally important to devout medieval patrons were scenes of the saints, whose protection or pious examples were quickly brought to mind by their comforting likenesses in private chapels or at home.

As the text panel suggests, saints served not only as positive medieval role models, they were believed to have apotropaic and intercessory powers. Saints' colorful lives and virtuous deaths by martyrdom were collected into anthologies; perhaps the most well-known of these is Jacopo da Voragine's *The Golden Legend*, dating to around 1260. Introducing the role saints' lives played in medieval Catholic devotion permits the rich and varied extra-biblical sources that informed visual expression, another important facet to study of the subject at hand.

Fig. 51
Cameo with the *Virgin Mary Praying*, Byzantine Empire (probably Constantinople), *ca.* 900 (gold mount added *ca.* 1925). Bloodstone, 2 ¼ × 1 ³⁄₁₆ × ¼ in. (5.7 × 3 × 0.6 cm). The Walters Art Museum, Baltimore (42.5, acquired by Henry Walters, 1928).

The notion of a saint's protective power and the esteem a patron drew from commissioning a valuable work is concisely presented in the chat label for the cameo with the *Virgin Mary Praying*, from the Byzantine Empire (probably Constantinople) dating to circa 900 (mount added *ca.*1925; fig. 51), which read:

> This miniature stone carving is very close in style to one in the Victoria and Albert Museum (London) that, according to an inscription, was made for the eastern medieval Byzantine Emperor Leo VI (ruled 886–912). For a wealthy patron, it was advantageous to identify the icon with a famous precursor.
>
> Although the gold mount is modern, it informs us about how such small images were once worn by their owners. Labeled in Greek "Mother of God," Mary is shown with outstretched hands, imploring her son to forgive the sins of humanity. The medieval person who wore this precious cameo invoked the protection of Mary, the Mother of Jesus, throughout the day, while simultaneously affirming a belief in the Virgin's efforts to restore humanity. Wearing the cameo was itself an act of worship.

The label succinctly introduces the multivalent meanings of this small, carved pendant linking the individual owner with the broader Communion of the Faithful who believed Mary to be a special intercessor between believers and her son.

*Realms of Faith* presented an ideal opportunity to teach core concepts about the Middle Ages directly from objects. Each work invited discussion of aesthetic, workmanship, patronage, audience, ritual function, iconography and symbolic significance; thus in an individual object, a student could begin to understand the multiple and nuanced contexts that informed an object's production and in which the object operated. The exhibition allowed students to examine a selection of representative objects significant, in part, for their very ubiquity. Most museum collections of medieval art contain works similar to those on view making very clear that animal-motif tiles, chalices, patens, crosiers, Eucharistic doves and the like played a significant role in the society making and using them. Organizing the works according to the "realms" in which they functioned and showing the overlaps encouraged students to think about how such works would have been perceived by medieval audiences, and perhaps most crucially, that medieval perception of the works differed greatly from our perception of them today. And all of this offered various starting points for lecture and discussion making *Realms of Faith* as presented by MOBIA but one example of how medieval art can be taught.

# Teaching Medieval Architecture at The Cloisters

Nancy Wu

To many enthusiasts of the medieval period The Cloisters Museum, with its rich depository of exemplary objects from the Middle Ages, epitomizes the beauty and serenity of a bygone era. Indeed, the architecture of the museum, designed and constructed in the 1930s by Charles Collens (1873–1956), was meant to evoke a medieval setting in a structure perched above the rustic landscape of the surrounding Fort Tryon Park (fig. 52).[1] The rugged, tiled rooflines, forbidding rampart walls, stone and brick-lined terraces overlooking the Hudson, and the silent arcades circumscribing the four reconstructed cloisters combine to create what many consider a romantic, even magical, backdrop for the medieval collection contained within.

Indeed, more than anything else the architecture of The Cloisters was, from the very beginning of the planning stage, meant to subordinate as well as support the display of objects. Take, for example, what was originally called the Spanish Room (now renamed the Mérode Room), for which the fifteenth-century painted ceiling reportedly from a small palace in Illescas, Spain, was destined (fig. 53).[2] As early as 1932, well before the start of construction, Joseph Breck (1885-1933), the curator then overseeing the design of the new structure, expressed clearly his desire "to give the windows and door openings [of the Spanish Room] a Spanish character; in other words, to make the rest of the room harmonize with the ceiling...."[3] Lacking any late medieval windows or doors in the collection at the time, Joseph Breck and his successor, James Rorimer (1905–1966), sought inspiration from surviving medieval monuments in Europe, in this case a window in Barcelona.[4] When sufficient information for the necessary architectural details could not be gleaned from existing monuments, as for example the coping stones for the parapet walls along the upper periphery of the museum, Collens was sent specifically to an image of the *creneau* in Viollet-le-Duc's *Dictionnaire raisonné de l'architecture française du XIe au XVIe siècle*.[5] The pressure to seek "precedents" for the design of architectural details eased considerably in 1934; becoming the first curator in charge of the newly formed Department of Medieval Art on January 1 of that year, Rorimer would acquire aggressively medieval architectural fragments with the financial support of John D. Rockefeller, Jr. (1874–1960).[6] A year later a large group of architectural fragments from the dismantled Salle de Musique in the Parisian residence of George Blumenthal (1858–1941) arrived, further enriching the collection with historical arcades, windows, doorways and other structural components now seen at The Cloisters.[7]

The successful integration of architectural remains into the fabric of a modern building has created a general misconception about the architecture of The Cloisters:

Fig. 52
The Cloisters, Fort Tryon Park, New York. View of the upper driveway entrance in winter, with the Froville arcade and Sens windows visible at center. Photographed in 2004. The Metropolitan Museum of Art, The Cloister Collection. Image © The Metropolitan Museum of Art.

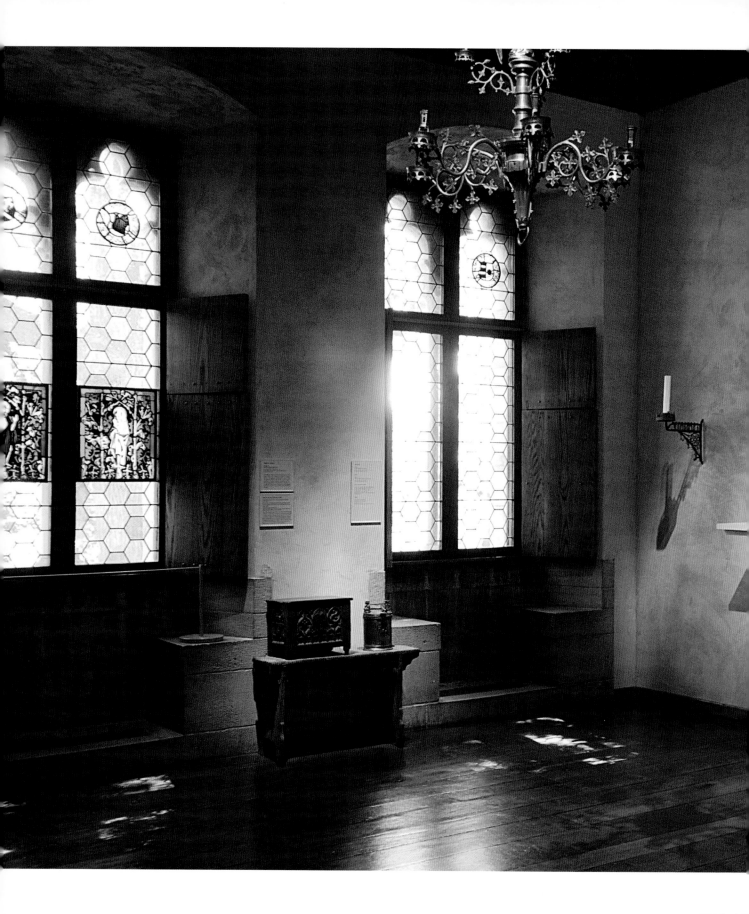

Fig. 53
Mérode Room, The
Cloisters, remodelled after
1956 to reflect the interior
represented on the central
panel of the Mérode
Altarpiece (right). Photo:
Nancy Wu.

96 a large number of the general public believe it a completely medieval structure uprooted from Europe; for those who understand the history of the museum, the prevalence of medieval fragments seems to guarantee a degree of ease with which medieval architecture can be taught with the collection. In fact, the lack of context can pose a significant challenge to better understanding the architectural objects: in some cases fragments are built into the museum structure in a context completely different from that at their original location; in other cases no information is available about the setting from which the objects came.[8] For example, a delicately carved limestone tracery window from the late thirteenth century now stands as a diaphanous screen on an interior wall between two galleries (the Early Gothic Hall and the Gothic Chapel), when in fact it once formed part of the exterior shell of a small church in La Tricherie, a village near Châtellerault in western France. Similarly, dozens of capitals and columns once belonging to the upper cloister of the Benedictine abbey of Saint-Guilhem-le-Désert are now on view at eye level. The decision not to install these sculptures at a higher level stems, in part, from the desire to make accessible the exquisite carvings to the visitor. Additionally the original cloister, extensively mutilated in the wake of the French Revolution, leaves no evidence as to the order in which the elements were arranged when the upper cloister was constructed in the late twelfth century.[9] When the original context is not discernible, the challenge becomes considerable to teach the architecture that is displayed in the collection. In this brief paper, four galleries (Fuentidueña Chapel, Cuxa Cloister, the Pontaut Chapter House, and the Mérode Room) will be discussed to demonstrate the kinds of topics selected, and strategies exercised, in our effort to teach medieval architecture at The Cloisters.

The Fuentidueña Chapel (fig. 54) comprises a rectangular "nave" constructed in 1959–60 to accommodate the twelfth-century apse from the church of San Martín in Fuentidueña, near Segovia, Spain.[10] The "nave," though in effect a modern gallery space, imitates the layout of a typical Segovian church of the twelfth century with a single, broad aisle and no projecting transept arms. As is often the case at the first meeting of any survey course on medieval architecture when key terminology is introduced, it is here in the Fuentidueña Chapel where students come face to face with architectural elements such as "apse," "nave," and "barrel vault," whose abstract definitions they have learned from pictures. Many of these terms describe some of the most prominent characteristics of Romanesque architecture: thick-wall construction, narrow slit windows, and round arches. While geometric, abstract motifs cover much of the moldings articulating the wall surfaces (for example, those framing each window or delineating the base of the half dome),

Fig. 54
Apse from San Martín at Fuentidueña. Spanish, Castilla-Léon (Segovia), *ca.* 1175–1200. Sandstone and limestone. Height to top of barrel vault, 29 ft. 8½ in. (9.055 m). Max. interior width, 22 ft. ½ in. (6.72 m). The Metropolitan Museum of Art, The Cloisters Collection, Exchange Loan from the Government of Spain, 1958. (L.58.86). Image © The Metropolitan Museum of Art.

Fig. 55
Cloister from Saint-
Michel-de-Cuxa. From the
Benedictine monastery
of Saint-Michel-de-Cuxa
(San Miguel de Cuixa),
near Perpignan. French
(Pyrénées-Orientales,
Roussillon) or Spanish,
*ca.* 1130–40. Marble, 90
× 78 ft. (27.4 × 23.8 m).
Photographed after
1985. The Metropolitan
Museum of Art, The
Cloisters Collection,
1925. (25.120.398, et al).
Photograph by Lynton
Gardiner. Image © The
Metropolitan Museum of
Art.

100

narrative scenes from both the Old and New Testaments dominate the capitals and other architectural members. These diverse decorative motifs are often included in discussions about the function and strategic placement of architectural sculpture in a Christian church.

The triumphal arch at the entrance to the apse and the vivid colors of the fresco adorning the half-dome above the windows are features already employed in some of the earliest Christian basilicas and continue to be seen in many churches built today. While many of the students who come to The Cloisters may not yet have had the opportunity to visit historical structures in Europe, most have set foot in, if not frequented, churches or other religious buildings. Therefore they find the spatial organization and liturgical furnishing of the Fuentidueña Chapel familiar, making it an ideal location to explore the relationship between architecture and liturgy. To many students, their familiarity with the sanctuary area within any modern-day houses of worship helps them relate to the apse's spatial preeminence. For example, as students file into the Chapel they often walk through a twelfth-century doorway (from Nevers) at the opposite end of the gallery. Without exception, they walk toward the apse and instinctively stop before the monumental, painted crucifix from the convent of Santa Clara at Astudillo.[11] Indeed the crucifix, suspended from the barrel vault, and below it the altar with a painted frontal from the church of Ginestarre de Cardós in Lleida province, Catalonia,[12] illustrate the importance of liturgical furnishings inside the church in declaring, however subtly, the boundary between the clergy and the congregation. When asked, most students are quick to point out that the presence of an Italian holy water font to the right of the apse, the pair of candlesticks flanking the triumphal arch, the narrative sculpture and fresco above, help identify the hierarchical importance of the apse within the gallery.

Just as we take advantage of the liturgical setting suggested by the way objects were selected and displayed in the Fuentidueña Chapel, in the nearby twelfth-century Cuxa Cloister (fig. 55) we explore many possibilities in teaching the monastic plan in general, and the notion of the cloister in particular.[13] Generations of students have had their first taste of a monastic cloister by walking under the covered walkways of Cuxa. They stroll past the arcade's intervals of light and shadow—cast by the row of columns with arched openings in between. Some of the more thoughtful students have even compared the rhythmically repetitive intercolumniation with the structured life of the monastery. Along the way they are encouraged to imagine the kind of structures that typically surround such a courtyard and how the practical function of each—sacristy, refectory, dormitory, *armarium*, and so on—illustrates

Fig. 56
Chapter House from the abbey of Notre-Dame-de-Pontaut. French, Gascony, 12th century. Limestone, overall 453 × 304 in. (1,150 × 772.2 cm). The Metropolitan Museum of Art, The Cloisters Collection, 1935. (35.50, 35.51). Photograph by Malcolm Varon. Image © The Metropolitan Museum of Art.

the daily spiritual and practical needs of the monastic community. The opening at the center of each arcade providing ready access into the garth, and the paved footpaths crisscrossing it, quickly remind everyone of the importance of the cloister as a well-trodden thoroughfare within the monastery. It is indeed in the cloister where myriad activities take place, and different ranks of the religious converge.[14] Accounts from medieval monasteries are read to the students, allowing them to visualize the chanting of monks processing in the cloister, or the hushed steps of someone rushing medicinal herbs to the infirmary. Some students practice sign language with each other to imagine life under the rule of silence, others look out into the garth to appreciate the serenity and tranquility it provides. The basic layout of the cloister makes it easy for students to understand the self-sufficient lifestyle within a monastery, one which allowed the monks to focus on their spiritual pursuit without disruption from the outside world.[15]

However, the most attractive—or put plainly, attention-grabbing—features of the Cuxa Cloister are the fanciful and sometimes enigmatic images decorating the capitals. There are, for example, naked men holding winged beasts, composite creatures glaring at each other, or proud musicians blowing the trumpet. The meaning of these images has not been fully comprehended by historians, although many tantalizing suggestions have been made.[16] The familiar *Apologia* to Abbot William of St.-Thierry written by Bernard of Clairvaux in 1125 describes certain carvings that are practically identical to what we see at Cuxa: "What is the point of those unclean apes, fierce lions, monstrous centaurs, half-men, striped tigers, fighting soldiers and hunters blowing their horns? In one place you see many bodies under a single head, in another several heads on a single body."[17] Indeed, the popularity of these unseemly creatures in the twelfth century is undeniable, but the protest of Bernard—arguably the most influential Cistercian of the Middle Ages—also reminds us of a fast-emerging reform movement by his order intended to return monastic life to its original ideal of austerity and simplicity. At The Cloisters, just off the Cuxa Cloister stands the reconstructed chapter house from the Cistercian abbey of Notre-Dame-de-Pontaut near the commune of Mant in southwestern France (fig. 56).[18] The direct juxtaposition of the exuberant sculptures of crouching monkeys and double-headed lions in the Benedictine Cuxa Cloister, and the non-figurative motifs such as spiral and basket-weave in the Cistercian chapter house, provides at a glance, literally, a stark contrast between the aesthetic manifestations of these two powerful religious orders.

The chapter house has been reconstructed almost entirely with material from its original location, except for the tile floor and the webs (the smooth, triangular

surfaces between the ribs), which are modern replacements.[19] It is a rectangular room of six square bays, each covered by a quadripartite rib vault. Two mono-lithic columns stand in the center, while three large archways open to the cloister walk outside. For students who have just examined Romanesque features in the Fuentidueña Chapel, it is easy to recognize the same thick-masonry construction, round arches, and small windows here. However, rib-vaulting is almost always discussed (at least in most classrooms) in association with the new Gothic style beginning in the 1130s and 1140s; thus, the presence of rib vaults here often causes confusion. We have found it useful to point out the remote location of Pontaut in rural Gascony, hundreds of miles away from the Ile-de-France, the birthplace of Gothic architecture. Perhaps in this chapter house we are witnessing a provincial architect's simple desire to add a new, "fashionable" feature to what possibly re-mained to him a more "traditional" structure. Whatever the intention, since we know it is more common than not to find in most historical buildings features of different styles to coexist with each other, the Pontaut chapter house offers stu-dents the opportunity to see how the potential of adaptability played a role in pro-pelling the transformation of architecture.

We are also not to lose sight of the fact that the placement of the chapter house reflects its essential role in monastic life. Typically situated in the east range of the cloister, the room is structurally integral to the cloister despite its self-contained appearance. Surviving structures at the site of the abbey suggest that the chapter house was separated from the monastic church by two other rooms that typically line the east range of a cloister: the sacristy and *armarium*. Local residents also spoke about a set of stairs in the sacristy leading to the upper floor; perhaps these were the night stairs providing convenient access to the dormitory above the chapter house and the church, where monks attended offices at night.[20] Although the reconstruction at The Cloisters does not include the additional rooms or fea-tures found in situ, the adjacent Early Gothic Hall to the south, and a passageway to the north, may be used to evoke the image of the original layout.

The chapter house also gives the opportunity to discuss the kinds of gather-ings and activities that took place here. The term "chapter house" may be unfamil-iar to most visitors, but the concept of a dedicated meeting room for certain pre-scribed activities is readily understood, and the stone bench set against the wall explains itself. In addition to the primary activities that take place in the chapter house, such as readings and prayers, there were confessions made by the monks for wrongdoings (and pronouncement of punishment), assignment of work, and other announcements, discussions, and remembrances.[21] Sometimes small details

Fig. 57
*following spread*
The Workshop of the
Master of Flémalle.
*Annunciation* Triptych
(Mérode Altarpiece). South
Netherlands, Tournai, *ca.*
1427–1432. Oil on oak panel,
overall (open) 25 ⅜ × 46 ⅜
in. (64.5 × 117.8 cm).
The Metropolitan Museum
of Art, The Cloisters
Collection, 1956. (56.70a-c).
Image © The Metropolitan
Museum of Art.

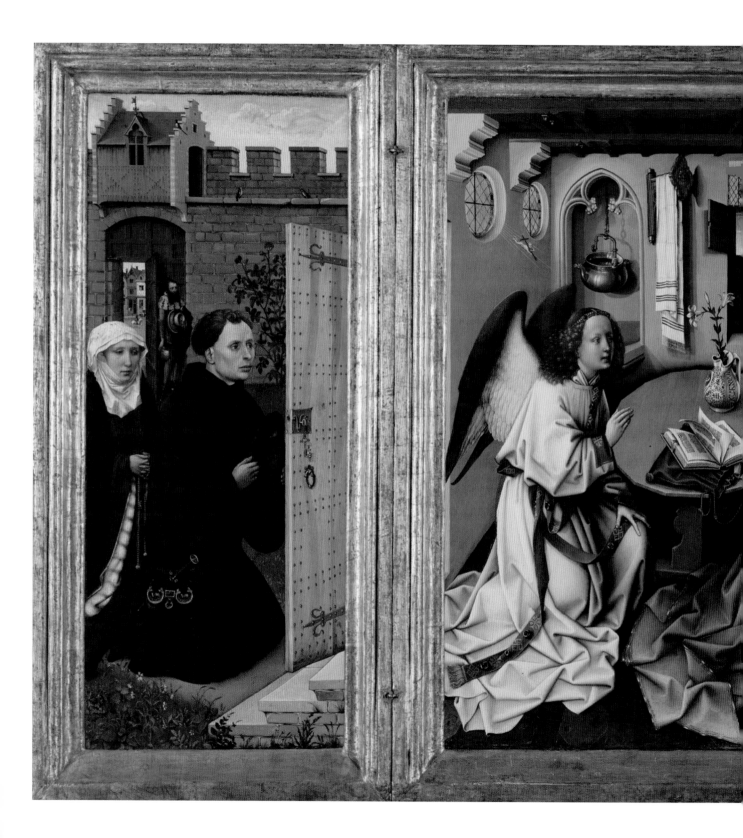

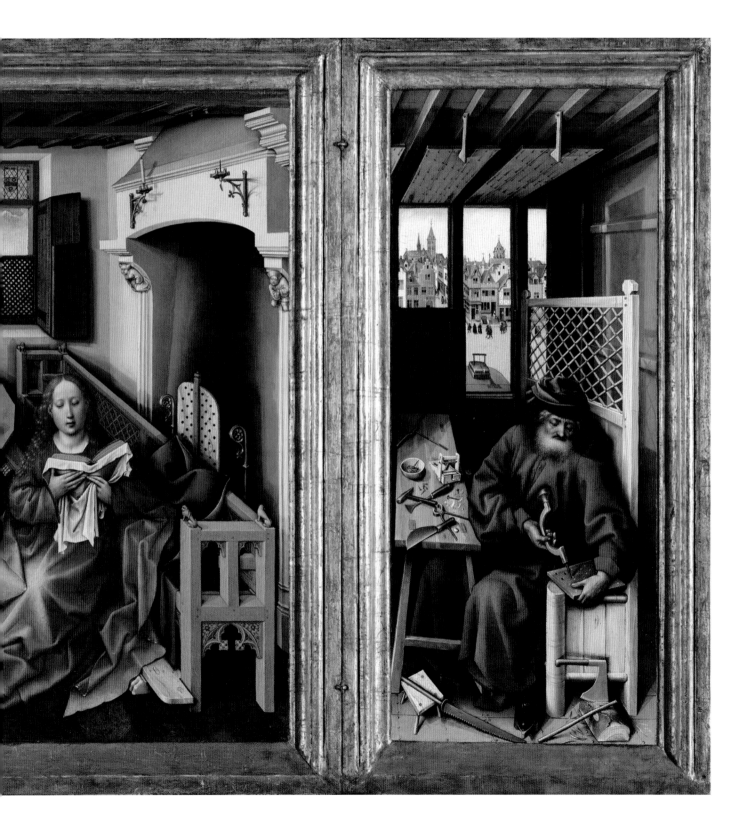

in the room, such as the metal rings hanging from the two central columns, invite wild guesses: when asked about their possible function, answers range from supporting a hammock, holding a pair of torches, to affixing a device for torture! In fact, these two inconspicuous rings explain the post-medieval fate of this chapter house, which was sold into private hands in 1791 following the French Revolution and was used as a barn where pigs and horses were kept until 1932, when the chapter house was sold to the Parisian dealer Paul Gouvert. For older students or adults, the history of the Pontaut Chapter House provides a natural transition to a general discussion about the damage and destruction to religious art and architecture caused by different political and religious upheavals.

The chapter house from Notre-Dame-de-Pontaut is a self-contained structure that is almost entirely original. The so-called "Mérode Room," while an equally self-contained space, is entirely modern (except for the painted ceiling) but furnished with thoughtful period details to invoke the appearance of a middle-class home in fifteenth-century Flanders (fig. 53). The period details provided a felicitous setting for the so-called "Mérode Altarpiece," (fig. 57) when it was acquired by The Cloisters in 1956.[22] The acquisition could have not been happier, for the famed triptych had been one of a handful of fifteenth-century paintings consulted by Breck and Rorimer when this very gallery was being designed and furnished in the 1930s.[23] With the arrival of the triptych, changes were made to give the gallery—formerly rather sparely furnished—a northern European domestic setting similar to the one depicted on the painting's central panel (the *Annunciation* scene). For example, the velvet curtains hanging on either side of the double-lancet windows were replaced by wooden shutters, with several German heraldic stained-glass roundels installed on the casement windows, to resemble the window behind the seated Mary.

For many visitors the Mérode Room is a fitting conclusion to their visit. The furnishing and scale of the room are akin to the comfortable home of a middle-class family, and many students quickly recognize objects that look like what they have at home: chairs, benches, wash basin, vases. It is always useful to explain the often multi-functional nature of the medieval furniture by pointing out some of the details in the painting. For example, on the right-hand panel, one of the lower wooden shutters in the window of Joseph's workshop opens toward the street to display a finished ware (a mousetrap), and the upper shutters are suspended from the ceiling to allow in light and ventilation during the day (and obviously lowered to secure the shop at night). As to the furniture in the actual gallery, the bench always attracts attention with its rather worn animal finials and the hinged seat

that also functions as a storage chest. Together with the other pieces of furniture, household objects and tapestries, we understand how homes were largely furnished with portable pieces that could be moved within the house and, as was often the case with aristocratic households, traveled with their owners. It is also interesting to point out that, respectful of medieval precedents, subtle changes were made to some of the features familiar to the modern visitors, rendering them either different from the modern-day (all casement windows swing inward) or simply absent (no baseboard).[24]  Although over the years some of these details have been modified, the Mérode Room is nevertheless an effective gallery showcasing architectural and interior details to complement the triptych. More importantly, it demonstrates how such an intimate space provided an ideal setting for private devotion, which became increasingly personal and earnest in the later Middle Ages. The triptych itself, and some of the other objects used for private devotion, are excellent examples of how objects of modest size could have been used in the privacy of the home for the daily prayers and meditations of the owners.

The challenges we face, when attempting to teach medieval architecture at The Cloisters, are formidable. This seemingly ideal place offers few canonical examples typically found in survey texts. There is not a single example to demonstrate the familiar elevation of nave arcades, triforium, and clerestory windows; nor are there flying buttresses, or a veritable west façade. While anyone teaching in the classroom can bring in as many images and texts as needed to compare, contrast, and illustrate, we are working with a finite material dictated by the scope of the collection. The Cloisters collection may not have encyclopedic architectural examples, but the museum's installation allows a direct physical contact with the objects. No high-definition image affords us the multi-sensory experience by walking in the Cuxa Cloister to understand the scale of the architecture, the presence of different rooms behind the windows; we hear the birds chirping, and feel the wind breezing by. Suddenly we understand why monks would leave their parchment leaves to dry in the cloister, why novices needed to be refrained from running in the corridor, how burials could be accommodated in the cloister arcade, and why such a courtyard was regarded the nucleus of monastic life. It is the opportunity to see, hear, smell, and move within the spaces that makes learning about medieval architecture a "different" experience at The Cloisters.

# Cataloguing Medieval Manuscript Fragments: A Window on the Scholar's Workshop, with an Emphasis on Electronic Resources

Margot Fassler

The original presentation on which this paper is based used PowerPoint slides with detailed photographs of the pages, and a demonstration of the online resources I used to begin the task of writing a short catalogue entry for them. For the written version I have tried to keep the format of the original, turning the Power-Point into prose. The audience on the day of our session followed me on a journey of investigation, and I often asked them for their opinions and solicited responses to questions I posed, something I cannot do here. Still, I have tried to keep the flavor of the original lecture/demonstration in the hope that it might prove engaging and useful for teachers in a variety of disciplines and venues.

There is much available now that is open-access in libraries, museums, and classrooms.[1] I hope to encourage non-specialists to view some of the thousands of medieval manuscripts and fragments or leaves now digitized and readily available to all with internet access, and also to take advantage of the kinds of tools for study once available only to scholars in research libraries. It is an ideal moment for specialists in medieval manuscripts to engage the public in our work as scholars, librarians, and teachers.[2] The other feature of my presentation to emphasize is the ephemeral nature of websites, truly here today, gone tomorrow. There is an irony in working with ancient texts that have survived incredible turmoil and whose very existence is a miracle using tools that were created in the last decade or so and that will either be greatly modified or not exist at all within a few more years. My paper is filled with URLs and I have checked them all for functionality, but they go out-of-date as I write.

### Introduction to the Nature of Medieval Manuscripts

In the Latin West, up until around 1450, books (codices) were usually made of cured animal skins, parchment, and mostly culled from goats, pigs, deer, sheep, and cattle, including calves, and even oxen for some gigantic late medieval choir books. The skins were soaked in slaked lime, scudded, and then processed on stretching frames.[3] They were carefully scraped to remove all residue, although it remains possible in most cases to tell if a page is hair-side or flesh-side from appearance, a useful bit of knowledge to have when trying to understand the way a codex was assembled. It took a substantial herd of animals to produce enough skins for one medium-sized codex. Some parchment was very refined, even somewhat delicate, with that from calves especially prized and called vellum. Parchment could also be crude and rough, and even oddly sized scraps were used for various book-making purposes. The kinds of parchment chosen for a book depended both on the nature of the book being prepared, and on the amount of money the persons or institution paying for it were willing to spend. Books were put together in sheets

Fig. 65
Detail of a leaf from an Antiphonary, Spanish (previously identified as Italian), *ca.* 1450–1550. American Bible Society Library. Photo: Gina Fuentes Walker.

of parchment that were laid out flat and ruled and otherwise prepared to receive writing. Sheets were then folded and gathered into groups (each called a gathering), and then sewn. Most medieval codices consist of stacks of sewn gatherings bound together. Scholars can tell by counting leaves within gatherings and gatherings within books if new pages have been added or others removed.[4]

Medieval scribes wrote with reeds or with goose quills, and had to keep them appropriately sharpened and replace them often. Mistakes could be costly and difficult to correct, and pictures of medieval scribes traditionally show them with a pen in one hand and a knife of some sort in the other. Scholars who study handwriting are called paleographers, and their specialized knowledge requires study of families of manuscripts and the book-production of particular points of origin, places where significant numbers of books were assembled and copied in a large room for writing and book production: the scriptorium. In the Middle Ages large monasteries and cathedrals had scriptoria, and charters for legal purposes could be produced in them as well. By the twelfth century, some institutions were sending work out to professional scribes. According to de Hamel, before 1100 most manuscripts were made in monasteries and after 1200 most were probably not.[5] The rise of the university in Paris in the course of the twelfth century and the need for great quantities of books altered production significantly, and increased the role of the secular scribe.

The art of the medieval calligrapher was of major importance in the production of deluxe manuscripts, with the large capital letters marking textual units providing opportunities for lavish display, as well as serving the practical purpose of creating divisions in the text. Deluxe medieval books often were illuminated by artists who worked in brilliantly colored inks or paints and used gold foil to highlight deluxe letters and drawings or paintings. Even moderate handling of gold-leaved manuscripts, therefore, can seriously damage them, and scholars are trained to never touch inks and illuminations when they handle manuscripts today.[6] A great number of the books that have survived from medieval Europe—and the numbers are very few compared to what must have been produced—are liturgical manuscripts, books used for Mass, Office (or hours of prayer) or other liturgical occasions, such as processions. Usually when a medieval book is in Latin with single lines of music, it is a liturgical book (although, of course there are important exceptions to this rule).[7]

Most major libraries have at least one or two leaves from medieval manuscripts, and some have significant collections of medieval manuscript leaves. Books were often dismembered, and the parchment reused even in the Middle Ages, but in the Reformation and religious wars of the early modern period, destruction was

especially high. England, for example, has a low percentage of surviving medieval manuscripts, and most of what must have been a brilliant polyphonic tradition in the Middle Ages has been lost. The ravages of medieval manuscripts in Sweden and other neighboring countries was severe as well, although many fragments exist, reused for wrappings of record books. The 22,500 fragments taken from more than 6,000 medieval manuscripts held in the National Archives in Sweden have been catalogued by Jan Brusius, Gunilla Björkvall, and other scholars. Indeed, theirs is the flagship enterprise of the kind of work we are engaged in today.[8] In recent centuries, booksellers acquiring medieval manuscripts have often despoiled them of their illuminations and dismembered the books to make more money by selling them piecemeal. Scholars often try to reassemble the component parts of especially important sources, and this kind of work shows why it is crucial not only to describe detached leaves carefully, but also, if possible to digitize them. Several examples of catalogued and digitized collections of manuscript fragments can be found online. The enormous collection owned by the Philadelphia Free Library, for example, has been the center not only of a digitization/cataloguing project, but also of a public exhibit, and several teaching initiatives. Local scholars were involved in the project as consultants, and a catalogue was published as well.[9]

The work of this presentation is to write a short catalogue entry for two manuscript pages from the Rare Scripture Collection of the American Bible Society (figs. 58 and 59).[10] The project introduces the tools that scholars, many of whom are rare-book librarians who consult with art historians and musicologists, use to do this kind of work. One of the most thrilling things about teaching today is the abundance of very important tools that are now available online, to anyone, free of charge. We will focus primarily on these, with others mentioned in the bibliography, and coming in at the end to double-check our work. With such tools at hand on the internet, the process by which scholars and professional librarians do their work has become far more transparent than it once was, making it possible to bring vast amounts of very precious material into schools, libraries, and museums, and showing people utterly marvelous and precious manuscripts in great detail, without harming them, and at low costs. Many of the best online sites include sophisticated zooming tools, so one can blow up letters and other details of a manuscript as if possessing a microscope, and ponder the ways in which the scribe made his letters or held his/her pen, and the kinds and qualities of ink, rulings of the page, parchment, paint and other features of book production.

An excellent site for digitized manuscripts originates where one of the oldest and most important collections of books for the study of Gregorian chant is held,

the library of the Benedictine monastery of St. Gall in Switzerland. Any citizen of the world, any student of medieval European culture can now page through much of this extraordinary collection at http://www.cesg.unifr.ch/en/index.htm (accessed in April, 2009). The digitization is part of the resolution of a dispute that has been ongoing since the early eighteenth century when the Prince-Abbot of St. Gall was defeated by armies from Bern and Zürich, whose leaders carried off many cultural treasures, including manuscripts from the abbey of St. Gall. These have now been returned to the monastery, on a permanent "loan," with the stipulation that they be digitized (for further discussion of this matter, see the website). Many institutions have been involved in the creation of the digital library at St. Gall, and funding has been provided by the Mellon Foundation, New York City. That digitization could provide a peaceful solution to an ancient dispute is one of the wonders of modern technology.

### The Set-Up of the Page

We begin with page A (fig. 58), which will be our primary source, consulting page B (fig. 59) from time to time.[11] The first thing to observe is that this page is not just of text; it also includes musical notation, on a five-line staff drawn in red ink. Latin texts and notation on single staff…does this ring a bell? Yes, this is probably a liturgical book with chant notation. We remember that medieval scribes planned their manuscripts so that capital letters were significant and that they distinguished major sections of pages, and were key to the ways that pages were laid out. Before we begin to trace down the function of this leaf, let us see what we can discern about how the page is laid out. Can we imagine what cues the scribes used to do their work? Let's imagine we have a blank sheet of parchment and we are trying to figure out in what stages it came to look as it does now. To quote Abbott and Costello: Who was on first?

Page A is complicated. We won't even look at the other side of the leaf for this brief discussion, but we can see the bleed through of the ink, enough to prove that it was set up in the same way. The page has been excessively trimmed, and surely there were originally more clues about how it was prepared to receive text and music. Nonetheless, there is a good deal of information here. What are the main components of the page? There are five musical staves, each with five red lines. Below each stave is written the chant text; the chant is written in what is aptly named "square notation," a type that evolved from more cursive note shapes (called neumes) in the course of the twelfth century (fig. 60). There are large flourished capitals at the start of each piece of music, and these are painted in blue, with red flourishing or in red, with lavender flourishing. As can be seen, the first of the

Fig. 58
Page A: leaf from an Antiphonary, Spanish (previously identified as Italian), *ca.* 1450–1550. American Bible Society Library. Photo: Gina Fuentes Walker.

Fig. 59
*opposite page*
Page B: leaf from an
Antiphonary, Spanish
(previously identified as
Italian), *ca.* 1450–1550.
American Bible Society
Library. Photo: Gina
Fuentes Walker.

Fig. 60
Square notation: detail of a
leaf from an Antiphonary,
Spanish (previously
identified as Italian), *ca.*
1450–1550. American Bible
Society Library. Photo: Gina
Fuentes Walker.

initials is a large U (which is read as a V) and the second is a B, so the color scheme alternates. If we check page B, we can see that this alternation continues. There is a secondary level of capital letter as well, and these are drawn in black ink but then tipped with yellow paint. You can see two of these in the first line of text on page A: the first is a letter "b" with an excessively jagged ascender and a curved belly; the second is a letter "s" with a doubling of the curve in the middle of the letter. These are simple cadel initials (the type can be very complex), and the word describes the style of flourishing, with a great deal of doubling or tripling of curves and ascenders.[12] There are also rubrics, letters in red ink, that provide additional information about the pieces shown on this page, in many cases labeling the kind of piece.

We have another page to consult as well, and can see that the set-up is exactly the same (page B, fig. 59). There were guide marks of some sort for the page that have been trimmed away as the lines are very precise. Probably the pages were pricked with uniform numbers of holes in the far margins and then ruled either with dry point or lead. We also can tell that the page was planned out chant by chant, with lightly ruled markings, traces of which can be seen around the margins of the big flourished initials. For example if we look at the large U beginning

Fig. 61
Detail of a leaf from an
Antiphonary, Spanish
(previously identified
as Italian), *ca.* 1450–1550
(page A). American Bible
Society Library. Photo: Gina
Fuentes Walker.

the second stave, we can see the thin line to the far right of this capital that served as a guide for the person who did the flourishing. It warns: do not go beyond this line! And the scribe doesn't. But to our right, for this same letter, the flourishing scribe went wild in the margin; no restrictions there. Clearly there were guidelines for the staves as well for the red lines are almost completely uniform at their ends and beginnings. The staves were drawn by a five-pronged rastrum, or rake, dipped in red ink. The use of this device made it possible to keep the lines at a uniform distance from each other (for a history of this aspect of notation, see John Haines, "The Origins of the Musical Staff," in the *Musical Quarterly* 92 [2009]). When he has to draw an individual line, the line looks more wobbly, as can be seen at the very bottom of the page. The capital scribe, the flourisher, and the text scribe and notator (the latter two at least, whom I believe were the same person) were aware of their limitations and stayed within them, functioning as a team. Sometimes the flourisher will train his work right alongside of the guidelines, which may have been in dry point, as they are very hard to see on this digitized slide. In any case, if we look at the capital letter B (fig. 61), which we can see opening the last stave of music on page A, we can see how the initial fits into the box that was drawn specifically for it, giving the body of the initial and its flourishing a rather square shape. Whoever worked on this page was following a carefully ruled page set-up.

One of the major problems with the copying of music is what is called text underlay. With chants there are some syllables that unfold note by note; but other syllables are accommodated to more than one note, and sometimes to many notes. If the copying is not carefully planned, things can go badly very quickly, as anyone who has ever copied music knows full well. So we can see how careful the scribe (or scribes) of this chant and its text has been with alignment, doubtless following a well-established tradition in his scriptorium. Look at the first complete chant, beginning on the second line. I have written the text out, line by line, attempting to add the various division markings the scribe has supplied in the text:

> Uenie,_.t. fortio,__.r me post.
>  .me.cuius.non sum dignus solue.
> ,__..._re.corrigiam calciamentorum:.
> eius.

(Veniet fortior me post me cuius non sum dignus solvere corrigiam calciamentorum eius: One will come after mightier than I, the lace of whose shoes I am not worthy to loosen.)

You can see that the scribe has carefully indicated breaks in the text so the notes fit in precisely above, using a system of commas, lines, and diamond-shaped points in red ink, which are always combined in that order for long melismas (groups of notes sung to a single vowel). The longest melisma in this chant is on the "ue" of *solvere*, and you can see that the text scribe drew a comma, a dash, three points, and a short dash to accommodate it.

I think the staves were drawn first and the notating scribe did his work, knowing full well what the text of the chants he was notating were. He drew little guidelines for the text scribe (who may have been himself) to offer further help at some points, as in the double line after *Ueniet*, which both indicates that the word has come to an end, and also shows when the intoning singer is joined by the rest of the choir. The text scribe writes underneath the music, leaving blanks where appropriate. And then he goes through at the end with a red pen and adds the rubrics, and also fills in the lines that separate syllables of text and also words, one from the other. This beautiful system would facilitate singing from the manuscript, and the shape of the music and its relationship to the text could be seen at a glance, even from a distance. It can be noticed from place to place that the text scribe's ascenders, especially that of a tall "s," break into the bottom line of the stave, this also suggesting that he did his work after the staves had been drawn.

Manuscript studies is a communal effort, and the internet has only made it the more so. In searching through digitized manuscripts for this project, for example, I was able to look at hundreds of late liturgical books, and found some that made useful points of comparison. New York, Columbia University, Rare Book and Manuscript Library, Western MS. 34, online through the Digital Scriptorium, consists of two leaves of a Spanish gradual (book of Mass chants). The scribe also uses a system of indicating text underlay in this liturgical manuscript that resembles that found in our manuscript page.[13] You will now be able to see the correspondences yourself, noting that the scribe of the Columbia fragment does not have the system of commas, dashes, and dots used by our scribe.[14] Yet another example for comparison is Barnard MS. 3 (fig. 62), which I found using Susan Boynton's excellent online introduction to manuscripts held in New York libraries.[15]

The last stage in the production of the page would be the work of the person drawing the capital letters and adding the flourishing. I have found a leaf in a Spanish antiphoner (office book) from the sixteenth century now at the University of Southern Mississippi that shows how a page was set up before a large initial was prepared, and in the space is written a small version of the letter to be supplied, a cue for the artist. In some manuscripts these so-called *lettres d'attente* can

Fig. 62
Antiphonary, Portugal,
16th century. Barnard
College Library, MS. 3, fol.
49. Barnard College Library,
New York, NY.

be seen in margins, as cues for the capital scribe as to what letter to draw in the space left for his work. Components of the flourishing could be profitably studied by scholars who work on such details, and they are crucial for careful dating and placing of manuscripts. My own expertise is not in late medieval manuscripts, and that is one of the liabilities of the cataloguing of leaves. You take what you are assigned. Sometimes a scholar is lucky and gets to work with the kinds of books with which he or she is very familiar; but usually the opposite is the case, and so one consults authorities. Correspondences between our page and the Columbia leaves, as well as the USM Spanish antiphoner, will be mentioned later when we come to the very difficult task of dating and placing this page. We have already been able to understand quite a few things about this and how it came into being. Now the time has come to understand its purpose.

### The Kind of Book to which the Page once Belonged

We have already surmised that this was a page of a chant book. Many cataloguing entries for medieval fragments do not provide accurate information about the kind of book to which a leaf belongs, nor do they identify the specific part of the liturgy celebrated through the particular texts and music found in a leaf or fragment. In order to do this work, we need a few tools, all of which are online, and we can solve the problems of identification once we have them. The first thing we need is a line of text, and we have one already: "Veniet fortior me post me cuius non sum dignus solvere corrigiam calciamentorum eius." We can check this out in a Latin Bible and see if it, or parts of it, were taken from Scripture. The best search engine presently for the Vulgate, the Latin bible of the Middle Ages, is the ARTFL Project of the University of Chicago.[16] A version of the phrase is found in the synoptic Gospels, the closest being Luke 3:16, but none are exact. The speaker is John the Baptist, and he is speaking of the greatness of the one to come after him, the Christian Messiah. The next thing to determine, then, is where in the medieval liturgy this text was sung, and we have two basic choices: was it a text for the Office (the eight hours of prayer making up the monastic or cathedral day) or the Mass (the Eucharistic service)? Of course if it is neither of these, we would have to refine our search, but the great majority of texts are for one or the other of these. Books containing the music for the Office are called antiphoners or antiphonales, or occasionally antiphonals (all from the Latin *antiphonale* or *antiphonarium*); books containing the music for the Mass are called graduals. So is this fragment part of an antiphoner or a gradual, or neither?[17]

To search the chants for both the Office and for the Mass, we can consult one

of the most useful tools online for the researcher, the La Trobe Medieval Music Database.[18] We click on "search by text" and type in "veniet fortior me." Bingo! We get a chant that exists in two manuscripts online at the La Trobe database, one from Italy and one from France from the first half of the fourteenth century. We click again and the appropriate page comes up. So we have a medieval version of the chant right before our eyes, in addition to a transcription in modern notation. Above the transcription, we have enough information to know that this is an early chant, an antiphon sung on Wednesday of the first week in Advent, the four-week season preceding Christmas. Days of the liturgical week had come to be called *feria*, and they were numbered beginning with *feria secunda*, feria 2, for Monday. So feria 4 would be Wednesday. The Latin above the chant says Wednesday in the first week of Advent, and then we are given both a late medieval source, the CAO number, and a ninth-century source that contains the text.

We can check to see if this is our chant, and if it is, we are about to be handed a great deal of information about the book to which our page once belonged. Even for those who don't read music it can be seen instantly that this, indeed, is the same chant. Older chants like this one that were part of the earliest layers of music transmitted throughout northern Europe in the ninth and tenth centuries will have uniform contours in most cases, with the minor variations that came in as manuscripts were copied and the music was learned in an oral tradition with manuscripts for consultation.

For the fun of double-checking this chant, we go to one of the greatest of all online tools for the study of medieval chant, the CANTUS database for the study of the medieval office, originated by Professor Ruth Steiner of Catholic University, and now coming out of the University of Western Ontario and maintained by Debra Lacoste and Gerard Stafleu.[19] There are so many features of CANTUS worthy of note, and we can only mention a few: you can search a chant by early keywords, and learn where in the office liturgy it was sung, studying the list of terms provided and their meanings. Almost one hundred key office manuscripts or fragments of manuscripts have been completely indexed on CANTUS, and you can read descriptions of the manuscripts and also download the indices for further searching. This feature means that the researcher can localize chants, and can study pieces particular to feasts of the cycle related to the birth, life, death and resurrection of Christ (the temporale), or of the saints (the Sanctorale).

So, let's do a search of our chant on CANTUS. It turns up right away, with its CAO number, the number that comes from the index of office chants made by René-Jean Hesbert in his classic work *Corpus Antiphonalium Officii* (Repertory of Antiphoners of the Office).[20] The CAO number for this chant is 5339, and we can

see that it matches the one assigned to it in the La Trobe database. We know we have the right chant. CANTUS will tell us many things about this chant, verifying what we already have learned from La Trobe: it was indeed sung on the Wednesday of the first week in Advent, and at the hour of Vespers, the time of prayer that was sung as the sun was setting. It was an antiphon for the Magnificat, the canticle from the Gospel of Luke sung every day at this hour (Luke 1: 46–55). The opening of the song text is "My soul does magnify the Lord." This canticle would be sung to a set of tones, one chosen to match the mode or scale in which the antiphon was sung. So the practice would be a singing of the antiphon, followed by the Magnificat text with a doxology as the last verse, and then the repeat of the antiphon or part of it to close out.

Now we can return to our manuscript page and look once again at "Ueniet fortior" (fig. 63). The rubric just before it, written in red ink on the side, says "ad magt" which means, if the abbreviation were expanded, "at the magnificat." This is a chant, an antiphon, sung for the Magnificat, as the tools we consulted already suggested.

Fig. 63
Detail of a leaf from an Antiphonary, Spanish (previously identified as Italian), *ca.* 1450–1550. American Bible Society Library. Photo: Gina Fuentes Walker.

There are so many other things we could now say about the page and its music, but I do not want to try the patience of non-specialists, hardy souls who have stayed with me so far. Instead, let's sum up: we have a leaf from a late medieval antiphoner depicting chants sung for the office during the first week of Advent.

### Dating and Placing

The well-practiced professional book hand that copied this manuscript writes in a style known as "rotunda."[21] Look at the cast of letters on our leaf, they are so amazingly round, as revealed especially in the bows of the letters "b" and "d." Rotunda is a name given to a late medieval book hand. But to have identified the handwriting style can only help us so much because it was widespread and over centuries. In fact, when I began this project, I ran down the wrong rabbit hole, first assuming that the leaf must be Italian because of the style of script. One day I went to the Index of Christian Art at Princeton University to consult there with research scholar Adelaide Bennett, an art historian who specializes in the decoration of thirteenth- and fourteenth-century manuscripts from France and England, but who has a wide range of experience with flourished initials. When she saw pages A and B, she said, I don't want to throw you off, but have you considered that it might be Spanish. I said that yes I had, and that I knew I needed to return to this idea at some point. She said the color, lavender, used in the flourishing for the red letters (see fig. 61), instead of the blue that might be expected, made her think of Spanish sources. What a great clue this was for me, and it also shows how important it is to digitize manuscripts because color is the norm, rather than the black and white usually found in books for the sake of saving money.

I turned from my long searching into dated Italian manuscripts, to Spanish sources, and it was then that I began to make progress. In the first place to have a five-line staff is somewhat unusual in Italian sources of the fifteenth and sixteenth centuries, but five-line staves are the norm in Spanish liturgical books.[22] I was able to find sources online that have letter flourishing somewhere close to that found on our leaf, in addition to the Columbia fragments mentioned above. These fragments have been dated to the range 1500 to 1599, and are Spanish. If we return to the Columbia fragments, we can see that the flourishing for the red capitals is indeed lavender, and, in this case that the handwriting style and the flourishing style is very similar (although far from identical) to our page. There are other places to check as well, such as the sixteenth-century Spanish antiphoner now in the University of Southern Mississippi, mentioned above.[23] I chose page 40 of this manuscript and direct attention to the large capital H, where the same

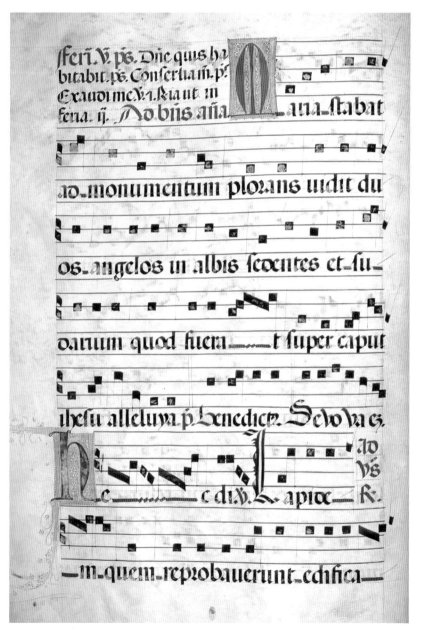

Fig. 64
Leaf (page 40) from a
Spanish Antiphonary,
16th century. Rare Book
Collection, McCain Library
& Archives, University of
Southern Mississippi.

Fig. 65
Detail of a leaf from an
Antiphonary, Spanish
(previously identified as
Italian), ca. 1450–1550.
American Bible Society
Library. Photo: Gina
Fuentes Walker.

style of flourishing found in initials for our leaf is displayed (fig. 64). There is also something about the way the capitals are made that is mindful of Spanish examples: the letters are somewhat square and carpet-like. Although the flourishing is fundamentally French in its style, a style widely imported, still the way it is used is along straight lines that suggest Spanish ways of flourishing. Paging through the Mississippi antiphoner, many other features we have already observed can be seen, and it is useful to have this kind of confirmation.[24]

So we close briefly by writing a description of these two pages, for they were concurrent in the manuscript. The only other fact that is needed is the dimensions of the leaves:

Two leaves from a Spanish antiphoner copied in the late fifteenth or sixteenth century. These two pages contain chants for the celebration of the Office during the first week of Advent. Square notation on staves of five red lines, with five staves to a page. Spanish rotunda script in black ink with some cadel initials tipped in yellow; rubrics provided throughout. Large flourished capitals alternate in blue with red flourishing (fig. 65) and red with lavender flourishing. Intricate pen work in the margins of some flourished initials, with carpet-like infilling that is characteristic of some liturgical manuscripts prepared in Spain in the sixteenth century.

# 2

# Reading Medieval Liturgical Objects: Perspectives from Different Fields of Study

If an image is worth a hundred words, a work of art is worth a hundred readings. Okay, perhaps not quite one hundred—but at least several very distinct ones, especially when done from the vantage points of different fields of study. Say we take a chalice crafted in the late fourteenth century in Italy (fig. 66) and discuss it with different professional hats on. As an art historian we would comment on style, focusing on its place in the evolution of liturgical art of the time; the quality of craftsmanship; possible documentation about the production workshop; and provenance history. As a liturgist we would address the role of this chalice within the liturgy, how it was used and how it connected with other components of the ritual. As a theologian we would discuss the symbolic role of the chalice within the doctrine of the Eucharist and the central role it played (and continues to play) in the administration of the sacred rite of communion. Finally, as a cultural historian we would examine the ways that contemporary treatises and other primary sources provide a contextual framework for our analysis of the object. Each of these perspectives is at once correct and incomplete. Presented together, they start weaving a more inclusive image of a multivalent work of art and the society that created and used it.

Using this model, we have given a group of scholars from different disciplines (art history; theology; history of Christianity) a group of works of art from the exhibition *Realms of Faith: Medieval Art from the Walters Art Museum*—all liturgical objects centering on the Christian practice of the Eucharist—to analyze and respond to. The essays that follow fully validate this model. Read together, they sketch an interpretive method that explores works of art concomitantly as functional, symbolic, and aesthetic. Through these combined vantage points, we learn to consider the selected chalice as exemplar of the larger category of vessels designed for Eucharistic service at the altar, and then place it in a specific place and time (Siena, fourteenth century) by virtue of its artistic features. Yet while some artistic features (size, shape, and so on) are indicative of stylistic shifts and preferences of workshops or patrons, others are simply a result of functional necessity. Thus the sixth-century Byzantine paten (fig. 69) is considerably larger than western ones because leavened bread was used for communion at the time, but also because communion was given to large numbers of congregants. This gives us an unexpected insight into the history of liturgical practices, and the changes they underwent in different parts of Europe and at different times. We learn of spiritual communion and its importance in the Middle Ages, and of the medieval writers who wrote about communion as a metaphor of divine embrace. We learn of the devotional and didactic (and not so much aesthetic) functions intrinsic to these objects. Read this way, art becomes a mediator between the sacrament of the Eucharist and the community receiving it through the centuries—and a mediator between medieval society and twenty-first-century understanding. Learning that these objects are all at once historical artifacts and exemplars in the history of art, components of a visual theology and prayer aids, teaching tools and functional ritual objects is the first step on the journey to appreciating them fully.

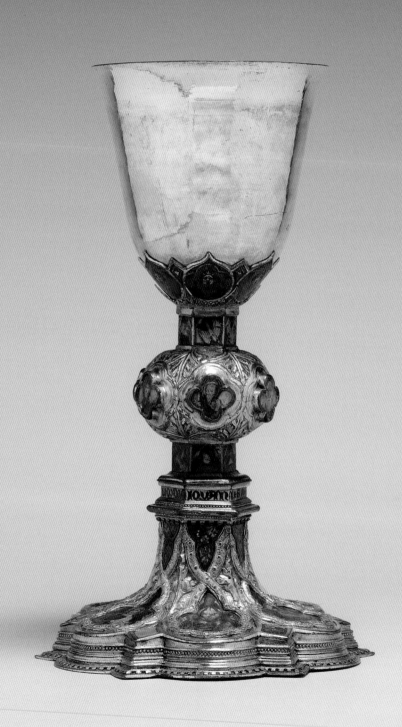

# The Living Past: Form and Meaning in a Late Medieval Eucharistic Chalice from the Walters Art Museum

C. Griffith Mann

Throughout the Middle Ages, in both the eastern and western churches, the liturgy and the visual arts were inextricably connected. Illuminated manuscripts, textiles, paintings, and metalwork designed for use in liturgical celebrations combined with spoken word, ceremonial actions, and communal worship to express symbolic connections between heaven and earth. Connecting local communities of believers with the universal Church, these objects fulfilled prescribed functions and gave expression to longstanding systems of belief and practice. This was especially true for works of art used in support of the Eucharistic rite, through which Christians commemorate the Last Supper and Christ's sacrifice. As vessels that played the central role in the ritual consecration of the bread and wine upon the altar table, the paten and the chalice were indispensable to the sacred acts they supported. Because of their sacred function, these handcrafted objects were often executed in precious materials by some of the most skilled artistic practitioners of the period. While liturgical custom imposed a degree of conformity on the repertoire of forms their makers adopted, these vessels could also serve as a locus of artistic innovation. Through these objects, medieval patrons and artists creatively engaged the related issues of liturgical function, theological doctrine, ritual drama, and regional aesthetics.

In fourteenth-century Siena, the production of Eucharistic chalices emerged as a niche industry, engaging some of Europe's most creative goldsmiths in producing work for a broad range of institutional and private patrons.[1] Consideration of one such chalice, currently in the collections of the Walters Art Museum (fig. 66), from the point of view of an art historian and a curator offers a glimpse of the kinds of questions that the study of liturgical objects pose for students of the Middle Ages.[2] What are component parts of the chalice and how do they relate to its intended function? What are the features that connect this chalice to the artistic legacy of a particular time and place? What kinds of strategies did its makers employ to relate the object to the ritual setting for which it was created? Finally, how can the display strategies adopted by the modern museum serve as an instrument in communicating the object's aesthetic significance and sacred meaning to contemporary audiences?

Any consideration of these questions must begin with a thorough examination of the chalice itself. As was often the case with chalices produced in the period, the object is a composite work, consisting of a gilt copper body and gilt silver cup. The surfaces of the chalice are rendered in a combination of beaten and chased reliefs, embossed and punched strapwork, and enameled medallions. The cup, which might be a seventeenth-century replacement, flares outward slightly

Fig. 66
Chalice, Italian (Siena), *ca.* 1375. Signed GIOVANNI E IACOMO DE SENI. Gilt copper with enamels on silver, 8 ¹⁄₁₆ × 4 ¾ in. (20.5 × 12 cm). The Walters Art Museum, Baltimore (44.223, acquired by Henry Walters, 1913).

130 at its rim. The base of the cup sits within a collar of six petals, each featuring an in-cised seraph with red and blue enameled wings, executed in champlevé enamel. The hexagonal stem that supports the flowered collar incorporates images of birds with wings outstretched. Immediately below these birds, the knop flares outward, its bulbous surfaces richly decorated with raised leafwork. Quatrefoil medallions of six bust-length sacred figures occupy the knop's outer perimeter. Engraved in silver, these medallions retain traces of their original translucent enamels, a tech-nique known as *bassetaille* enameling. Enameled birds inserted into the stem be-low the knop create pendants that match those in the corresponding section of the stem directly below the cup. In the lowest section of the stem, a molded ridge frames a ribbon of text rendered in black enamel letters: GIOVANNI E IACOMO DE SENI. This chalice is one of two to survive with this same signature, suggesting that the work is the result of a collaborative arrangement between Paolo di Giovanni di Tura and Giacomo Nicolo di Berardello. Along the broad hexafoil base of the chal-ice are six more *bassetaille* enamels of sacred figures inserted into hexafoil medal-lions. The bossed and stippled strapwork and leafwork that frame these enamels further enliven the surface of the base. The variegated surfaces of the metal en-hanced the reflective character of the object, causing it to sparkle in the light of candles that illuminated the altar table. Seen in this light, the glistening gilt sur-faces and translucent enamels of the chalice announced the object's special status as a sacred receptacle.

If the surface decoration of the chalice invested the object with its symbolic sig-nificance, its tripartite format was conceived to meet the functional requirements of the priest who used the object in the celebration of the Mass. Indeed, the picto-rial evidence of fourteenth-century paintings depicting Eucharistic celebrations clarifies the underlying purpose of the chalice's component parts. In Simone Mar-tini's frescoed rendition of the *Mass of St. Martin* from the Lower Church at Assisi a keenly observed image of a chalice conforming to the same basic type as the Wal-ters' vessel sits covered on the altar (fig. 67). As the fresco makes clear, the broad base of the chalice allowed the vessel to rest securely on the altar table. Designed without handles, the chalice was lifted by its base and stem. In the Walters' chalice, the worn condition of the enamels around the knop testifies to the repeated use of this section of the object as a grip employed by the priest when raising the cup from the altar table. The cup at the top of the stem ensured its core function as a receptacle for the consecrated wine, which the priest transformed through ritual action into the blood of Christ at the high point of the Eucharistic celebration.

The small size of the cup offers an insight into the type of Eucharistic service this

Fig. 67
Simone Martini, *St. Martin and the Miraculous Mass, ca.* 1317. Fresco with tempera. Assisi, Italy, Chapel of St. Martin, Lower Church of San Francesco. Scala/Art Resource, NY.

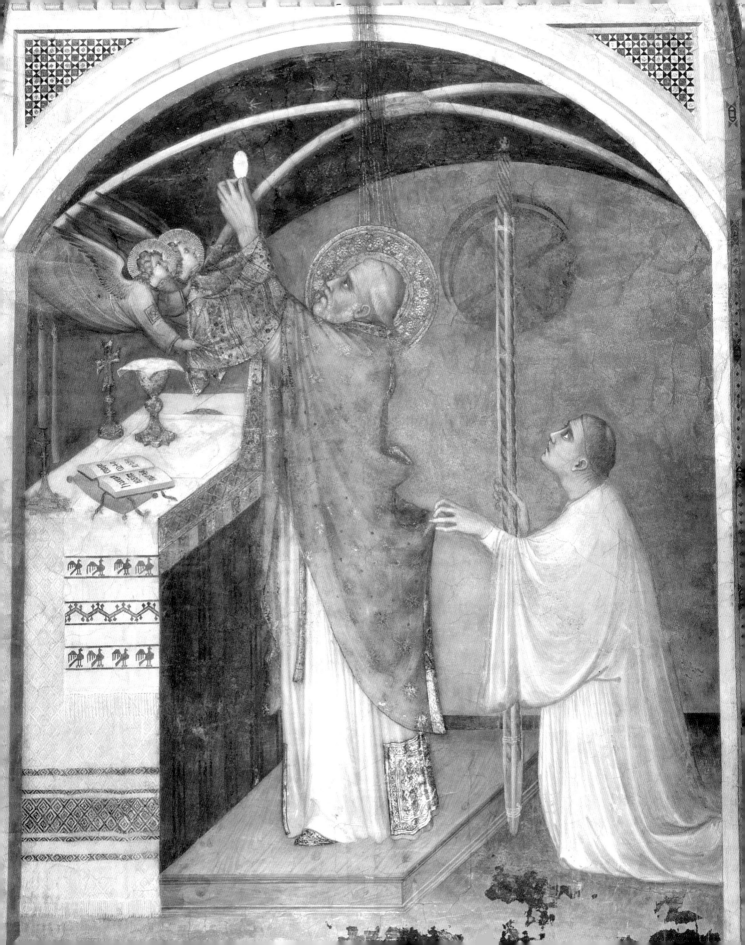

chalice was designed to support. By the fourteenth century, the western Church had formally affirmed the principle of transubstantiation, asserting that the body and blood of Christ were actually present in the consecrated bread and wine on the altar table. At the most solemn moment of the Mass, when the host and wine were transformed into flesh and blood, the priest elevated the cup heavenward, holding the base and knop to make the cup visible to the assembled faithful. The solemn commemoration of Christ's sacrifice was enacted sequentially, with the consecration of the wine following the Elevation of the Host. It is precisely this moment that Simone Martini captured in his fresco of the *Mass of St. Martin*. In the mural the saint reaches heavenward, both hands clasping the consecrated wafer above his head, while the chalice stands, still covered, on the altar table. The Fourth Lateran Council (1215) required that all members of the Church partake in the sacrament of the Eucharist once per year at Easter. In the period when the Walters' chalice was made, the priestly celebrant generally took the sacramental wine and bread on behalf of the assembled congregation. The small size of the cups produced during this period can consequently be understood as a reflection of a narrowly defined attitude towards the administration of the daily Eucharistic rite, which conceived of the priest as the primary recipient of the sacrament.[3]

As the comparison between mural and chalice suggests, the Walters' vessel conforms to a chalice type that had become well established in Siena during the late thirteenth and fourteenth centuries. Indeed, a specifically Sienese innovation to the essential format of the Eucharistic chalice was the decision to move away from a hemispherical cup with mounted handles, to a longer, attenuated cup with flaring lip and conical silhouette. Scholars have attributed the first appearance of this particular chalice type to the workshop of the thirteenth-century Sienese goldsmith Pacino di Valentino.[4] As they moved away from an older chalice format with mounted handles, Valentino's successors developed further innovations, adding successive layers of decorative embellishments. This new type of chalice would dominate Sienese goldsmith production for the next several centuries, establishing a signature product that was eventually disseminated throughout Italy.

The Walters' chalice was consequently produced at a moment when Sienese goldsmiths had established a reputation for exquisite workmanship. A large part of this reputation was built on their perfection of an enamel technique ideally suited to the application of delicate, pictorial decoration. The *bassetaille* enameling technique developed in Siena exploited the translucency of thin coats of brightly painted enamels applied over the bright, reflective surface of engraved silver plaques. One of the first Eucharistic vessels to combine the structural novelties in-

troduced by Valentino with the decorative embellishments of *bassetaille* enamels was the magnificent chalice commissioned around 1290 by Pope Nicholas IV for the Treasury of San Francesco at Assisi and signed by Guccio di Mannaia. In this object, the major outlines of the Sienese chalice are visible. While this chalice is much more elaborate than the Walters' vessel, the essential features that emerged as the hallmark of Sienese goldsmiths' work are present in both works. In both objects, the gilt silver cup sits within a petaled calyx, or collar, on a polygonal stem. The stem rests on a circular, repoussé knop embellished with translucent enamels. The lower section of stem leads to a large, lobed foot. Signatures and other information is concentrated on inscribed enamels on the polygonal stem sections.

Comparison of the Walters' chalice with the chalice of Peter of Sassoferrato (1341–42) at The Cloisters in New York (fig. 68) testifies to the legacy established by the work of Guccio di Mannaia, and its impact on the work of subsequent generations of goldsmiths. Like the Walters' chalice, the Cloisters' chalice incorporates a base, knop, and stem richly decorated with raised leafwork in gilded silver, enclosing gemlike figurative hexafoils of enameling. The introduction of delicate enamel work into the repertoire of the Sienese goldsmith had a profound effect on the kinds of imagery that were associated with metalwork and allowed micro programs to be applied to chalices. The similarities of the pictorial programs incorporated into the bases of the Walters' and Cloisters' vessels demonstrate the importance of established iconographical features that connected these works to their Eucharistic function. In both the Walters' and the Cloisters' chalice the base displays an image of Christ on the cross, flanked by half-length figures of the Virgin Mary and St. John the Evangelist.

At the same time, the much more flexible use of enamel plaques throughout other portions of the chalice, including the base and the knop, meant that patrons could tailor the basic iconography of their commissions to suit dedications and saints that were especially meaningful to their institutions or affiliations. In the case of the Cloisters' chalice, for instance, the presence of enameled busts of St. Louis of Toulouse, John the Baptist, and St. Anthony of Padua on the base and St. Francis and St. Elizabeth of Hungary on the knop testify to the Franciscan sensibilities of its patron, Peter of Sassoferrato. In contrast, the incorporation of paired enamels of SS. Peter and Paul into the knop and base of the Walters' chalice suggests that the vessel was destined for use in a religious establishment where these saints were especially revered.

Throughout medieval Italian churches, the presence of frescoes, altarpieces, and textiles on or around the altar announced the special character of the church's

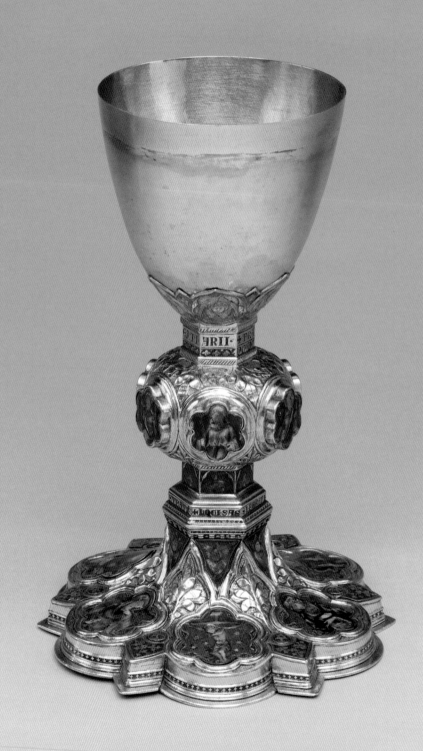

Fig. 68
Chalice of Peter of
Sassoferrato, Italian
(Siena), *ca*. 1341–42.
Silver-gilt with translucent
enamels, 8 %₁₆ × 5 ⅞ in.
(21.7 × 14.9 cm). The
Metropolitan Museum
of Art, The Cloisters
Collection, 1988. (1988.67).
Image © The Metropolitan
Museum of Art.

**135**

most sacred realm. The application of enameled decoration allowed the program of the chalice to be tied into the decorations around the sanctuary. When imagined as part of this larger artistic context, the Walters' chalice emerges as part of a larger ensemble of art used in the commemoration and reenactment of sacred history. Indeed, the composition of the enamels depicting Christ Crucified between Mary and John the Evangelist echo the standard pairing established for the terminal figures of painted and enameled altar crosses, as well as the large painted Crucifixes that hung above the high altar in Tuscan churches. This pairing connected the ritualistic commemoration of Christ's sacrifice to the historical event of the Crucifixion, at which Mary and St. John the Evangelist were present.

For its most immediate audience, the officiating priest, the program of the Walters' chalice emphasized the significance of the Eucharistic rite. The figure of Christ crucified, commemorated in the liturgical rite for which the chalice was designed, appeared on the base of the chalice. Noting the blood emerging from Christ's wound in the enamel prompted the celebrant to meditate on the ritual actions that tied him to this historical event. Moreover, the association of Christ crucified with the base of the object, which connected the chalice to historical events enacted on earth, and the presence of the seraphim around the base of the cup created a vertical axis that served as a reminder of the link between heaven and earth achieved during the liturgy. The involvement of congregation and clergy in a ritualistic reenactment of Christ's sacrifice offers an important reminder that, through the liturgy, the lay public was constantly made aware of the permeability of boundaries between the universal and the local, the past and the present.[5] For modern audiences encountering the Walters' chalice in the setting of the museum gallery, the details of its decoration and its shape work together as a reminder of the living meaning this object once evoked for audiences in a distant time and place.

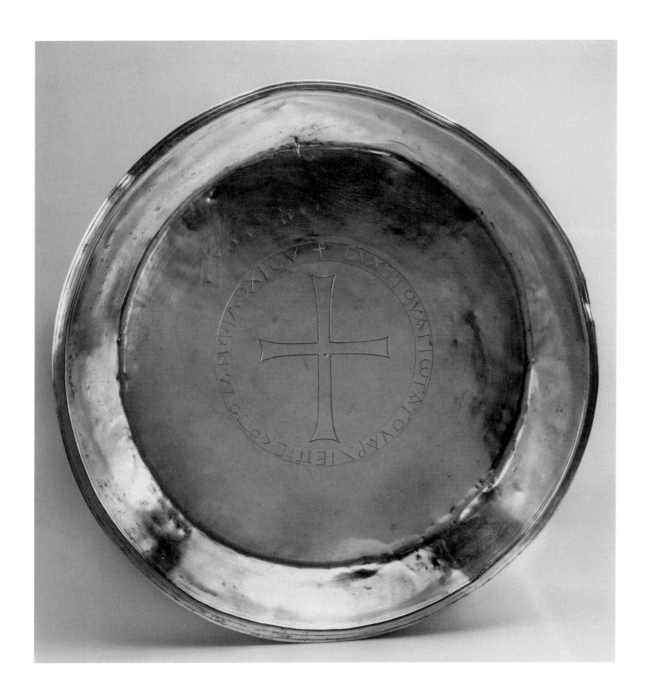

# Liturgical Instruments and the Placing of Presence

Xavier John Seubert, OFM, STD

The history of the understandings of the Eucharist in the Middle Ages in the eastern Byzantine and western Latin Churches is a very involved affair. Consideration of this very rich and dynamic theological history and the doctrine it wrought is crucial to understanding Eucharistic vessels, for theology directly impacted the liturgical instruments made at various times throughout Christianity. The complexity, nuance and dynamic nature of Eucharistic doctrine over time and place is suggested in the forms and uses of the sixth-century paten (fig. 69), chalice (fig. 70) and spoon (fig. 71) from the Byzantine Empire and the fourteenth- and sixteenth-century chalices from Siena (fig. 66) and Eastern Europe (fig. 72) that were part of the exhibition *Realms of Faith*.

First, let us look at the Byzantine liturgical instruments.[1] By the end of the fourth century both Byzantine clergy and laity were receiving communion at the Divine Liturgy under the two forms of bread and wine, although this practice falls into desuetude for various reasons in different periods. The enormous paten or plate (fig. 69) in *Realms of Faith* testifies to a large number of Eucharistic recipients and also to the fact that leavened bread, which takes up far more room than the unleavened host of the west, was used. Leavened bread is a fermented, raised bread and is much larger than the unleavened and flat wafer used in the Latin Rite.

In a communion practice of the Byzantine Rite after the eleventh century, the bread would be mixed with the wine and dropped into the mouths of the recipients with a liturgical spoon (fig. 71). Spoons were also used just to receive the wine. The chalices filled with wine were at times too heavy to be lifted without danger of spilling the sacred contents (fig. 70). Spoons were therefore used to safely dispense the Blood of Christ to the communicants.[2]

As in the western Latin tradition, in the eastern Byzantine Church there is a good deal of allegorizing with regard to the different moments of the liturgy. For instance, in the east after the priest cuts out a central square from the bread, which will be used during the Liturgy, he pierces the bread with a small spear to symbolize the crucified Jesus being pierced with a spear in his side. However, the east's understanding of the relationship between the sacrament of the Eucharist and the community provided a theological corrective to what became an overly realistic and historical understanding of the Eucharist in the west. This can be seen in the different views of the *filioque* ("and from the Son"), a Carolingian (i.e. western) addition to the Nicene Creed, the ancient and sacrosanct formula of faith promulgated by the First Ecumenical Council held in Nicaea in 325. The decisions and wording of the Council were accepted by the principal religious and secular authorities of both east and west. The addition of the phrase *filioque*, considered heretical by

Fig. 69
Paten, Byzantine Empire (probably Antioch), *ca.* 550–75 CE. Hammered and engraved silver, diameter 16 5/16 in. (41.4 cm).
The Walters Art Museum, Baltimore (57.643, acquired by Henry Walters, 1929).

the Byzantines, meant that the Holy Spirit proceeds from the Father and from the Son, whereas in the original creed it is stated that the Spirit proceeds from the Father alone.[3] This divergence had ramifications in the celebration of the Eucharist.

In the Latin Rite the central activity of the Eucharist was done by the Son. There was no inclusion of the Spirit in the Roman Canon because, by implication, the power of the Spirit was that of the Son. From this point of view, there was no need for the inclusion of the Spirit in the canon. What we see by the thirteenth century is the priest acting in the person of Christ, speaking the words of Christ and thus effectively establishing the sacrifice of Christ within the Eucharistic liturgy. The sacrifice came to be seen as the appeasement for sin, witnessed in the Masses said for the dead (also opposed by the Byzantine Church). Not that the Byzantines were opposed to praying for the dead, but they believed that the dead were included in the communion of all believers, which was sanctified by the Spirit in the course of the Liturgy.

The Byzantine Church saw things quite differently. The calling down of the Holy Spirit was the pivotal aspect of the eucharistic liturgy and also of the other sacramental prayers. Through the Spirit Christ was united with the Church and active in it. The in-breaking of the Incarnation into human nature made human nature a potential part of the *koinonia* or *communion*, which was the Trinitarian life within God.[4] The Divine Liturgy was seen as a gathering, a procession into the uniting power of the Love that is God. This was creative of the Church community as a place of God's presence and as a revelation of this Love within the world. Now, this is not to say that the Byzantine Church did not and does not have its problems. Obfuscating allegorical interpretations of the Divine Liturgy as well as a decline in the number of recipients at communion were problems that plagued both the eastern and western Christian Churches. However, as Alexander Schmemann writes:

> Byzantine liturgical piety fell under the grip of a *mysteriological* perception of worship, which was constructed on the contraposition of the "initiated and the uninitiated." But this influence proved to be too feeble at its very root to alter the original *order* of the eucharist, for each word and each act continues to express the concelebration of all with each other, with everyone in his proper place and proper ministry in the single *leitourgia* of the Church.... [T]his new piety succeeded neither in eclipsing nor distorting beyond recognition the actual *communal* character of the eucharist, which could never be torn away from the Church and, consequently, from the assembly.[5]

The Byzantine spoon, paten and chalice all express a sense of full participation in

Fig. 70
Chalice, Byzantine Empire (probably Antioch), *ca.* 547–50 CE. Hammered and engraved silver with niello, 4 $^{15}/_{16}$ × 4 $^{11}/_{16}$ in. (12.5 × 11.9 cm). The Walters Art Museum, Baltimore (57.633, acquired by Henry Walters, 1929).

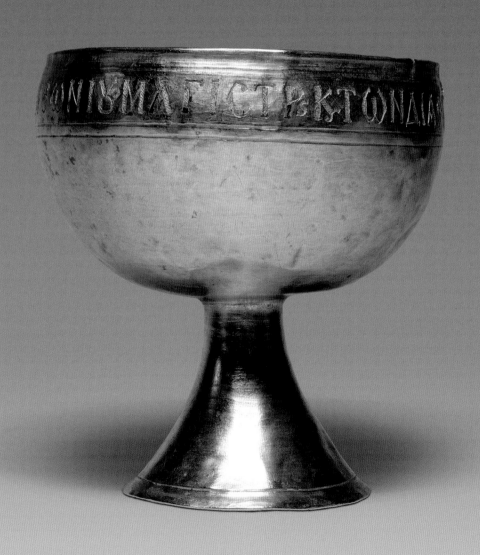

the *res* or deepest reality of the Eucharist, which is the union of God with God's people. The spoon is one of the most essential and intimate instruments of human nourishing. Its use in the liturgy brings to mind all the associations we make with a spoon and we bring this into the idea of God nourishing God's people. The capaciousness of the paten bespeaks the abundance of God's life given for us. And the inviting roundness of the cup seems to gather in without exclusion. Although these are Byzantine liturgical elements, they could very easily be found in the west and are expressive of the *communio* that is at the heart of the eucharistic liturgies of both the east and the west despite distracting additions that had been made to both sets of rituals.

The chalices produced in the west for the Latin Church are symbolic of another reality (fig. 72).[6] The eucharistic controversies in the west in the ninth and tenth centuries combined with a Germanic realistic understanding of symbol to concentrate attention on the how and the when of eucharistic conversion—the moment of transubstantiation—the point at which the bread and wine were converted into the Body and Blood of Christ. This focus makes the *res*—or principal effect—of the Eucharist the efficacious presence of Christ on the altar, which will be offered to the Father for the forgiveness of sins. The *res* becomes sacerdotal in the sense that it is exclusively concentrated in the work done by the priest; this is what normally is referred to as the clericalization of the Eucharist. Hence the smallness of the cup, from which only the priest would receive. The often lavish decoration of the chal-

Fig. 71
Liturgical spoon, Byzantine Empire (probably Antioch), *ca.* 565 CE. Hammered and engraved silver, 1 × 7 ¹⁄₁₆ in. (2.5 × 18 cm), bowl 1 ⁷⁄₁₆ in. (3.7 cm) wide. The Walters Art Museum, Baltimore (57.651, acquired by Henry Walters, 1929).

ices was first of all done out of respect for the sacred contents of the cup—the Blood of Christ. But the elevation of the chalice to the gaze of the people was also an important aspect of contemporary spirituality, which will be explained below.

What is lost in this western interpretation, underscored by the forms of the chalices, is the fuller sense of the *res* as the union of all the people with God, which should be the ultimate effect of the sacrament. In various ways the people became excluded from participation in the Eucharist. By the Middle Ages only the priest ordinarily received. With the Fourth Lateran Council in 1215 all are required to receive at Easter-time, but this does not significantly change the patterns of reception and participation. These patterns, combined with an overly historical and realistic interpretation of the Eucharist, transform the ritual into an epiphany at which the priest officiates and the people are present. In contrast to the capaciousness of the Byzantine paten (fig. 69), the form of the Sienese chalice (fig. 66) communicates it to be the exclusive province of the celebrant who uses it.

The Franciscan St. Bonaventure of Bagnoregio (*ca.* 1217–1274) seems to have understood the one-sidedness of this interpretation when he develops the distinction between sacrifice and sacrament. He reasons that "[w]hen Christ becomes present through the signifying words of the priest, his flesh and blood may be offered as a sacrifice of propitiation, and they may be consumed in sacramental reception in a communion of faith, love and devotion."[7] For various reasons, the sacerdotal and sacrificial understanding overwhelms Bonaventure's sacramental emphasis.

With the increased clericalization of the Eucharist the laity and theologians negotiate a new form of participation and union with God that skirts clerical control: spiritual communion. This idea began to develop in the twelfth century and it articulated the reality that a human being with active faith and love can communicate with God—without the priest as mediator. The Franciscan Alexander of Hales (*ca.* 1185–1245) develops one of the most important distinctions of thirteenth-century sacramental theology: the idea that intention is what gives one access to sacramental realities. At this time, it was discussed whether animals and heathens, having consumed the sacred species (the Eucharistic bread and wine), actually received the Body and Blood of Christ. Alexander's answer is that although they receive the consecrated species, the sacramental reality of the Body and Blood of Christ does not touch them. Alexander argued that one needs intention, that is knowledge of the sacramental reality—active faith—in order to truly receive the Eucharist. Love is also mentioned and the degree to which one has this, the greater the access to and participation in the sacramental reality.[8]

Alexander's insight, as well as the notion of spiritual communion, emerges

141

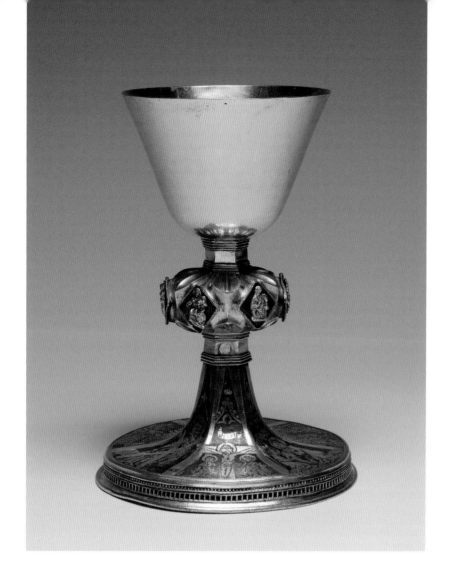

within the intellectual heritage stemming from antiquity and St. Augustine of Hippo (354–430). The understanding of the mechanics of sight that took place by means of a "visual ray" emitted by the eye is at the basis of a theory of spiritual transformation through objects of sight. This is why the Franciscan and Dominican methods of meditation and the ritual of spiritual communion could become so central to medieval lay spirituality. The Augustinian scholar Margaret Miles describes the inherited doctrine of the mechanics of sight in this way:

> For the classical people who originated the metaphor [of "visual ray"], sight was an accurate and fruitful metaphor for knowledge because they relied on the physics of vision, subscribed to by Plato and many others, that a ray of light, energized and projected by the mind toward an object, actually touches its object, thereby connecting viewer and object. By the vehicle of the visual ray, the object is not only "touched" by the viewer, but also the object is "printed" on the soul of the viewer. The ray theory of vision specifically insisted on the connection and essential continuity of viewer and object in the act of vision.[9]

This doctrine of vision held that the soul of the viewer actively projects the visual ray

Fig. 72
Chalice. Base, Bohemia or Austria, *ca.* 1400; stem and cup, Germany, *ca.* 1500. Gilt silver with enamels, 7 ⅓ x 5 ⅒ in. (18.5 x 13 cm). The Walters Art Museum, Baltimore (44.116, acquired by Henry Walters, 1913).

that touches the object of its attention. Through the imagination an image of what is visually touched is formed out of the substance of the soul and is permanently retained in the memory.[10] This is how the soul is formed into whatever it eventually becomes; it takes the shape of whatever it chooses to gaze upon and to take into itself as its own. If a person is not disciplined and is attracted to everything, then the soul of the person will be chaotic and superficial in its concerns. Where the soul systematically focuses, for instance, on the reality of Christ and his history, there its resulting images shape it into a hospitable receptor of the presence of Christ.

Augustine theologically develops the distinction between physical vision and spiritual vision. Spiritual vision depends on divine illumination, that is on the power of the Spirit of Christ working in the soul of the individual. But, as with physical vision, spiritual vision demands the focused attention of the viewer. The soul of the viewer must conform itself to the contours, so to speak, of the divine energy at the foundation of spiritual vision in order for that vision to take place. It can do this through the exercises of meditation, as propagated by the Franciscans[11] and Dominicans, and the concentrated ritualistic gazing of spiritual communion.

As the notion of spiritual communion is developed and understood, it is thought that spiritual communion is the higher form of participation in the reality of Christ. In gazing on the host, the image of the transubstantiated bread is imaged in the soul of the viewer and the soul becomes it. One does not have to actually receive the eucharistic species in order to communicate with Christ. And, certainly, an idea of *communio* was involved in this understanding, for, as one communicated with Christ, one was obliged to live out that life by service to the poor.

Beginning in the thirteenth century, the Franciscans and Dominicans develop patterns of meditation for the laity that, in effect, result in spiritual communion.[12] They are concerned with giving the laity and the poor access to the reality of Christ, but this does not necessarily entail sacramental reception, and, it could be argued, these methods of meditative spiritual communion served to solidify the clericalization of the Eucharist and the explanation of it as an offering of sacrifice.

The chalices made for the western Latin Church (e.g. fig. 68) underscore the clericalization of the Eucharist outlined above. Their small size and finely detailed and diminutive ornamentation indicate that they were intended to be used by a limited group—the ordained clergy. The chalices were not intended for reception by the laity.[13] By the thirteenth century, this was the exclusive preserve of the clergy. The chalices, such as the ones exhibited in *Realms of Faith*, are exquisitely decorated and their elevation, after the priest's words of consecration, would be the highpoint of the ritual: Christ, our sacrifice, is present on the altar. This epiph-

143

any was a principal aspect of the ritual in the Latin Church, and the people, who ordinarily would not receive the sacred species, would still be able to communicate spiritually, which, they had come to understand, was the higher form of connection with God. And although there was no paten for use in the Western Catholic liturgy in the exhibition, like the chalices discussed here they would not have been very large. The paten's circumference would only slightly exceed the circumference of the mouth of the chalice, its small size big enough to hold only the priest's unleavened host.

Considering the Eucharistic vessels within the context of the history of theology is crucial to understanding how such vessels were used, how use changed over time and geography, and the aesthetic impact such changes occasioned. These objects also have great resonance for me as a Franciscan and I take a moment here to address them from my own personal context.

A major Franciscan concern is to give people access to the forgiving, healing, and unifying Love that is God. Even Canon Law indicates that the sacraments are *pro populo*—they are for the sake of the people.[14] But the aesthetic through which a sacrament is presented—whether this be the use of word and song, of movements and gestures, of clothing and liturgical instruments, of paintings and statues—this aesthetic fashions the sacrament in a certain direction, as we could see quite clearly in the liturgical instruments in the exhibition *Realms of Faith*. What the chalices, paten and spoon tell us is that what we use and how we use them announces and presents the reality in question in a certain way. They are, on a certain level, constructive of the sacramental reality, because they are an aspect of the bodiliness into which and through which the spiritual reality emerges into our present.

I would like to conclude with some remarks on how space is created. The distant inspiration of my remarks is Martin Heidegger, but this is my own appropriation of some of his thinking on the origins of place. I read food recipes for relaxation. They are gatherings of all the fruits of the earth into a celebration of nourishment and sharing. I love to cook. And when I do a dinner for friends, it is always a sacramental event for me. The gathering and preparation of the food and drink; the serving of the guests—this usually leads into great conversation—so that we are not only nourished by the food, but nourish and feed on each other with our words, thoughts, gestures and spirits. And none of this would have happened if it had not been for the gathering and preparation of the food and drink. The meal itself becomes the bodiliness through which all the levels of nourishment and sharing take place and are released; through food and drink everything else takes place.

But to prepare the meal many instruments are necessary: knives, bowls, spoons,

pots, skillets, table settings. Together they create a space that did not exist—a space for gathering, sharing and nourishing. Just think in terms of when you are setting a table. You place a plate down—the plate is the beginning of a process of gathering that will result in the meal. But none of this will happen without the placing of the plate—without the gathering space that our use of things creates for us.

The space of all our celebrations would not exist without these. And, certainly the quality of what happens depends on them. As in all our meals, so in all our Eucharists, the tools with which we create space will either allow something to appear—or prevent its appearance—and both in very specific ways.

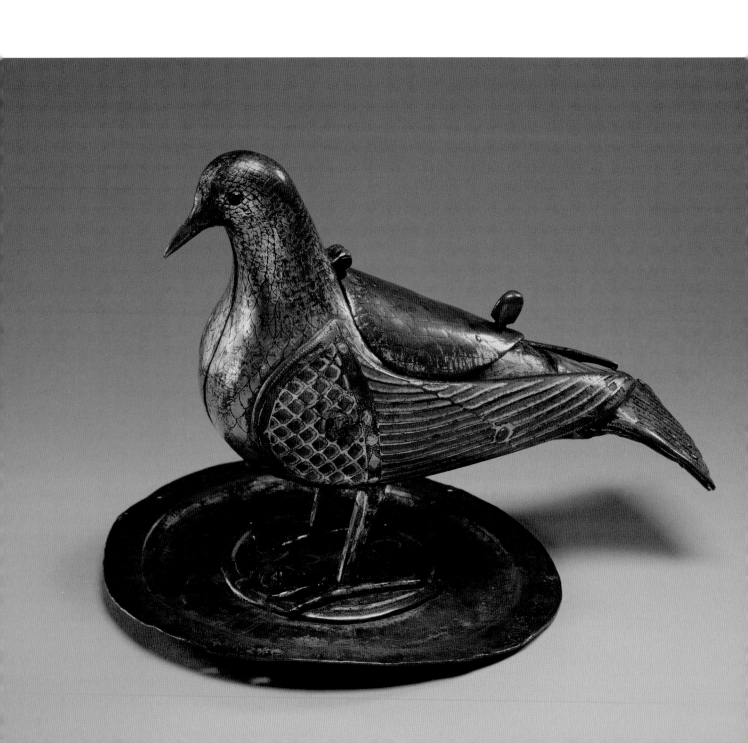

## What the Eucharist Dove Teaches: Protestant Theology Students and Medieval Liturgy

Robin M. Jensen

A charming, almost life-sized gilded copper dove cocks its head and turns a glass eye toward visitors from inside its glass exhibition case (fig. 73). Made in Limoges, France sometime in the early thirteenth century, its breast and head are etched; wings and tail are engraved and enameled to give the appearance of plumage, but in un-dove like colors (red, green, yellow, and blue). Chains attached to a small plate under its feet probably allowed it to be suspended from the stone canopy (baldachin) over a church altar and a hinged lid on its back opened to allow access to its hollow interior. This cavity served as a repository (or ciborium) for Eucharistic wafers that had been consecrated during the liturgy but not consumed by the faithful.

Although modern museum-goers might be unaware of this object's special significance, thirteenth-century Christian worshipers would have as they genuflected in its direction as they entered the church. They did this because they deemed the consecrated wafers it contained as worthy of adoration. These small fragments of bread had been transformed into the flesh of Christ during the prayer known as the Great Thanksgiving, when the presiding priest invited the Holy Spirit to come upon the elements and repeated Jesus's words at the Last Supper ("This is my body, which will be given for you"). Placed inside the dove's body, they were an ongoing mode of the Divine presence to the faithful.

Ancient documents refer to dove-shaped vessels suspended above the altar as well as placed within a box-like tabernacle (cf. *Liber Pontificalis* Sylvester: 39.18; and Innocent: 42.4). Presumably such objects were common in medieval European churches, even though only a single collection of them survive, almost all made in Limoges around the same time. Their design was especially appropriate; the dove symbolizes the Holy Spirit who descended "like a dove "upon Jesus at his baptism (cf. Matthew 3:16). Furthermore, their interior compartments alluded to the Blessed Virgin's womb, filled with the Holy Spirit to bring forth the incarnate Son. This moment was reenacted but somewhat in reverse, as the dove was itself filled with the consecrated host. Incarnation—insofar as it extended to the transformation of earthly matter into Christ's body in the miracle of the Mass—was cyclically complete. God came down to earth and became earthly substance; earthly substance in turn became divine flesh and blood. This also made the gilded dove's body into a shrine or reliquary. In this instance rather than a saint's bone or tooth, it contained nothing less than the body of God.

Thus this vessel's design was particularly apt for its purpose. Although undoubtedly treasured by the medieval church privileged to possess it, it was one of many precious objects that adorned the altar as well as the rest of the worship

Fig. 73
Eucharistic dove, French (Limoges), *ca.* 1210–30. Champlevé enamel on gilded copper, 7 × 9 ⁵⁄₁₆ × 6 ⁷⁄₈ in. (17.8 × 23.7 × 17.5 cm). The Walters Art Museum, Baltimore (44.77, acquired by Henry Walters, 1926).

space. As a whole, they created a complex program of visual theology. The portals, windows, walls, and fixtures of such a church would have been enhanced by all kinds of artworks—carved, painted, glazed, or cast images on nearly every surface and in every type of material. Woven tapestries, silver candlesticks, gilded chalices, gem-studded processional crosses, elaborately embroidered vestments, and ivory Gospel covers adorned every niche and side altar. Stained-glass windows and flickering candles filtered and refracted colors. The clergy's movements and gestures were as precisely patterned and the liturgy was as carefully choreographed as a dance performance, on a stage as wonderful as human imagination could make it.

Medieval worship was a profoundly visual event, but it was more than that. Dazzling sights were coordinated with sacred sounds—whispered prayers, chanted scripture, intoned psalms, and rung bells. To this interplay of sounds and sights were added the aromas of smoking incense, candle wax, and (almost certainly) mundane human odors emanating from bodies encased in unwashed wool. Figures moved in and out, sinking in prayer and rising again. Fingertips dipped in water made the sign of the cross forehead to heart, shoulder to shoulder. Cold, damp drafts brought relief in the summer. Elevation of the mind and spirit was a matter of activating all of the senses. God's presence was something that a medieval person expected to hear with the ear, feel in the knees, smell with the nose, and (at least occasionally) to taste with the tongue. Above all, however, the devout came to *see* and in this they were satisfied.

Although theologians through the centuries have argued that visual art could serve as a "Bible for the illiterate," in reality a church's collection of artworks and holy objects was less aimed at instruction than at inspiration, and would have induced awe and gratitude in princes as much as in unlettered paupers. Unlike many modern church-goers, medieval worshipers came not to be edified, but to praise God and beg divine mercy. Even if they had come to "read" the pictures, most of those images would have been so high or hidden that an ordinary person would have had difficulty discerning what they were. Rather, viewers were simply surrounded by beauty, bathed by the dappled colored light from the stained-glass windows, and conscious of how space and liturgy together generated their feelings of fear, pity, love, or consolation, depending on the action, time, or their own spiritual state.

Coming from muddy fields and thatched huts, the sounds, sights, and smells of the church thus served a devotional, not a didactic purpose. Undoubtedly, this was the most beautiful sight that most would ever see—a powerful evocation of

Fig. 74
West porch and tympanum of the *Last Judgment*, early 12th century. Conques, France, Romanesque abbey church of Ste. Foy. Vanni/ Art Resource, NY.

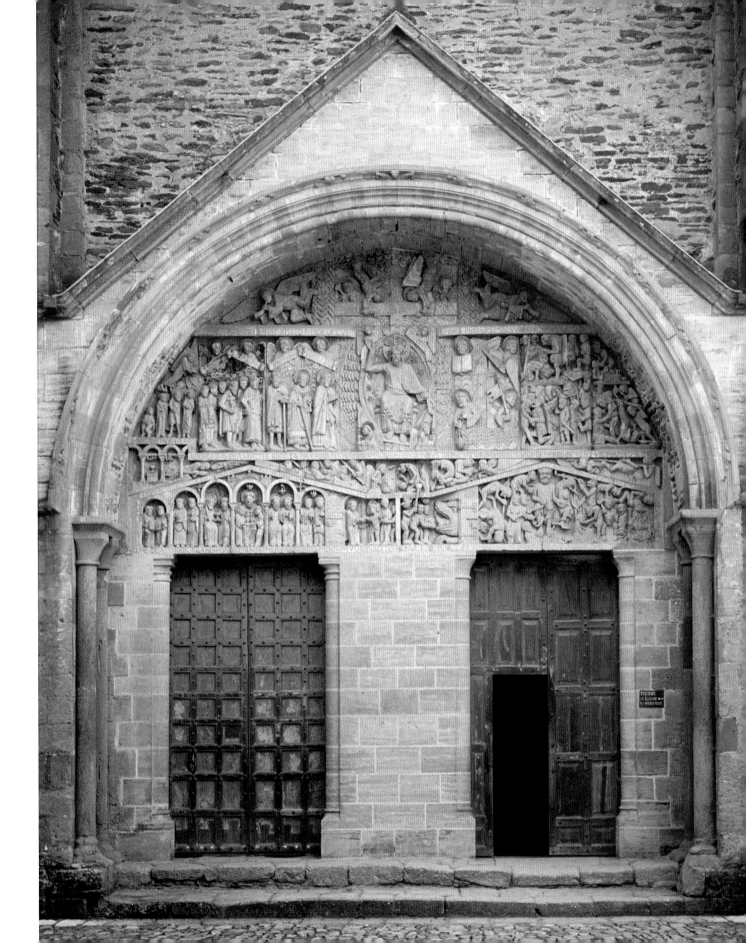

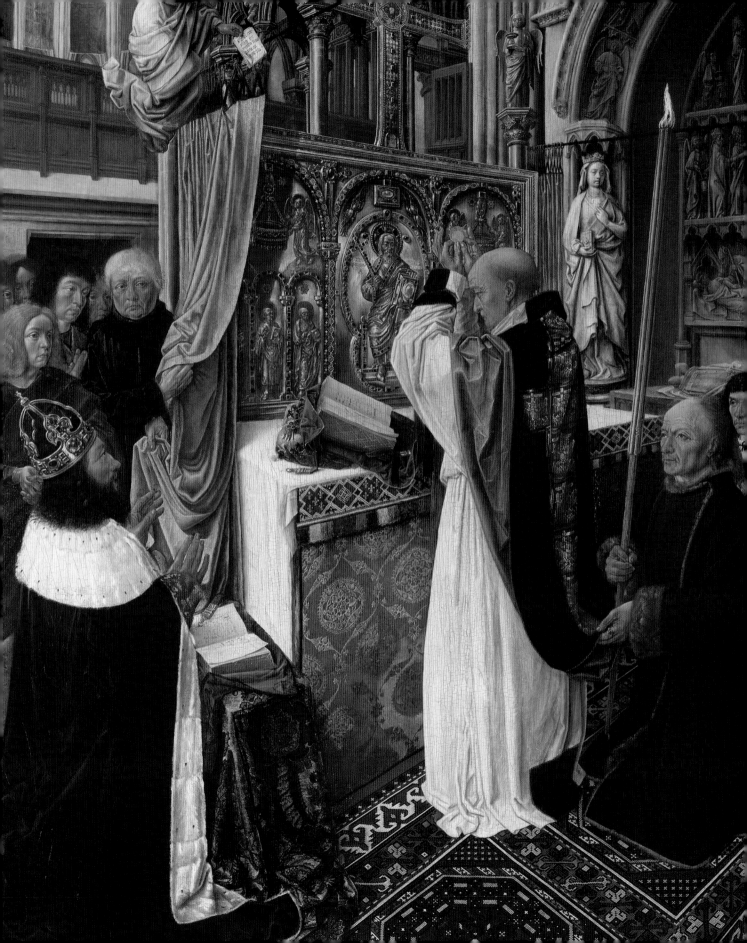

**151**

the heavenly realm and a profound contrast to their outside world. Moreover, saints, reprobates, emperors, and ordinary folk alike had access and there was enough for all. This relative and temporary social equality had an eschatological dimension. Whatever their class or station, Christians were constantly reminded that life's short span was merely a rehearsal for the eternity that awaited. Scenes of the *Last Judgment* appeared above most western entrances (fig. 74). Looking up as they entered, parishioners saw the dead rising from their tombs at the sound of angels' trumpets. Souls were weighed, and sinners cast down into the pits of Hell. Thus, the church was a threshold—the intersection of this world and the next; an awesome place holding both terror and promise. Heaven was never guaranteed—not even for bishops or kings who in their need to confess and be forgiven were no more privileged than the most miserable beggar.

This universal vulnerability is illustrated by a fifteenth-century painting by an unknown master, known as the *Mass of St. Giles* (fig. 75). Based on a story included in the *Golden Legend* (a medieval compilation of saints' miracles), the image shows St. Giles elevating the host while the Frankish king Charles Martel kneels to receive communion. Above, an angel drops down a paper that interrupts the ritual by specifying a sin that Charles had failed to confess. St. Giles's intercession won the King divine pardon, but not before he had acknowledged his transgression and exhibited signs of true contrition.

Other such miracles served as proof that the consecrated Eucharist truly was the flesh of Christ and not merely bread. This sacred food, believed to nourish the faithful and sustain them on their ultimate journey, also condemned those who received but denied its reality or doubted its power. The *Communion of St. Francesca Romana* (fig. 76) depicts another famous Eucharistic miracle. Francesca, a fifteenth-century saint known for her good works toward Rome's poor as well as for her ecstatic visions, was rewarded one Christmas Day by receiving communion from St. Peter himself, and in the presence of the Virgin Mary. In other scenes from her life a glowing orb appears above her head as she receives communion. This orb not only indicates her particular holiness, but also that Christ was truly present in the elements.

The transcendent sanctity of this holy food meant that ordinary folk would rarely commune. No one ate casually. And since wine was easily spilled it was withheld from the laity. But seeing the miracle—being present at the solemn moment when ordinary wafers and wine became God's body and blood—was as good as receiving it. Spiritual communion was (in fact) actually safer for those who were conscious of their sins. After it had been distributed to those worthy of

Fig. 75
Master of Saint Giles, *Mass of St. Giles*, about 1500. Oil and egg tempera on oak panel, 24 ¼ × 18 in. (61.6 × 45.7 cm). Presented by the National Art Collections Fund, 1933 (NG4681). National Gallery, London, Great Britain. Image © National Gallery, London / Art Resource, NY.

it, the remainder of the host needed to be stored in a special container—perhaps one shaped like a dove. From here it would be taken to the dying—the last and most precious food they would receive.[1] Forgiven for the final time, they were as much out of danger as they would ever be, and most in need of God's sustenance for their journey.

These late medieval sensibilities are utterly foreign to many twenty-first century Protestant theology students. They not only find them difficult to comprehend, but difficult to engage as sympathetically as they would any foreign culture. Their resistance is rooted primarily in the pervasive rejection of medieval Catholicism that has been part of their history and caused them to be (almost unconsciously) intolerant of religious practices that they regard as superstitious, idolatrous, other-worldly, and irrational. In their view the sixteenth-century Reformation did away with empty rituals and pagan sacrifices, the Enlightenment introduced reason into religion, and modern psychology has freed them from anxiety about Hellfire. The miracles of St. Giles or St. Francesca Romana may be judged as legends designed to manipulate pre-modern or simple-minded believers. For many modern Christians, faith is constructed from theological propositions that can be tested by rational arguments, and piety is founded upon ethical actions aimed at establishing peace and justice in this world. To the extent that sensuality is celebrated, it is associated with sexual pleasure or worldly entertainments and not with worship, miracles, or divine encounters.

While their more evangelical counterparts seek and express powerfully emotional experiences of the Divine presence at a tent revival or Pentecostal service, worshippers in the liberal Reformed traditions are typically restrained and more cerebral in their forms of worship. Emotional responses are reserved for secular entertainments—plays, films, or musical performances. These parallels are instructive in their ability to summon memories of transcendent or transformative encounters with beauty, but the pervasive distinction between worship and art is a stumbling block. So long as worship primarily aims at the intellectual and ethical faculties while art is reserved to the aesthetic, affective, and sensory ones, the two will be kept apart. The tactile, acoustic, somatic, or visionary dimensions of knowing are not part of "going to church."

This separation is part of their Reformed heritage. Because visual art has been more or less absent from many Protestant worship spaces for centuries, their members tend to puzzle at and even disapprove of the costly adornments of medieval cathedrals (including gilded Eucharistic doves). Although Calvin and his successors grudgingly granted art a pedagogical function for the church, in the end it was relegated mostly to

the secular sphere—to museums, galleries, and domestic decor. To the extent that art is viewed as ephemeral or even wasteful, it has little or no religious value.

One must consider, of course, the distinct sociological, ethical, racial, theological, and regional differences among these groups. Lutherans and Anglicans are almost always exceptions to these sweeping generalizations and Protestants of all kinds are likely to be moved by music, and will sing their hymns with impressive harmonies and deep feeling. Still, those who have been formed in Reformed traditions that regard the Lord's Supper as a memorial meal of ordinary bread and wine tend to focus on what is unambiguously apparent. In the same manner that they

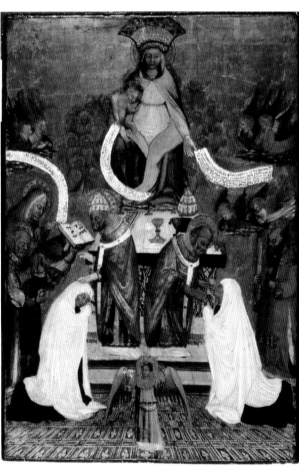

Fig. 76
*Communion and Consecration of St. Francesca Romana*, panel from an altarpiece, Italian (Rome), *ca.* 1445. Tempera on panel, 21.9 × 15.1 in. (55.8 × 38.4 cm). The Walters Art Museum, Baltimore (37.742, acquired by Henry Walters, before 1909).

have difficulty accepting that something is more than it appears to the eye or tastes to the tongue, they earnestly struggle with the idea that a symbol mediates an invisible reality. This idea is, of course, central to medieval sacramental theology.

Helping students to understand this basic concept is, I think, the key to making the medieval experience both comprehensible and plausible. Moreover, these students' inclination toward rational theological argument may serve as a useful starting point. By guiding them through the pre-Reformation definitions of sacraments and arguments about the Real Presence in the Eucharist, students may realize that these beliefs were neither foolish nor simplistic. The various conclusions may not be ultimately persuasive, but the intellectual complexities of the various positions, not to mention deep and pious devotion of their proponents are both impressive and affecting.

Starting from the crucial distinction first made by Augustine between sign (*signum*) and reality (*res*), theologians acknowledged that the Eucharistic elements never ceased being bread and wine even when their underlying "reality" was miraculously changed by the invocation of the Holy Spirit and the words of institution spoken by the priest in the consecratory prayer. The double-reality was crucial since only the faithful believer received the life-giving reality, while the unbeliever would simply eat ordinary food. Debates over the way these two distinct realities could be materially united, especially during the famous Eucharistic debates of the ninth century, reprised many of the same arguments from earlier centuries about how the divine and human natures could coexist in the single person of Christ. At the incarnation, the divine nature condescended to join human nature in a single individual without any loss of divinity or humanity. A parallel consubstantial existence is the outcome of Christ's words of promise: 'this is my body, this is my blood.'

Much of the historical controversy focused on how to understand the meaning of scriptural passages such as "I am the living bread from heaven. Whoever eats this bread will live forever; and the bread that I give for the life of the world is my flesh" (John 6:51). Those who took this literally, along with Jesus's words "this is my body" at the Last Supper, believed that the essential nature of the elements changed during their consecration. But others through the ages saw these phrases as efficacious symbols or metaphors. Jesus did not mean that his followers would chew on his flesh any more than he really meant that he was a grapevine (cf. John 15:1). Medieval theologians were not so literal-minded. But in the theological language of sacrament, they recognized that spiritual realities might be accessed through symbols that were not in their own essence spiritual things—and that

nothing need be only one thing or another, but could truly contain within itself the possibility of change or transubstantiation.

The language of "transubstantiation," however, did not become common until the mid-eleventh century and and was not made official until the Fourth Lateran Council in 1215, which insisted that Jesus's body and blood were truly contained in the sacrament of the altar under the species of bread and wine, having been transubstantiated into the precious body and blood by divine power. Some decades later Thomas Aquinas further elaborated on the "science" of this change, insisting that the substance of the bread and wine were destroyed in their consecration while their appearances ("accidents" in Aristotelian terminology) remained.

This theological exposition emerged about the time that Limoges artisans were producing enameled Eucharistic doves. One might argue the doves illustrate the link between abstract theological argument and embodied liturgical practice—between ideas and acts. The doves belong both to the sphere of symbols and concretely to the material world and may mediate between them. A metal figure of a dove is not the Holy Spirit, but insofar as it performs the Spirit before the eyes of the faithful, it makes it present. This is only realized, of course, by those who believe that it is so. Just as the Eucharist is only eaten by the one who recognizes its underlying reality (others receive only what they take to be ordinary bread), a believer's eyes see more—or differently—than the skeptic's. Thus expectation affects the nature of received reality and truth depends on something other than convincing external proofs.

But one may argue that this reduces religious faith to merely a matter of mind over matter, or even to simple wishful thinking. But as any poet knows, rational explanations are partial and almost always insufficient. Symbol and metaphor (such as poetry, gesture, or image) are required for explaining (or expressing) even ordinary experiences, for example the smell of rain, the coolness of marble, or the taste of a cucumber. As purely sensory experiences, they may only be recollected—and transmitted—by reference to sensory memory, which makes the absent (scent, feel, or taste) palpably present. We trust this and act on it without being certain that others' sensibilities are identical to ours. Mind requires matter to act upon—and matter is shaped by our perception of it. That perception's trustworthiness is therefore a matter of faith. A poetic metaphor or a visual image is a sign (*signum*) that eyes take in and minds give meaning (*res*) to. This is almost exactly how the Medieval Christian thought of the Eucharist.

This also describes the profound connection between art and liturgy in the Middle Ages. Both were profoundly and simultaneously sensual and spiritual.

Both were instrumental agents: the one led to insight, the other conveyed Divine grace. Through gazing on or eating material and visible externals, believers encountered and even entered the invisible and immaterial realm.

This process depended on doing as much as (or more than) on thinking. Those whose religious formation was essentially conceptual rather than performative will find it hard to appreciate. Nevertheless, the incarnational dimension of this theological worldview offers possibilities for identifying the holy in everyday things, in the created world, and in the arts. At this juncture the ethical dimension finds its place as well. Reverence for individual human bodies, care for the natural environment, and building a just and loving community are nourished through the intimacy of eating and developed through the habit of seeing. Finally, beauty is a form of nourishment, for rich and poor alike. Souls need to be fed as much as bellies. The senses are conduits to the heart and can bring about conversion as well as healing. Thus, reincorporating the meaning-mediating possibilities of visual symbols, and the attending to the somatic and sensual ways of knowing, are not against theology but, in fact, another way to practice it. Learning from the eucharistic dove might be a useful starting point—an exercise in expanding modes of perception as well as in historical appreciation.

# A Theological Reading of Medieval Eucharistic Vessels as Emblems of Embrace

Mary C. Moorman

In the Middle Ages it was understood that it is the task of the theologian to contemplate God and the relation of all things to God. Medieval theologians understood themselves to be engaged in the pursuit of the deepest sort of wisdom, first with regard to God as the ultimate end to be attained, and then with regard to a suitable and pleasing plan for attaining God.[1] The theological method thus proceeded along the lines of a speculative and practical science, which gathered religious proposals together and engaged them in a spirit of playful delight.[2] Accordingly, a theological reading of medieval liturgical objects would consider these objects in relation to the annual joyful encounter with God by all faithful persons at the Easter Mass; and thus a theological approach to liturgical objects might draw associations between the Eucharistic objects, which were used as means of attaining God, and the medieval doctrines that described God's very self. The great Abbot Suger, bishop and abbot of Saint-Denis (1081–1155), provides an example of such a theological reading of Eucharistic vessels when he explains the connection between the sacred vessel and the worshipper, since both are considered in relation to God; just as it seems fitting to him that the precious vessels be crafted of "whatever is most valuable among created things be set out with continual reverence and full devotion to receive the blood of Jesus Christ," in the same way the worshipper in the liturgy "should also serve God...in all internal purity and in all external nobility."[3]

As a young theologian looking back on the medieval world and its pervasive influences on the modern context, I find that the time between the two eras is collapsed by the standard theological move of typification, through which both medieval and modern theologians contemplate a general truth by means of a representative example. In this way, it strikes me that each medieval Eucharistic vessel could characterize the entire drama presented in the Eucharistic liturgies of the medieval period. Writing in the early thirteenth century, St. Thomas Aquinas (1225–1274) offers such a theological perspective of Eucharistic vessels in relation to the liturgy in his *Summa Theologiae*. In the first place, Aquinas explains that the Eucharistic chalice and paten represent the earthen tomb that embraced and enclosed Christ's body prior to His resurrection.[4] Secondly, Aquinas continues that the materials and craftsmanship involved in the particular artistry of the Eucharistic vessels, which are consecrated to their use just as the human ministers of the sacrament are consecrated to theirs,[5] serves to reflect the human reverence that is offered to the Eucharist as the sacrament of human union with Christ.[6] Finally, while the consecrated host that is retained in the church's tabernacle represents the blessed company of saints in glory, the Eucharistic vessels represent all

who live in the world and hope for heaven, particularly when they consume and contain the very presence of Christ during the Eucharistic liturgy.[7] Perceived this way, the Eucharistic vessels of the medieval age can be construed as emblems of the persons who worshipped with them. As such, these vessels function as symbols of the Christian faith, more tangible than the symbols spoken or read, as is the case with creeds and catechisms.[8] Nonetheless, as functional symbols the Eucharistic vessels exemplify the same teaching as the church's confessions, in as much as they offer a vivid depiction of the Christian confession that Jesus once took bread and wine in His hands and gave them to His friends, saying "take, eat;" and they did.

In the broader context of the entire Eucharistic liturgy, the medieval priest stood at the altar, facing the vessels, and called to his people with some form of the phrase *sursum corda* ("lift up your hearts.") The medieval worshippers responded, "we lift them to the Lord." The prayer of consecration was then spoken, and the vessels were offered to hold and protect the consecrated bread and wine, in an interchange that hearkens in the Christian tradition to the verbal embrace of the medieval nuptial rite: "I take you, to have and to hold."[9] For instance, in the words of Theodoret of Cyrus (393–457), "in eating the elements of the Bridegroom and drinking His blood, we accomplish a marriage union."[10] At the last, the vessels were used to convey the embraced elements of the Eucharist to the people who received them. When the worshippers had held and consumed the Eucharistic presence of Christ in their bodies, it was they who had become the Eucharistic vessels; thus perhaps it is within this exchange of spoken and enacted invitation and assent that the Eucharistic vessels that we contemplate here might be best understood as emblematic of an embrace.

Considering the sixth-century Byzantine paten and chalice in the exhibition *Realms of Faith* (figs. 69 and 70) from this perspective, we are reminded of the words of St. Augustine of Hippo (354–430):

> Narrow is the mansion of my soul; enlarge it, that you may enter in. It is ruinous; repair it…. Great art thou Oh Lord, and infinite…and thee would man praise, though we are but a particle of thy creation…. Is there indeed oh Lord my God anything that can contain thee? Do heaven and earth, which thou hast made, and wherein thou hast made me, contain thee? Most highest, most good, most omnipotent; most merciful; most hidden, yet most present…. Oh! that I might repose on Thee! Oh! that Thou would enter into my heart, and inebriate it, that I may…embrace Thee, my sole good.[11]

The tenor of Augustine's plea that he might contain and embrace the infinite God is echoed in the language of the Athanasian Creed, which was promulgated in a time roughly contemporary with the date of the Byzantine vessels. This sixth-century confession explores the ramifications of the statement that God has sent His son into the world so that full humanity and perfect divinity might embrace in the person Jesus of Nazareth. The confession holds that in this man, human personhood has been taken into God, in the sort of mutual "embrace" wherein one has not displaced the other:

> For this is the true faith that we believe and confess: That our Lord Jesus Christ, God's Son, is both God and man. He is God, begotten before all worlds from the being of the Father, and he is man, born in the world from the being of his mother.... Although he is God and man, he is not divided, but is one Christ. He is united because God has taken humanity into himself.[12]

Echoing Augustine's words, the traditional dogma of the incarnation also holds that the infinite God has entered His finite creation in great humility, in such a way that the receptacle of the Virgin's womb could receive Him; and thus He has entered as one who is contained, and as one who entrusts Himself to His creature's handling. As the God who enters, and as the creature who dwells among other creatures, this God incarnate became at once both God and man; and thus God became amenable to the human embrace and the reception of the divine Person in a Eucharistic vessel.[13]

In the same vein, the second-century liturgy attested by Justin Martyr of Ephesus (100–165) had explained that the bread and wine of the Eucharist are not to be received as common bread or drink; rather, as St. Justin states,

> Just as our Savior Jesus Christ, being incarnate through the word of God, took flesh and blood for our salvation...so too we have been taught that the food from which our flesh and blood are fed by transformation is both the flesh and blood of that Incarnate Jesus.[14]

More than a thousand years later, the Fourth Lateran Council (1215) extends the idea of divine embrace to the understanding that God would so embrace His creature as to be truly present in the Eucharistic vessels that were crafted to contain Him. As the Canon states,

> In (the Church) there is...Jesus Christ, whose body and blood are truly con-
> tained in the sacrament of the altar under the forms of bread and wine; the
> bread being changed by divine power into the body, and the wine into the
> blood, so that...we may receive of Him what He has received of us.[15]

This theological motif of Christ embracing the believer in the Eucharist carries
over into a common devotional theme of the later European medieval context.
Expanding the monastic theology of the late twelfth century, St. Bernard of Clair-
vaux (1090–1153) developed vivid references to the Christic embrace in his popu-
lar *Sermons on the Song of Songs*, wherein Christ is explicitly portrayed as the de-
voted lover who embraces the individual soul within the corporate body of the
church; we find this idea expressed poignantly in Bernard's concluding remarks
of *Sermon* XII:

> Thank you, Lord Jesus, for your kindness in uniting us to the Church you so
> dearly love, not merely that we may be endowed with the gift of faith, but that
> like brides we may be one with you in an embrace that is sweet, chaste, and
> eternal, beholding with unveiled faces that glory which is yours in union with
> the Father and the Holy Spirit for ever and ever.[16]

In another sermon, Bernard elaborates on the same idea with even greater atten-
tion to the idea of God's mystical embrace of His people being consummated in the
church's Eucharist:

> That in heaven it is like this, as I read on earth, I do not doubt, nor that the
> soul will experience for certain what this page suggests, except that here she
> cannot fully express what she will there be capable of grasping, but cannot
> yet grasp. What do you think she will receive there, when now she is favored
> with an intimacy so great as to feel herself embraced by the arms of God,
> cherished on the breast of God, guarded by the care and zeal of God lest she be
> roused from her sleep by anyone till she wakes of her own accord.[17]

Bernard's beautiful theme of the divine embrace persisted and developed in vari-
ous ways throughout the following centuries, as the theme of the divine embrace
was commemorated in various ways. Developing the theme of Bernard's sermons,
the thirteenth-century textual *Exordium* of Konrad von Eberbach (d. 1221) hagio-

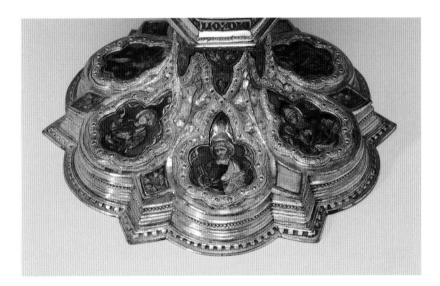

Fig. 77
Detail of the base of a
chalice, Italian (Siena),
*ca.* 1375 (see fig. 66). Gilt
copper with enamels
on silver. The Walters
Art Museum, Baltimore
(44.223, acquired by Henry
Walters, 1913).

graphically applies the theme of mystical embrace to St. Bernard himself: "and the Majesty Himself, with the arms separated from the extremities of the Cross, was seen embracing and clasping (this) servant of God to His bosom."[18] In a strikingly similar vein, the thirteenth-century *Manuale Augustini* also describes the motif of Christ embracing His creature: "He stretches out His arms on the cross, and lays open His hands, ready to embrace the sinners. In the arms of my Savior I will live and die. There I safely will praise and laud you, my Lord, as you have accepted me."[19]

It is with such devotion in mind that St. Catherine of Siena (1347–1380) wrote these words to a pious laywoman of the same region:

> We do not seek joy elsewhere than in Jesus, and we avoid any glory that is not that of the Cross. Embrace then, Jesus crucified, raising to Him the eyes of your desire! Consider His burning love for you, which made Jesus pour out His blood from every part of His body! Embrace Jesus crucified, loving and beloved, and in Him you will find true life because He is God made man. Let your soul burn with the fire of love drawn from Jesus Christ.[20]

St. Catherine's mystical language of embrace is illustrated on the bases of the medieval vessels, which are inlaid with images of people interacting directly with Christ in the more mundane aspects of daily life, and perhaps in their final

martyrdom (fig. 77). Writing in the thirteenth century, St. Bonaventure (1221–1274) had explained that the sacraments are themselves vessels of daily grace, given to accommodate the human need for God;[21] and Bonaventure's contemporary, St. Albert the Great (1206–1280), also elaborated that the sacraments are given for the purpose of making the human recipients into vessels suitable for God to fill.[22] The idea of a divine and human embrace is again clearly at play in St. Albert's emphasis on the exclusivity of this divine "filling;" Albert taught that the soul that is formed by grace will be filled by the God who fills Heaven and earth—and hence cannot be filled by the devil.[23] Echoing the medieval construal of each Eucharistic recipient as the mundane and priestly bearer of the grace of Christ, the seventeenth-century German Lutheran theologian Valerius Herberger (1562–1627) explains as follows:

> *Extensus in cruce universum orbem complexurus, brachia pietatis expandit*, says Augustine: He will embrace and attract the whole world with His arms of love.... Christ measures with His outstretched hands the orb to show that a great people covering all languages and generations from sunrise to sunset will be assembled under His wings. You see that He has stretched out His hands the whole day towards an evil and disobedient people to embrace it with the arms of His grace, like a mother her child...thus we also are saved under those outstretched wings. You see clearly that He has inscribed you in His hands. Oh then speak cheerfully and comfortably: *intra brachia salvatoris mei et vivere et mori desidero*: in the arms of my Savior I desire to live and die.[24]

Medieval thought continues to play a role in the modern era: the poignant lyrics of Johann Sebastian Bach's *Matthäuspassion* (1727) employ the motif of the embrace of Christ in a manner that resonates closely with the theological context of the medieval period, wherein the faithful worshipped with the Eucharistic vessels considered here. For example, the libretto in Bach's modern *Actus Crux* describes how the crucified Christ's body is made present in the Eucharist with these words: "He would draw us to Himself—where? In Jesus' bosom, seek redemption, seek ye mercy. Seek them!—Where? In Jesus' bosom, live ye, die ye, rest ye here, ye whom sin and guilt oppress, rest."[25] The operative image is, again, that of an embrace between God and humanity. This idea is consummated in the doctrine of the Eucharist, and is externalized and exemplified by its vessels.

The Christian tradition's persistently underlying theological idea of Christian worshippers as human vessels who embrace and hold their God in the Eucharist might seem to relativize the importance of even the most beautiful liturgical im-

plements. The notion of a real and divine embrace, which contextualizes the use of the medieval vessels, reminds us that at every point in the Christian tradition the Eucharist has been understood to be the actual "marriage supper of the lamb," though it is presently veiled for us in its earthly form. While the form of this union will change, its reality will not, such that the recipient of the Eucharist does now, with the aid of vessels, what she will do in the end: she embraces Christ. Thus in conclusion, if we read these Eucharistic vessels as emblems of a human embrace, their beautiful symmetry, human ornamentation, and graceful gesture of openness recalls the viewer to the most central aspect of the Christian tradition. Writing in the late thirteenth century, the Franciscan theologian Blessed Duns Scotus (1266–1308) explained that a truly human act of real human love must be as free and uncoerced as the open availability of a vessel, reflecting the person's free response to God's own free self-offering.[26] The undercurrent of such theology, memorialized in Christian art of all ages and kinds, finds contemporary expression in the writings of a modern Franciscan theologian:

> The (Christian) tradition emphasizes a particular vision of the divinity in whose image the person is created. Accordingly, God would be understood as...generosity, mercy, and conserving presence. God's nature is that of the Artist who never tires of inventing creative and generous responses to human actions...[and] the goal of such a perspective [is] union with God, understood not as the beatific vision, but as the beatific embrace.[27]

# 3

# Broadening the Perspective

Medieval art and culture is a topic too broad and complex to be captured, even in an introductory way, in any one study. The aim of this volume, prompted as it was by a specific exhibition (*Realms of Faith: Medieval Art from the Walters Art Museum*, at MOBIA in the spring of 2008) and the symposium occasioned by it, is intentionally focused and limited. The essays included thus far suggest that even such a narrowly defined topic demands an interdisciplinary approach if we aim to present the artworks in as full a context as possible. At the same time, this exploration leaves out much of the medieval world. In order to give our readers a better sense of that world, we felt that it would be important to also include studies that address topics beyond the scope of the exhibition. The following essays—which introduce medieval traditions with long-lasting consequences from another major religion of medieval Europe, Islam, and an area of medieval art not tied to any specific faith (arms and armor)—are but two examples of fields central to the Middle Ages that we encourage our readers to investigate further.

Ci coumence li prologues du premier liure.

In acion
ont
a de
tous
tuma
de met

auant uens ᴣ sines.
il ne fussient pas recev
ne venuz en a victoire.
ᴣe il naptient pas a
nule home a sauoir
meilleurs choses ne
plus dignes. ᴣ me il
fait au prince de cui

tr en escrit les cho
ses quil pensoient ᴣl

# Arms and Armor: a Farewell to Persistent Myths and Misconceptions*

Dirk H. Breiding

Attempting to study the European Middle Ages without encountering the concepts and ideals of chivalry, in all their various forms and manifestations, would probably be an impossible undertaking. One may go further still and argue that most children in today's Western society, by the time they have their first history lessons at school, have already come across images of, and stories about, the *knight in shining armor*. This is hardly surprising: courtly romances have lost none of their appeal during half a millennium, and, in terms of subject matter and protagonist, they usually leave little to be desired. What person, especially if he or she already has an interest in the Middle Ages, would not be intrigued by the exploits of a hero who has been (romantically) characterized as follows?

> But the image remains—the knight in shining armor, gleaming, protected, hidden, isolated behind helm; yet gallant, courtly, protector of the weak, of maidens, of orphans, widows; dedicated to God, devoted to the distant lady, never turning back from the challenge of a joust, brave and gentle, proud and courteous, forever riding off in search for adventure, in quest of Holy Grail or holy war.[1]

A somewhat more somber approach was offered by a scholar who reduced the appeal of chivalry to the combined presence of four essential topics: *women, adventure, weapons and horses.*[2] In his view, which is not entirely unjustified, these topics have always been the chief interest of all mounted warriors. Indeed, if the term 'women' is courteously exchanged with 'love', and—by way of a little modernization—a motorized vehicle is substituted for the horses, it becomes clear what has made, and continues to make, chivalry and the knight so popular: the underlying themes are timeless, the hero's behavior is exemplary and thus worthy of imitation, and the promised gains and achievements are most desirable. In short: love, adventure, and gadgets have always been essential ingredients for a good story. It is therefore hardly surprising that tales of chivalry are still popular today, while the figure of the knight, to some extent, became the model for many subsequent (super-)heroes of Western society, be it the North American cowboy, James Bond, or Batman.

Most students of medieval and early modern history know, of course, that it is important to differentiate between (romantic) fiction and (historical) fact. But even for scholars this can sometimes be a daunting task because the image of the knight has been the subject of idealization ever since the concept of chivalry and its personification were developed in medieval writing during the late eleventh

*The original title of the talk, held at MOBIA's symposium on May 31, 2008, was "What you always knew about the 'Knight in Shining Armor' and therefore didn't think you needed to ask, or Knights and 'chain mail': Common misconceptions and teaching about arms and armor." Apart from being too long, a new title was also chosen in order not to immortalize—once more—two common misconceptions in bold print.

Fig. 78
Man-at-arms mounting his horse. Miniature from Jean de Meung, *L'Art de Chevalerie*, 1284–*ca.*1325. London, British Library, Sloane MS. 2430, fol. 2v. Image © The British Library.

century and the twelfth century. Moreover, during the Middle Ages and early modern period, the ideal of chivalry was not only confined to contemporaneous accounts, real or fictitious, it was also widely applied retroactively to any literature ranging from biblical passages and religious writing to historical accounts and classical Greek and Roman mythology.[3] Thus, the romantic idealization of chivalry is as old as courtly literature itself—seemingly it is even older—but nothing has distorted today's knowledge and perception of the Middle Ages more deeply than the Romantic Movement of the late eighteenth century and the nineteenth. Accordingly, the distinction between courtly ideal and historical reality, as well as the problem of accurately defining the terms 'knight' and 'chivalry', have been the subject of much scholarly debate since the last century.[4]

Rather less attention has been devoted to the question in what ways modern perceptions of chivalry have become distorted to such an extent that a number of erroneous beliefs have come to be accepted as historical facts.[5] This applies particularly to the material culture of the Middle Ages. Misconceptions are of course not exclusive to the field of (medieval) history, but can be found more or less prominently in any scientific discipline. In the field of arms and armor, however, some misconceptions are in fact so common and persistent that they are not only found among the general public but have occasionally even entered into the academic sphere. This article aims to dispel some of the most common myths, to examine their often interesting origins and causes, and finally, to offer some ways by which popular but mistaken notions about medieval arms and armor may be corrected.

Fig. 79
Screenshot of the "Arms and Armor" section of the Metropolitan Museum's "Heilbrunn Timeline of Art History." Image courtesy of the Metropolitan Museum of Art, New York.

Let us begin with a closer look at the *knight in shining armor*. The origins of this well-known phrase—as far as we can tell—are probably not medieval but date back at least to the seventeenth century, although it only rose to unfortunate fame during the Victorian age.[6] Popular and valued for its romantic appeal ever since, the phrase is nevertheless misleading since it implies, and thus helps to perpetuate, many of the myths and misconceptions surrounding the knight, arms and armor. Among the most popular and prevalent examples are notions that:

- Only knights wore armor—Wrong
- Armor was so expensive, only princes and the high nobility could afford it—Wrong
- If armor is (highly) decorated, it is for ceremonial use, not for war—Wrong
- Armor is extremely heavy and renders its wearer virtually immobile (and, by implication, anyone wearing armor had to have almost super-human strength)—Wrong
- Knights had to be hoisted into their saddles with cranes—Wrong
- It took years to make a single armor—Wrong
- Wearing armor makes it difficult to go to the toilet—Wrong
- The military salute originated from the raising of a visor—Very doubtful
- Women never fought or wore armor—Not entirely true
- Only knights were allowed to carry swords—Not entirely true
- Armor became obsolete because of firearms—Not true without qualification

Since a list of common misconceptions and frequently asked questions about arms and armor, together with concise corrections and explanations, can be found on the Metropolitan Museum's website (fig. 79), it will suffice here to examine, illustrate, and hopefully dispel only the first few of these statements in more detail.[7]

The erroneous assumption that anyone wearing armor is a knight is so common and widespread that it is taken as fact. It has therefore become relatively commonplace to hear not only members of the public but art historians and even some arms and armor scholars quite naturally refer to any representation of a man in armor as a "knight." The German language reflects this development in the term *Ritterrüstung* (literally "knight's armor"), or its abbreviated form *Rüstung* (the original meaning of which is "armament"), which have almost entirely eclipsed the correct German term for armor: *Harnisch*.[8] It is not hard to see how this belief, by reverse conclusion, can then lead to the assumption that it was only knights who wore armor. In connection with two other myths, these ideas easily create a circular argument: "armor was only worn by knights" because "only

members of the high nobility could afford armor," and since "decorated armor was intended not for warfare but ceremonial purposes (which only the nobility would engage in)", and was thus even more expensive, it "proves" that "armor was only worn by knights"...and so on.

Although not strictly 'medieval', a good example is a celebrated print by Albrecht Dürer, which, for a long time, has been known almost exclusively by the nineteenth-century title *Knight, Death, and the Devil* (fig. 80). Much has been written about this arresting image, heralding it as the epitome of the *miles christianus*, a fearless Christian knight, battling Death and Devil as the forces of evil. It was not until 1969 that scholars remarked on the fact that the print's exclusive interpretation as *miles christianus* presents some problems.[9] How is it known that the man-at-arms shown is indeed a knight, and what makes him an exemplary figure of Christianity? Dürer did produce this print around the same time as *St. Jerome in his Study* and the even more famous *Melencolia I*, which gave rise to the interpretation of the three prints as a series illustrating three different aspects of Christian life (moral, theological and intellectual). However, in his writings Dürer never mentioned the three prints in connection to one another, and he only refers to the man-at-arms as *Der Reuther* (a somewhat ambiguous term that can mean either "knight" or simply "rider/horseman"). In short, there is no evidence that would unmistakably identify this man-at-arms as a knight. And contrary to what is sometimes stated in the relevant literature, neither the three-quarter armor, although of good quality, nor the saddle or horse harness could—by any stretch of professional assessment—be identified as being of unusually high or "splendid" quality. Nor is his armor particularly "outmoded." It is the typical outfit one would expect to see on a man-at-arms serving as a mounted soldier or mercenary in the early sixteenth century, a depiction that does not necessarily qualify as being "idealized."[10]

This is not to say that the figure could not be a knight; but without any pictorial or documentary evidence, any identification as such must remain speculation. Accordingly, the assertion that Dürer specifically intended his print to be a representation of the *miles christianus* is rather uncertain. While dog and lizard, again in contrast to the literature, can at best be imbued with ambiguous Christian symbolism, there is no attribute on the mounted figure itself that would justify any decidedly Christian interpretation. On the contrary, both the oak leaves braided into the horse's mane and tail, and specifically the fox tail below the lance head, have rather negative connotations in Christian symbolism. Is this print perhaps a moralistic reproach of the professional soldier and his way of life, the mercenary or *Landsknecht*, who does not battle evil and the devil, but who has a profession that

Fig. 80
Albrecht Dürer, *Knight, Death, and the Devil*, 1513. Engraving, 9 9/16 × 7 3/8 in. (24.3 × 18.8 cm). The Metropolitan Museum of Art, Harris Brisbane Dick Fund, 1943. (43.106.2). Image © The Metropolitan Museum of Art.

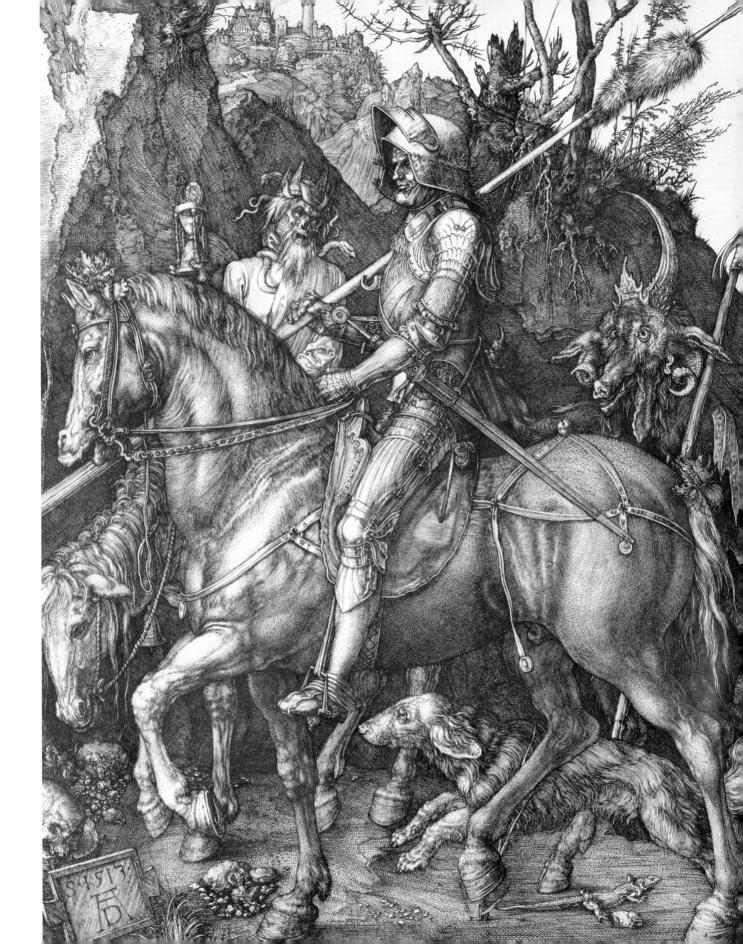

Fig. 81
Johann Adam Seupel
(1662–1707), *Levies of
Strasbourg*. Print after a
lost window (late 14th
century) from Strasbourg
Cathedral. Illustration
for an unknown book.
Inventar-Nr.: 262-132.
Photo: Volker-H. Schneider.
Kupferstichkabinett,
Staatliche Museen zu
Berlin, Berlin, Germany.
© Bildarchiv Preussischer
Kulturbesitz/Art Resource,
NY.

is evil by contemporary definition, and whose appearance leaves a trail of death, destruction, and lawlessness? The fox tail could also have a perfectly mundane explanation (during the early sixteenth century it was an official requirement for leaders of groups of one hundred mounted soldiers in the Imperial army). Perhaps the *Reuther* is simply a *memento mori* and an exquisite exercise in the depiction of a horse (with deliberately ambiguous symbolism)?

If we turn to other artistic representations of men in armor, and documentary references to medieval people owning and wearing armor, it is rather conspicuous that not all of them could possibly have been knights or belonged to the nobility. Religious artworks usually depict people in contemporary (that is, medieval) clothing, and they frequently feature soldiers armed to varying degrees, including full armor. Best known are those at the Arrest of Christ, at the Crucifixion, and the group of sleeping guards at the Resurrection. Surely, noble audiences would have taken offence if anyone had implied that these negative characters were members of the knightly class? Furthermore, legal documents from cities throughout medieval and early modern Europe attest that the possession of weapons and some form of armor was in fact a widespread requirement for anyone wanting to become a citizen. In order to ensure that these citizens were indeed able to defend the city in times of war, musters and training were held on a more or less regular basis. From the late fourteenth century onwards, the rich and confident citizens of the imperial city of Nuremberg even began to hold their own tournaments, during which, of course, they would protect themselves with armor.[11] Documentary evidence shows that armor for all these different customers and purposes came in varying qualities and price ranges—from custom-made examples for the most affluent clients, to ready-made armor that could be bought "off the rack," as well as pieces that were acquired second-hand or even looted. The cities, the nobility, and even the clergy also stored and dispensed arms and armor in order to outfit militias, personal bodyguards, or other people who fought on someone else's behalf (or wanted to joust) but did not have the means to properly equip themselves. The *Levies of Strasbourg*, a late seventeenth- or early eighteenth-century engraving after a lost stained-glass panel from the late fourteenth century in Strasbourg Cathedral (fig. 81) serves to illustrate these observations. The two levels of men in armor, presumably setting off to battle, clearly show city-dwelling nobility side by side with burghers (each group identifiable by their respective heraldry). All men are clad in similar mixtures of plate, mail, and textile armor.[12]

In conclusion, armor was not only worn by knights (or members of the nobility that had never been knighted), it was also available to and worn by citizens,

174 such as merchants and craftsmen, by hired mercenaries, and even by servants and common soldiers. In keeping with the medieval proverb that "the cowl does not make the monk" (*cucullus non facit monachum*), the wearing of armor as such was never definite proof of social rank or status, nor did it automatically transform a person into a knight.[13] In this context it is essential to keep in mind what knighthood meant during the Middle Ages.[14] Depending on the period and region, knighthood denoted a more or less well-defined social honor and/or political status, comparable to a military rank, which had to be individually bestowed upon a person. In practical terms, therefore, the knighthood alone said little about that person, his family, and political influence, or his means and the armor he could, or could not, afford. Unless documentary or other evidence provides proof for a knighthood, it is preferable to use the general term "man-at-arms" for any person wearing armor.[15]

The following two beliefs, that "armor was extremely heavy and rendered its wearer immobile" to such an extent that "'knights' had to be hoisted into their saddles with cranes," bring us to the misconceptions surrounding the weight and immobility of armor. Both notions are obviously linked to one another, but for arms and armor scholars, the concept of the crane is probably the most frustrating fallacy of all. To date, it has proven to be absolutely impossible to dispel, despite the fact that literature on the subject has continuously disproved both myths for almost a century.[16]

A complete field armor (armor for battle) of the fifteenth or sixteenth century, covering a man-at-arms from head to toe, weighed between 45 and 60 lb (*ca.* 20 to 27 kg).[17] Although not light, it is certainly less than the weight of a fireman's equipment (including full oxygen gear) or what most modern soldiers have been carrying into battle since the nineteenth century. Moreover, the weight of a well-fitted armor is not suspended from the shoulders alone but distributed all over the body. That armor impaired the mobility of its wearer is also incorrect. A complete armor was made up of individual elements for each of the body's main parts. Each element in turn consisted of lames and plates, linked by combinations of moveable rivets and leather straps, and thus allowed practically all of the body's movements without any impairment due to rigidity of material. It follows that the widely held view that a man in full armor could hardly move, and that once he had been brought (or fallen) to the ground, was unable to rise again, is also without foundation.

On the contrary, historical sources tell us of the French knight Jean de Meingre (*ca.* 1366–1421), known as Marshal 'Boucicaut', who—in full armor—was able to climb up the underside of a ladder using only his hands.[18] Modern experiments,

Fig. 82
Villard de Honnecourt, Man-at-arms mounting a horse, *ca.* 1230. Leadpoint, pen and ink on parchment. Paris, Bibliothèque Nationale, MS. Fr. 19093, fol. 23v. Image © Bibliothèque Nationale de France.

Fig. 83
*following spread, left*
Man-at-arms mounting his horse. Miniature from Jean de Meung, *L'Art de Chevalerie*, 1284–*ca.* 1325. London, British Library, Sloane MS. 2430, fol. 2v. Image © The British Library.

Fig. 84
*following spread, right*
Hector's family begs him not to go into battle. Miniature from Christine de Pizan, *L'Epître d'Othéa*, *ca.* 1410–*ca.* 1414. London, British Library, Harley MS. 4431, fol. 135r. Image © The British Library.

both with genuine fifteenth- and sixteenth-century armor as well as with accurate copies, have shown that even people with moderate or no training, in a properly fitted armor, can mount and dismount a horse unaided, sit or lie on the ground, get up, run, and generally move their limbs freely and without discomfort.

Turning to the belief that knights had to be hoisted into their saddles with cranes, let us pose the hypothetical question what a fourteenth-century knight or man-at-arms would have thought about such an idea? It is worth keeping in mind that a knight like Marshal Boucicaut, as well as any man-at-arms he commanded during the Hundred Years War, was a professional soldier. His survival and continuous military employment depended on physical fitness and agility. The only reactions that we may reasonably assume, therefore, would probably have been disdain and ridicule, perhaps even anger. For any warrior the idea of hanging helplessly in the air, at the mercy of other people, is dangerous and undignified.[19] For a medieval knight or aspiring man-at-arms the use of a crane would have been very much at odds with his self-image, an image that was strongly influenced by the ideals of chivalry and the abilities of its hero.

In an attempt to trace the elusive origins of the infamous crane, Tobias Capwell has suggested that it was probably an invention by Victorian playwrights. A likely candidate is the second act of the farcical play *When Knights Were Bold*, written around the turn of the century by 'Charles Marlowe' (a pseudonym for Harriett Jay; 1857–1932) and Robert Buchanan (1841–1901), parts of which are loosely based on Mark Twain's novel *A Connecticut Yankee in King Arthur's Court* (published 1889).[20] In one scene, a crane apparently hoisted an extremely overweight knight into his saddle to general hilarity.[21] During the early decades of the twentieth century, this scene was meant as a joke and clearly understood as such, and the play enjoyed immense popularity in England as well as in America, Australia, and New Zealand. Soon, movies based on Twain's book as well as the play (bearing the same titles, respectively) were made both in the USA and in England.[22] Perhaps inspired by these examples of knightly comedy, Laurence Olivier included scenes of knights helplessly hoisted into their saddles in the script for his 1944 movie version of Shakespeare's *Henry V*.[23] When his two advisors, Sir James Mann and Charles Beard, two of the world's leading authorities on arms and armor at the time, protested against the historical inaccuracy of this idea, Olivier compromised only slightly: the final movie version shows the English knights and men-at-arms leaping into their saddles, while it is a Frenchman who needs the aid of a crane—notwithstanding the fact that both French and English are wearing exactly the same armor!

Olivier's humorous but unfortunate decision to retain one of the crane scenes

Fig. 85
Man-at-arms mounting a horse. Detail from Filippo da Verona, *Apparition of St. Anthony to the Blessed Luca Belludi*, ca. 1510. Fresco. Padua, Scuola del Santo. Photo: Dirk Breiding.

has not only immortalized this colorful image among his entire generation (which mistook it for fact), it also unwittingly ensured that it will probably continue to cause frustration to arms and armor scholars for as long as people will see his movie. Instead of reinforcing this powerful misconception yet again by showing the relevant still of the infamous *Henry V* scene, let us once more turn to medieval works of art. A series of images, dating from the early thirteenth century to the early sixteenth, and published together here for the first time (figs. 82–85), demonstrate unmistakably that men in full armor were perfectly able to mount their war horses simply by using a stirrup. This point is further supported by more than a century of scholarly research, which has found no evidence suggesting that there ever was a historical figure, knight or otherwise, who had to be hoisted into his saddle with a crane because of the weight of his armor.[24]

### *Fallacies, Fallacies, Everywhere!:*
### *Origins and Reasons for Popularity and Dissemination*

At this point, let us take a look at why these misconceptions are so "successful." The reasons are probably to be found in their self-perpetuating and mutually reinforcing nature: the subject's general popularity engenders wide dissemination through continuous and constant repetition, while the credibility of seemingly "logical" explanations to any questions is aided by a common lack of knowledge about the actual objects.

The subject's fascination is unquestionable. The film industry has shown a continuous interest in all things chivalrous and medieval since the early twentieth century, while the last two decades have also seen the production of several television "documentaries."[25] In addition, the publication of historical novels has increased noticeably, and a wide variety of source material is available for the general interested reader, ranging from plentiful children's books and a few coffee-table volumes to a small number of museum publications. In the Metropolitan Museum, the galleries of the Department of Arms and Armor rank among the most visited parts of the museum.[26] The popularity of renaissance fairs and reenactments, as well as the quasi-academic interest expressed by some "living history" groups and "experimental archaeology," is yet another indication of the public's fascination with the Middle Ages and its material culture (especially arms and armor). Unfortunately, it appears to be mainly the romantic or gruesome fascination, both real and imagined, rather than the cultural or artistic appeal, that makes both the subject and the fallacies so popular.

Most expressions of this popularity are equally dominant when it comes to the

dissemination of misconceptions. Many of the general publications, especially those for children, cater first to the fascination but do not address the historic context with the diligence the subject demands.[27] Publications by museum professionals, such as new editions from Vienna or the Cleveland Museum, for example, do not usually present any problems, while some—like the new guidebook to the arms and armor collections of Glasgow Museums—may even be called exemplary as a mixture between collection catalogue and guidebook.[28] Yet when such guidebooks are not written by museum professionals (or a freelance writer willing to do at least a minimum of research), the results are predictably disappointing. Examples like a small guide to a German public collection (which reads as if written in the nineteenth century, with over 25 percent of the pictures showing fakes)[29] are as troublesome as the collection catalogue of a newly established American museum, which promises a "History of Weaponry" but instead presents the reader with a meager number of genuine objects of debatable quality (which are heavily outweighed by an array of poor-quality objects that also includes some copies/fakes, all of which are described indiscriminately).[30] It is mostly these publications, together with children's books, that lend an aura of academic authority to myths and misconceptions, not only by putting them into print but through aggressive marketing (suggesting through popularity that the book is a standard work on the subject). Cinema, television, and public gatherings can achieve similar effects since they are extremely powerful media for direct and uncontrolled dissemination of misconceptions in the form of a "personal experience" through vision, sound, and touch.

By contrast, the number of significant arms and armor collections, in the care of specialized staff, is in fact relatively small.[31] Moreover, in these few institutions, just as in any other museum or collection that may possess at least a few examples of arms and armor, the objects can be studied through glass, or from an appropriate distance, but they cannot be touched. Accordingly, very few people have ever handled a genuine weapon or piece of armor, and fewer people still have ever had the opportunity to wear original armor (or an authentic copy) under proper instruction. Given also that weapons like those of the medieval or early modern period have not been in use for several centuries, the widespread unfamiliarity and lack of experience with genuine objects and their cultural background is readily understandable. Regrettably, the few alternatives available to members of the public often serve to reinforce rather than dispel misconceptions. For example, in many museums and numerous European castles it has become part of the "visitor experience" to allow the handling of a few sample objects (usually, these are copies that cannot be regarded as authentic and which are handled by the visitors

themselves without any instruction). In other instances, someone—preferably a child—is given a genuine or reasonably authentic mail shirt of *adult* size, which is placed over one or both of the (outstretched) arms. Everybody then proceeds to smile and nod affirmatively when the child expresses his astonishment and discomfort over the "enormous weight" of armor (which would normally have been *worn* by a grown man over special undergarments).

Accordingly, by far the most essential requirement for any misconception is its "believability": the more convincing and logical an (erroneous) theory may seem, the more successful its dissemination and general acceptance as fact will be. One example that can frequently be observed in a museum collection is the first reaction of many visitors when looking at a complete armor. "General knowledge" provides the physical qualities of most metals: they are heavy, hard, and stiff. If armor is made from metal, and more or less completely encloses the human body, it is only "logical" for the visitor to conclude that *armor is extremely heavy and renders its wearer almost immobile*. Reaching this (erroneous) conclusion, "common sense" will then bring forth the "familiar" solution to his problem, the crane…!

It is interesting to note that the aspect of believability, in a way, even supports itself: as soon as the first "logical" and "credible" conclusion is achieved (or a "fact of common knowledge" is "confirmed"), few people ever question their initial line of reasoning. Anyone who witnesses or participates in anything similar to the "mail shirt experiment" would probably maintain afterwards that they have personally experienced the "enormous" weight of armor. To clarify this point let us reconsider the notions examined above. If armor was indeed extremely heavy and rendered its wearer immobile, why would people have bothered to wear it for hundreds of years? Do we have to imagine medieval battles as groups of men-at-arms swearing and hurling verbal abuse at one another since none of them could move? If cranes were really needed to hoist a man-at-arms into his saddle, how many of these cranes would need to be constructed? And who would want to be the first when—based on rough estimates of historical figures—he would probably have to wait anywhere between a few hours and several weeks until everybody else was also on horseback? Finally, if people more than half a millennium ago were clever and educated enough to build cathedrals and found universities, to invent mechanical clocks, eye glasses, and the printing press, why would these people not use the stirrup, a small foot stool, or a helping hand from a squire?

### *"How to Slay a Misconception": Education through Facts, Images, and Popularity*  183

What remains to be examined are ways in which misconceptions may be tackled and possibly overcome. If we can successfully correct fallacies in the professional sphere, the results may, in the long run, have a positive and lasting effect on "general knowledge," since historians and art historians are members of the general public and can help to "spread the word." Vice versa, if misconceptions among the general public can be positively influenced and corrected, the sphere of academia will follow eventually since each generation of scholars is, of course, recruited from the general public.

If a widespread lack of knowledge is indeed one of the main reasons for misconceptions, then teaching and education have to be the answer. Ideally, of course, the information must be offered in various forms that will suit different target audiences. Within the field of academic learning, medieval historians and arms and armor scholars will always produce specialized literature, of course. But occasional publications aimed at a much wider and more general audience are also desirable, particularly when the more specialized subject can be shown to interlink with other fields of art history in general, or better still with historical or contemporary events. Lectures and gallery talks, likewise, can be an effective means to dispel misconceptions, because they reach a relatively large audience at once. A simple way to multiply and enlarge the outreach is to regularly train both professional and volunteer museum guides. And although not always desirable for scholarly publications, the internet does have the potential to be one of the best and most promising media to dispel misconceptions (see fig. 79).

Almost too obvious to put into print is the advice only to address audiences that are willing to accept corrections, or those that seem the most promising to understand and pass on these corrections. An ideal target audience in both respects is children. Not only can misconceptions be caught and rectified at an early age, a child is also very likely to pass on the information he or she acquires. A successful and enticing way to interest children in history is to tell them that they are about to learn and know something new, something that, in a way, is a secret. The hint that most grown-ups either do not know much about this subject or "have got it wrong" can be extremely powerful. In many years of teaching, this method has never failed to get undivided, focused, and enthusiastic attention from the majority of the museum's younger visitors (which often results in parents listening and asking questions just as enthusiastically as their children). There will, however, always be the occasional instance in which correct information is provided but rejected (since it must be "wrong").[32]

During personal interactions with audiences, the help of teaching aids in the form of good replicas serves both to get and hold a visitor's attention, but the experience will also be more intense, involving practically all senses, and thus ensure that the visitor will remember the experience more vividly. Naturally, it is extremely important that careful handling of the objects is properly demonstrated, but also that uncontrolled and incorrect use (by either the visitors or improperly trained staff) does not achieve the exact opposite of what is intended (as in the "mail shirt" example above).

In the context of lectures and publications the use of good images is imperative. Misconceptions are perpetuated through print, film, and electronic media, but even verbal communication is likely to create powerful mental images (for example of cranes, or "knights" lying helplessly on the ground). In slightly altered form, Gregory the Great's maxim *pictura est laicorum literatura* ("pictures are the literature of the illiterate" or, in this instance, of "those under the influence of misconceptions") has not lost its validity. Since repetition is an important factor in establishing memory, a sufficient quantity of images should be used. The images themselves should be visually clear, and if possible, colorful and striking (which, in the case of medieval works of art, fortunately, is relatively easy to achieve).

Written texts or lectures should provide the essential facts to accompany the images. There are a number of ways to correct myths, legends, and misconceptions that can be just as entertaining as they are educational. It can be great fun, especially for children, to de-mystify "stupid ideas," although adult audiences tend to be more sensitive and may mistake ridicule about misconceptions for mockery of their cherished ideas or exposed lack of knowledge. While an occasional joke will keep (or recapture) an audience's attention, a more successful way to approach misconceptions is their explanation as an understandable, certainly plausible, and perfectly common misinterpretation. It is a logical explanation that will address and successfully counter any ideas created by uninformed "common sense."

 Modern comparisons may help to clarify that it is misleading to refer to the representation of a man in armor as a "knight" solely because he is wearing armor: not anyone driving some sort of motorized vehicle is called a "racecar driver," nor should anyone wearing a uniform (such as sergeants, police officers, or flight attendants) be addressed as "captain." (To prevent any confusion, it must be emphasized that armor should *not* be referred to as a "uniform" since, especially when it is worn with a coat of arms, it is the exact opposite.) Very useful in this context is the removal of what may be called a "social barrier": the demonstration that armor was not only worn by the nobility and knights but also by people "like you and me" (husbands,

fathers, sons, brothers, uncles, nephews, cousins, and so on). While many families may have relatives in the army, which makes this concept even more approachable, the historical fact that women wore armor only in exceptional circumstances, admittedly, may present some challenges. Another approach can be to address armor and weapons as clothing and accessories, which in many periods is a historically correct assessment, and focus on detailed discussions like that of fashion, for example, which is as valid today as it was five hundred years ago.

As far as specialized terminology is concerned, the field of arms and armor, admittedly, is as confusing to the general public as it is to fellow (art) historians. The best example is the fact that already the designation "arms and armor," the accurate title referring to the field of study that examines weapons of all types and descriptions, appears to present occasional problems: terms like "arms and *armory*" or "arms and *armament*" are incorrect. [33] When describing the actual objects, the use of proper period terms may sound sophisticated and mysterious, but continuous references to *armets*, *couters*, and *poleyns* are probably the best and fastest way to lose the interest of an audience.[34] Descriptive terms, such as "knee defence" (instead of *poleyn*), are therefore preferable, since statements like "*haute-pieces* are not to be confused with *volant* pieces, of course!" will certainly—and most deservedly—be rewarded with a blank stare.[35]

Finally, if popularity and a romantic appeal are among the main causes for perpetuating misconceptions, there is no reason why we should not use the same means and "beat the enemy with his own weapons." In an academic context, the titles for publications, exhibitions, and lectures should be kept factual, although a little humor and attempts to relate arms and armor to other historical or scientific disciplines may go a long way to ensure an audience's continued interest. A good use of the romantic allure is the use of quotes from contemporary documents or courtly romances. The same applies when scholarship meets the commercial realm. However, the overly competitive instincts of many a marketing professional or designer to come up with the most ludicrous titles should be avoided: puns on the words "knight" and "night" have by now been abused *ad nauseam*, while allusions to blood and gore are as tiresome and pointless as they are misleading. The assertion that such titles do indeed have a significant effect on visitor numbers or sales figures remains to be proven.

In the public sphere, a well-measured use of romantic notions may in fact serve to help dispel and correct the myths, legends, and misconceptions that surround the field of arms and armor. There is nothing to be said against legends in the context of historical research and teaching, as long as they are clearly identified as

such. When myths and legends are juxtaposed with actual historical events, the latter will serve to captivate the audience's interest through (educational) entertainment in much the same way. Ideally, they may even help to convey to the general public a conclusion at which most historians and art historians inevitably arrive after only a few years of study—to paraphrase Sir Arthur Conan Doyle's immortal detective: "history can be infinitely more exciting than anything which the mind of man could invent—no misconceptions need apply!"[36]

# The Cure of Perfection: Women's Obstetrics in Early and Medieval Islam

Kathryn Kueny

The God, of whom the men who guard Islam's traditions conceive, fashions only perfected beings in the wombs of women. For example, Abu 'Uthman 'Amr ibn Bahr al-Jahiz, a famous ninth-century Arab author of prose, literature, and Mu`tazilite theology, notes how each part of the body—hand, leg, eye, ear—is "designed to the highest standard of wise appropriateness,"[1] which is "evidence of Divine wisdom, design, and execution."[2] As a result, humans whose faculties fall short of such optimal functioning become marginalized from the rest of a divinely designed, physically perfected society. For Jahiz, one without hearing is like "someone absent though present and dead though alive";[3] those who lose their memories "cease to be human beings and become beasts."[4] And, this is from a man who himself suffered from severely deficient eyes.[5]

As Jahiz' own condition, ironically, illustrates, the world humans experience is laden with anything but perfection, especially with regard to birth and reproduction. As every woman knows, pregnancies are fraught with danger. Conception may or may not occur, conception may take place only to be followed by a miscarriage or stillborn child. Both mother and child may die as a result of the traumatic experience of giving birth and/or being born. Mothers may undergo the successful delivery of a child only to find its limbs twisted in ways that do not conform to that divinely perfected human God designed. In other words, actual human experience, and the world that scholars like Jahiz describe, are disjointed—often wrenchingly so. The first section of this paper will explore how men and women, from the mid-eighth century to the mid-thirteenth, with a few examples from the fourteenth and fifteenth centuries that draw heavily from earlier materials, negotiated the discrepancies between the actual and ideal as seen in the vagaries of reproduction. Elite male theologians and physicians tended to blame a woman's morality and physiology—and not God—for reproductive anomalies while women (and some men, too) resisted such blame by fashioning an obstetrics that presumes an experiential reality far removed from that of privileged scholars. The second part of the paper will argue that this experiential reality challenges the dominant scholarly view that the pain, grief, suffering, and joy associated with everyday, reproductive experience serves as a powerful means through which women could resist and bypass privileged male control to access, in a participatory way, a God who far surpasses the physical and social limitations of human gender and biology.

### The Qur'an

According to the Qur'an, God's creation of the fetus occurs through a series of tightly controlled transformations that progress in an orderly and systematic fashion. The

Qur'an boldly asserts that God has full knowledge of what every womb contains, what every womb bears, and what changes take place within a woman's womb.[6] As Sura 22:5 (the word "Sura" refers to a particular segment, or Chapter, in the Qur'an) states, "We created you from dust, then from a drop of sperm, then from leech-like coagulated blood, then from a lump, formed and unformed, in order that we make evident to you our power."[7] In Sura 23:13 God positions the drop of sperm in the womb, a part of a woman's body the Qur'an refers to as a "shadow of darkness" that is, like all else, subject to divine jurisdiction. Sura 22:5 portrays God as the sole determiner of who is allowed to rest there and who is not, and of what sex the child will be. The Qur'an also presents women themselves as subordinate to the creations in their wombs. Sura 2:228 reveals it is unlawful for women to conceal to others what God has formed in their wombs.

In its fairly elaborate narratives of gestational development, which often mirror Hippocratic and Aristotelian views of fetal formation, the Qur'an makes very little mention of reproductive anomalies (here defined as that which deviates from God's orderly, perfected processes of procreation). Sura 22:2 portrays one of the few examples of a reproductive irregularity, where the miscarriages of every pregnant female serve as one of the signs of the Day of Judgment. Here, miscarriage, like other qur'anic examples, such as a mother abandoning her suckling or a man reeling like a drunkard despite the fact he is not drunk, becomes just another of the unnatural horrors that God's chastisement will bring about that fateful Day. God's power over reproduction borders on the inscrutable as Sura 42:50 depicts how God makes sterile whomever he wishes. Sterility, like "good food," simply serves as another sign of God's omniscience and omnipotence.[8]

According to the Qur'an, God grants sight and hearing to most infants who come out of their mothers' wombs. But independent of judgment the Qur'an occasionally recognizes the fact that not all humans have these capabilities, and offers some explanation as to why certain individuals were formed differently in the womb, or were afflicted later in adult life. Sura 47:20 suggests God uses blindness and deafness as punishment upon those who forget or ignore the revelation. The physical handicaps become an obvious expression of the "metaphorical" blindness or deafness of the apostate or unbeliever. But what about those who follow God's path, but are still physically blind or deaf? The Qur'an finds no moral deficiency in them. Sura 24:61 and Sura 48:17 both freely admit their innocence. These two passages resort to the promise of future heavenly recompense for disproportionate suffering—at least for those who believe in "God and the Last Day."[9] Here God's inscrutable power is most clearly on display: his goodness and justice may

not be apparent today but are not to be doubted. The Qur'an is strikingly free of
Jobs who question God's will.

In each of these examples, human bodies, both male and female, serve as mere vessels through which God's power and benevolence, or his disapproval and punishment, are displayed. What God produces from the womb is always a perfected being, but perfection in the qur'anic context means the perfect embodiment of God's Will, whatever that Will may be. This point is confirmed by the fact that the Qur'an condemns the exposure of infants for either their sex or for their parents' inability to care for them.[10] However, while the Qur'an accepts the gift of life, no matter what the form or circumstance, the exegetical literature attempts to rationalize the discrepancies, which for many male elites come down to a woman's physiological or moral failings. Interestingly, within the medical and exegetical literature, there is never a concerted effort to interpret particular birth "defects" as reflections of certain aspects of God's will, as one might expect, especially given the fact the Qur'an itself does so by linking deafness with those who ignore the revelation. Rather, the overwhelming inclination is to blame women.

### Medical Literature

The medical texts, like the Qur'an, also emphasize how the orderly and perfected mechanics of reproduction bear witness to God's Will and His creative ideals. Because of their life-producing capabilities, the genitalia and their procreative properties become the focus of much attention and scrutiny, more so than less "potent" limbs and organs like hands and livers (fig. 86). For example, 'Arib ibn Sa`d, the tenth-century Hispano-Muslim historian and physician who converted to Islam from Christianity, paraphrases Hippocrates by elaborating in great detail how "the sperm of the man and the woman goes forth from both of them into the womb at the same time, one mixing together with the other, blending equally so that they are balanced and that one of them is not overshadowed by its companion."[11] According to Ibn Qayyim al-Jawziyya, the famous Sunni jurist writing in the fourteenth century, God plotted the dimensions of the vagina to accommodate precisely the penis.[12] Jahiz, also, suggests God optimally fashioned the penis so that it would stiffen only as required for procreation, otherwise remaining limp so as not to cause the male trouble as he walks about in public.[13] Abu Hamid al-Ghazali, one of the great jurists, theologians and mystics of the twelfth century, reflects upon the miraculous ways each phase of the sexual act contributes to conceptual success: arousal, for example, is not a gratuitous sensation but plays a significant role in gathering material from the entire body that eventually transforms into

the healthy sperm capable of mixing inside the woman's womb to produce off-spring.[14] The "heart" and its workings hardly generate such prolonged and intensive consideration.

Despite the fact that early Islamic physicians emphasize God's creative and orderly perfections, they are also well aware that things can and do go wrong (fig. 87). Contrary to the Qur'an's emphasis on the procreative process as a divine sign, medical texts focus primarily upon the rote mechanics of reproduction within women's bodies, which are thought to be naturally weak.[15] As a result of this emphasis on the weakness of the female body, early physicians suggest reproductive anomalies stem not from God's design but from the natural processes associated with a woman's inherent physical limitations. In much of the Islamic medical literature (which both preserves but modifies Greek medical wisdom), women are described as being colder, softer, moister, and more passive than men. Unlike men, who are solid, dry, hot, and active, women appear as spongy, soggy vessels carved out by a hollow, continuous tube that links their nostrils with their vaginas. This tube carries blood to and from all parts of the body, thus serving as the root cause of both nosebleeds and the menstrual flow, and everything in between.[16] Because the entire physiology of a female can be reduced to the health and maintenance of this one single tube, the complex corporeal and psychological illnesses of women are generally reduced to a mere malfunction in plumbing.

Natural reproductive processes must somehow navigate the womb's treacherous terrain in order to generate a healthy child; a successful pregnancy is often conceived as the exception that can be secured only under the most optimal conditions. In order for reproduction to take place, for example, only attractive and naturally perfected women can serve as the nurturing hosts for God's procreative activities. 'Arib ibn Sa`d, for example, notes women will only conceive if they are "normal," that is, not overly fat, thin, or filled with phlegm.[17] Jalal al-Din al-Suyuti, a prolific fifteenth-century Egyptian scholar, encyclopedist, and historian whose writings are often concerned with issues of natural science and regimen, even warns against engaging in sexual intercourse with a woman who is too old, too young, sick, has had no sexual relations for a long time, or whose appearance is not pleasing.[18]

'Ali ibn Sahl Rabban al-Tabari, a ninth-century Muslim jurist, scholar, physician, and psychologist of Persian Jewish or Zoroastrian descent, who produced the first encyclopedia of medicine, also warns of the difficult conditions under which a woman can conceive. Rather than blaming a woman's appearance for her lack of reproductive success, which presumably she could modify, if she so desired, Rabban al-Tabari holds accountable a woman's natural constitution, which

*left to right*

Fig. 86
A couple having sexual
intercourse. Miniature
from a copy of Jāmī
(d. 1492/898), *Kitāb
Salāmān va Absāl* (The Book
of Salāmān and Absāl).
Iran, 16th–17th century.
Bethesda, MD, National
Library of Medicine, MS. P
16, fol. 35b. Image courtesy
of the National Library of
Medicine.

Fig. 87
Figure of a pregnant
woman. Illustration from
Manṣūr ibn Muḥammad
ibn Aḥmad ibn Yūsuf Ibn
Ilyās, *Tashrīḥ-i badan-i
insān* (The Anatomy of
the Human Body). Copy
completed by scribe Ḥasan
ibn Aḥmad, working in
Isfahan, December 8, 1488
(4 Muharram 894 H).
Bethesda, MD, National
Library of Medicine, MS. P
18, fol. 39b. Image courtesy
of the National Library of
Medicine.

she can not alter. In his monumental encyclopedia (*Firdaws al-hikma*), following
the Greek theory of humors and the four elements, Rabban al-Tabari states that very
cold women do not get pregnant because their coldness solidifies the seed. Likewise
very hot women do not get pregnant because their heat burns the seed. Dry wombs
parch the seed, and wet ones cause the seed to slide out of the womb.[19] He also sur-
mises miscarriages may occur when too much moisture gathers in the womb and
the seed slips, or the woman's blood dries up, or she has a great fright or scare, hears
a loud sound, or suffers some sort of misfortune.[20] Abu Ja`far Ahmad ibn Abi Khalid
Ibn Jazzar al-Qayrawani, a tenth-century Arab Muslim physician, suggests preg-
nancies fail because of a woman's excessive worries, undue fatness, or extreme
youth.[21] Not only are women's bodies inherently hostile to reproduction, but so too
are the normal activities and desires they pursue in their everyday lives.

Unlike the qur'anic depiction of wombs as shadows of darkness governed by di-
vine jurisdiction, medieval physicians portray them as diseased cavities hostile or,
at best, indifferent to God's orderly generation of life (fig. 88). Not surprisingly, when
it comes to comparable discussions of flawed or faulty male reproductive organs,
the texts are relatively silent. What appears are scant discussions of how to counter

192 limp erections or a failure to arouse with better diet[22] or better thought, all of which are rooted in behavior modification rather than nature.[23] When it comes to a male's physiology, the medical texts supply no extended litanies of physical defects elaborated in such expansive detail, nor do they embark upon a near obsessive interest to catalogue a penis's myriad defects with a similar gusto. Women's reproductive organs malfunction because they are inherently hazardous or even flawed; men's reproductive organs are fundamentally sound but malfunction because of improper diet, lack of sleep, poor thoughts, or they are sleeping with the wrong woman.

For example, Rabban al-Tabari illustrates the inherently flawed nature of the womb when he depicts how problems in embryonic development may occur when a woman's belly constricts, which leaves the child with little room to grow, or when a woman's womb is weak, and the embryo is deprived of vital nourishment.[24] Rabban al-Tabari also points out that good seed can, in fact, fall on "rocky ground," or a deformed womb, which may lead to the twisting or contorting of a child's limbs.[25] In a discussion of multiple fetuses produced during a single pregnancy, Rabban al-Tabari likens a woman's womb to the multi-chambered ones found in pigs and dogs, unclean animals prohibited by Islamic law.[26] This disturbing analogy likens women's bodies with what jurists consider detestable. While not directly responsible for the demise of their pregnancies, in each of these examples women are identified as agents of their own unsuccessful reproductive capacities by nature of their bodies. Here, a woman's body—but not a man's—becomes equated with an unbelieving human free will, a stubborn, intractable will that rejects God's authority and the natural processes he controls.

Other Muslim scholars take the conclusions of the physicians one step further to suggest that defective female bodies are not the only cause of reproductive disasters; they also blame the moral behavior of the mother for her procreative misfortunes. For example, hadith scholars often cite the moral character of the prophet Muhammad's favored wife 'Aisha as the cause of her barrenness. From the prophet Muhammad's many biographers we know 'Aisha was jealous of Muhammad's first wife Khadija, with whom he produced many children, including two male heirs, who died tragically at young ages. She would often ask why, since she was so much younger and more attractive than Khadija, God did not allow her to conceive.[27] However, because 'Aisha once referred to Khadija as "that toothless old woman whom God had replaced with a better,"[28] a phrase that mocks a divine revelation sent to Muhammad that promises more obedient and pious wives in replacement for ones divorced (presumably because these women were disobedient and impious),[29] many scholars attribute 'Aisha's barrenness to her hubris.[30]

Fig. 88
Final page of the treatise *al-ṭibb al-nabawī* (Prophetic Medicine) by al-Dhahabī (d. 1348/748). Syrian/Egyptian copy, August 19, 1464 (14 Dhu al-Hijjah 868). Bethesda, MD, National Library of Medicine, MS. A 79, fol. 102b. Image courtesy of the National Library of Medicine.

'Aisha's transgressions are put into even sharper relief when we note how both Abraham and Zakariya, the father of John the Baptist, depicted in the Qur'an as being "too old" to reproduce, had only to ask God to grant each of them a righteous child before He immediately complied.[31]

In addition to displays of questionable physiologies and moral behaviors, early Islamic literature also links prohibited behaviors before, during, or after the moment of conception with negative reproductive outcomes. In these examples, the culprit appears to be the moral behavior of both parents, not just the mother. For example, Muhyi al-Din ibn 'Arabi, the infamous thirteenth-century mystic and philosopher, in the exegetical work that is attributed to him, speculates on how parents who have consumed unlawful foods will then produce children with souls that are dark, filthy, and evil. Their souls are corrupted because "the sperm of which the child is formed is itself born of that nourishment (i.e., the unlawful food), and nurtured by that soul, and thus it must concur with it."[32] Likewise, his fellow Sufi al-Ghazali, in his monumental 'Ihya 'ulum al-din (Revival of the Religious Sciences), warns how intercourse during menstruation, which the Qur'an condemns, engenders leprosy in offspring, and sodomy causes permanent harm.[33] The physician al-Suyuti states whoever has a wet dream and does not wash before having sexual intercourse will produce an epileptic.[34] Other scholars note how, if conception takes place during menstruation, the child produced will be a *jinn*, which, in popular folklore, is an ugly and evil demon who convinces men to do evil.

What are characterized by the Islamic tradition as extreme forms of reproductive anomalies do make an appearance in the *hayawan* (bestiary) literature, and again, in these cases, moral degradation is often the culprit (fig. 89). Not surprisingly, these beasts only appear in lands that fall outside the geographical borders of Islam. In these examples, the female serves as the uncivilized, wild animal that tempts the man into committing the heinous act of bestiality. Hamdullah al-Mustawfi al-Qazwini, a thirteenth-century Persian natural historian, anthropologist, and geographer, discusses in the zoological section of his *Nuzhatu-l-qulub* the *khirsar*, an animal born of a bear and man, in form and speed like a man, but in the quantity of hair on its body like a bear;[35] the *sagsar*, an animal with a head like a dog's and a body like a man's;[36] and the *atam*, a fish-creature with a face like a pig and private parts like a man's.[37] In each description, the creature produced is likened to animals whose meat is prohibited for consumption by Islamic law. Never identified as humans, these offspring can still mate with men and produce further monstrosities whose forms have rarely been seen before. An example of what is produced as a result of unnatural sexual acts includes the *nasnas*. Its face is beautiful but she can not speak

194 and has no power of comprehension. Men have sex with the *nasnas* and even beget sons with her, but the sons are dumb.[38] Obviously law-abiding men and women would not produce such exotic creatures through prescribed acts of intercourse; only those who thwart the law bear such unnatural forms.

### After Birth

Even when women successfully traverse the treacherous terrain of their own wombs, and defy all odds by producing healthy offspring, we find their role as mother further denigrated by masculine elites who suggest that even though babies come from the wombs of women, it is ultimately the men who must bestow upon that child a meaningful life; that is, the men are the ones who engender the child's social, religious, and cultural identity essential to its very existence. The privileging of the father's role as the "life-giver" is guaranteed through a number of rituals that serve to sever the infant from its birth mother, and bind him more fully with his father, rather than his mother. The ceremony of the *tahnik*, which originated with the Prophet (but then transferred to the father) chewing a few dates, and then placing the masticated dates produced in an infant's mouth to be consumed as the child's first food, or with the Prophet chewing a few dates and then simply rubbing the date on the palate of the child's mouth, is one such example.[39] Contrary to what is natural, these traditions argue the first thing a child should put in his mouth is not his mother's milk, but the masticated date juice produced by his father, which symbolizes the father's willingness to accept the paternity of his child, the child's subordination to the father, and the initiation of the child into the Muslim community.

While Sunni practice depreciates the mother's authority and principal role as caregiver of her child through this ceremony, many Shi`ite writings further reduce the mother's importance in the early months of her child's life in even more radical examples of the Prophet nursing his grandchildren himself. Ibn Shahrashub, for example, describes how the Prophet forbade his daughter Fatima to nurse her own child and instead suckled Husayn himself for forty days by putting his thumb or tongue into the child's mouth.[40] While not a practice suitable for the average believer, this tradition underscores a persistent desire to transfer a biological reality into a social one where the male is dominant. So while the mother may be a life-producer, the father is ultimately, in tandem with God, the life-giver.

All of these medical and exegetical examples paint women's wombs as harmful or even hostile to God's procreative efforts. Conception, pregnancy, and birth would all progress in orderly fashion if only women's wombs were less dysfunc-

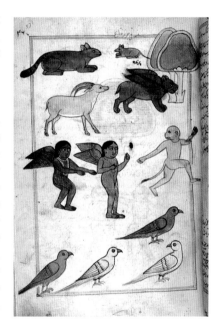

Fig. 89
Creatures from the Island of Zanj (jazirah-i Zanj). Miniature from *'Ajā'ib al-makhlūqāt wa-gharā'ib al-mawjūdāt* (Marvels of Things Created and Miraculous Aspects of Things Existing) by al-Qazwīnī (d. 1283/682). Undated copy, possibly from the Punjab, 17th century. Bethesda, MD, National Library of Medicine, MS. P 2, fol. 47a. Image courtesy of the National Library of Medicine.

tional. And perhaps even more startling is the outcome envisioned once a profitable pregnancy is ensured. While the mother successfully houses and nourishes the child for forty weeks, she is then deemed incapable of properly or fully engendering in her child a meaningful life. The question, of course, is how did women respond to those elite scholars who bestowed upon them this marginal, if not detrimental, role in the formation and care of their own offspring?

### Popular Literature: Female Curative Practices

In popular literature, Muslim literati and women themselves challenge the privileged view that women's morals or bodies thwart God's procreative plans. Driven by their own experiences, women see that the perfect pregnancies God wills—or perhaps better put, that male scholars have come to expect—are not always attainable nor often, in fact, desirable. In popular literature, women take control of seemingly uncertain birthing outcomes as they direct and navigate their own fertility, in/ability to conceive, sex of the child, length of gestation, ease in delivery, postpartum health, and breastfeeding success. These women, and to some extent men, strive to do all they can to ensure a positive reproductive outcome (however that may be defined for themselves) while still acknowledging it is God's plan that will ultimately prevail. This model of human efforts in tandem with God's will is illustrated in several hadith that discuss the Prophet's approval of the practice of `azl, or coitus interruptus. For example, according to Anas, "A man asked the Prophet about `azl and the Prophet said, 'Even if you spill a seed from which a child was meant to be born on a rock, God will bring forth from that rock a child.'" And likewise, according to Abu Sa`id, "The Jews say that `azl is minor infanticide, and the Prophet answered, 'The Jews lie, for if God wanted to create something, no one can divert Him.'"[41] These examples suggest human effort may avert conception from taking place, but only because God deems it to be.

This proactive approach to human reproduction opposes the dominant scholarly position outlined above that women's bodies are somehow the cause of negative reproductive outcomes, and supports more firmly the qur'anic position that only God—and not man—has full knowledge of what every womb contains. Marginal to the dominant discourse are several theological positions and religious rituals that further envision active human participation in the maintenance of God's creation, rather than a passive and complete reliance on divine will. For example, while most types of bodily mutilations and excessive adornments are condemned by Muslim legal scholars, circumcision—which really is a radical human alteration of the body subsequent to its creation—becomes an obligatory act required to

purify both males and, to a lesser extent, females. Jahiz, also, writes how cleaning and removing body hair, which, he argues, Manichaeans often cite to defend their position that nature is flawed, places in human beings a wholesome responsibility for the needs and care of the body. Body hair is not a defect in nature but part of God's overall plan for his creation that demands human participation in the insurance of its proper care. According to Jahiz, body hair is not a gratuitous growth but a meaningful part of God's design; by cleaning and removing it humans are able to reduce wickedness by restraining aggression and distracting themselves from the consequences of idleness.[42] This example demonstrates how seeming imperfections in nature are keys to understanding God's creative processes that demand human engagement and participation to a necessary, albeit limited, extent.

Female curative practices reflect this theological position in concrete, practical terms by giving women the recipes and practical information they need to navigate their own reproductive health outside the jurisdiction of men (fig. 90). In midwifery and medical texts, female curative practices and drugs appear mainly in proscriptive lists. Male elites systematically condemn obstetric practices developed via midwives and folklore. Such practices could subvert the divinely ordered world where men answer to God, and women to men. Ibn Jazzar, for example, states upfront he is only providing lengthy and detailed lists of drugs harmful to the fetus and a woman's internal organs so that women will know what to avoid.[43] However, it appears from his discussions that various forms of birth control and abortifacients were well known among women and men. The popularity of such remedies is not surprising, given how often women would have experienced the physical and emotional pain of miscarriages and early infant death. Ibn Jazzar, for example, cites how birthwort with pepper and myrrh cleans out the afterbirth, but will also expel a dead fetus.[44] Mint used as a suppository before intercourse also prevents pregnancy.[45] If women use tar as a suppository, they will abort living fetuses or expel dead ones, and be barren forever.[46] Flour of lupine also serves as an effective abortifacient.[47] Kamal al-Din Muhammad ibn Musa al-Damiri, a fourteenth-century Egyptian writer on canon law and natural history, suggests in his *Hiyat al-hayawan* that by employing the earwax or sweat of a mule as a pessary, a woman will not conceive; by eating a mule's heart or drinking its urine she will never become pregnant.[48] Mules, of course, are sterile animals because of their hybrid nature, so it is not surprising that parts of the mule would serve as a pregnancy preventative. Despite the heavy emphasis on what to do to avoid conception, recipes also exist for women wishing to conceive. Drinking hawk excrement[49] or elephant ivory,[50] for example, are sure keys to reproductive success. A woman can also determine the sex of her child, according to

Fig. 90
Illuminated headpiece
in a copy of the treatise
on Prophetic Medicine,
*al-Manhaj al-sawī wa-al-
manhal al-rawī fī al-ṭibb
al-nabawī* (An Easy Manual
and Refreshing Source
for the Medicine of the
Prophet), by Jalāl al-Dīn
al-Suyūṭī (d. 1505/911).
Possibly 16th century.
Bethesda, MD, National
Library of Medicine, MS. A
41, fol. 1b. Image courtesy
of the National Library of
Medicine.

al-Damiri, by drinking the rennet of a male hare if she prefers a male child, and vice versa if she prefers a female.[51] She can even determine the appearance of the child by staring at a portrait of a beautiful boy during the sexual act. The child produced during such an act will come out resembling the portrait.[52] Women also played an important role in the process of delivery, which is described uniformly in midwifery texts as being slow, difficult, and painful (especially for the delivery of baby girls, for whom a mother's labor is notoriously more drawn out and agonizing). However, if one takes human hair, burns it, then mixes it with rose water, and places it by a woman's head at the time of delivery, the birthing process will quicken.[53] If a pregnant woman is fumigated with cow dung[54] or if she is given cattle bones to wear around her neck during labor,[55] a quick partuition will be facilitated. The list could go on and on, but these proscriptive lists speak to a robust women's traffic in folk medicine—if not outright magic[56]—designed to avoid a disastrous pregnancy or to ensure what was desired: a healthy child born into God's world. These alternative avenues, however, are systematically condemned by male scholars as harmful to God's creation. Implicit in each of these proscriptive lists of drugs, folk remedies, and practical action is that women challenge the elite view that they must passively accept what men deem to be God's will.

## Conclusion

In times where childbirth was often a dangerous enterprise, and infant death common, as evidenced by the hadith's depiction of a special place in paradise for women who have suffered through the deaths of three or more of their children,[57] it is not hard to understand why women would want to participate in God's creative act to let their own hopes, desires, fears, and joys be known. Implicit in women's curative practices is that female reproductive defects that have been catalogued and characterized by men can be overcome, or at the very least their potentially negative consequences can be negotiated or ameliorated. In this way, folk remedies serve as a form of resistance over and against a submissive acceptance of what males vocalize as being God's will. It is through direct participation in the life cycle that women tap into marginal theologies, like that of the Muʿtazilite al-Jahiz and the Qur'an itself, to challenge normative, elite male constructions of a God who demands perfection from faulty female bodies that never quite can conform to these ideal expectations. In the lived experiences of everyday life, women reclaim the qur'anic vision that only God, and not men, know the true contents of the womb, and that ultimately only God, and not men, cause a life to be or not to be, in whatever form, or through whatever means, he chooses.

# Notes

**Why the Medieval Matters**
Ena Giurescu Heller

1 Dirk Breiding's essay in this volume also addresses many of our pre- and misconceived notions of the Middle Ages.

2 Written by Michael Otterman in *The Australian*, March 27, 2007, http://www.theaustralian news.com.au/ story/0,20867,21423633-7583,00.html.

3 Umberto Eco, *Travels in Hyperreality,* trans. William Weaver (San Diego, New York, London: Harcourt, Inc., 1986), 64–65.

4 *Didascalicon* 7:4, PL 176:184, quoted in Conrad Rudolph, *The "Things of Greater Importance": Bernard of Clairvaux's "Apologia" and the Medieval Attitude Toward Art* (Philadelphia: University of Pennsylvania Press, 1990).

5 Quoted by J. Hamburger, "The Place of Theology in Medieval Art History: Problems, Positions, Possibilities," in Jeffrey F. Hamburger and Anne-Marie Bouché, eds., *The Mind's Eye: Art and Theological Argument in the Middle Ages* (Princeton: Princeton University Press, 2006), 15.

6 See the brief history of the Baroncelli Chapel in my dissertation: Ena Giurescu, *Trecento Family Chapels in Santa Maria Novella and Santa Croce: Architecture, Patronage, and Competition* (Ann Arbor, MI: University Microfilms, 1997). For the decoration of the chapel, see Julian Gardner, "The Decoration of the Baroncelli Chapel in Santa Croce," *Zeitschrift für Kunstgeschichte* 34/2 (1971), 89–114 and Robert J. H. Janson-LaPalme, *Taddeo Gaddi's Baroncelli Chapel: Studies in Design and Content* (Ann Arbor, MI: University Microfilms, 1986).

7 One also needs to keep in mind that in the fourteenth century the chapels were for the most part closed by wrought iron gates, and decorated with banners, family arms and other insignia that have since disappeared; see Giurescu, 212–45 for a tentative reconstruction of the original appearance of these chapels and their ritual.

8 The generalization used here for the purposes of emphasis does not mean to imply that travel motivated by faith has completely disappeared in the twenty-first century; rather, that it now constitutes the exception and not the rule.

9 On access to chapels, and more generally to the east end of the church, itself separated from the rest of the church by the rood screen, see Giurescu, *Trecento Family Chapels,* 205–11.

10 Egeria, quoted in Robert F. Taft, *Through their Own Eyes: Liturgy as the Byzantines Saw It* (Berkeley: Inter Orthodox Press, 2006), 76.

11 Quoted in Charles Barber, "From Transformation to Desire: Art and Worship after Byzantine Iconoclasm," *Art Bulletin* 75/1 (March 1993): 9.

12 For a thorough analysis of the tapestries, see Margaret B. Freeman, *The Unicorn Tapestries* (New York: E.P. Dutton, Inc. and The Metropolitan Museum of Art, 1983).

13 See also John Williamson, *The Oak King, the Holly King, and the Unicorn: The Myths and Symbolism of the Unicorn Tapestries* (New York: Harper and Row, 1986).

14 Quoted in ibid., 83.

15 For a detailed analysis of the symbolism of flora and fauna in the second tapestry, see ibid. 97–120.

16 This notion, from the perspective of Islamic studies, is developed in Kathryn Kueny's essay in this volume.

17 Debra Hassig, "The Iconography of Rejection: Jews and Other Monstrous Races," in Colum Hourihane, ed., *Image and Belief: Studies in Celebration of the Eightieth Anniversary of The Index of Christian Art* (Princeton, NJ: Princeton University and Princeton University Press, 1999), 25–37.

18 Eric Zafran, "Saturn and the Jews," *Journal of the Warburg and Courtauld Institutes* 42 (1979): 18.

19 See the excellent study of Jews in the Middle Ages by Marc Cohen, *Under Crescent and Cross* (Princeton, NJ: Princeton University Press, 1994).

20 Quoted in Zafran, "Saturn and the Jews," 17.

21 Term coined by Hassig, "Iconography of Rejection," 25.

## The Middle Ages in Life and Art
Thomas Cahill

1 Thomas Cahill, *Mysteries of the Middle Ages: The Rise of Feminism, Science, and Art from the Cults of Catholic Europe* (New York: Nan A. Talese/Doubleday, 2006).

2 Henry Adams, *Mont Saint Michel and Chartres,* with a new introduction by Francis Henry Taylor and photographs by Samuel Chamberlain (New York: The Heritage Press, 1957), 93, 94.

## From the Lecture Hall to Museum Gallery: Teaching Medieval Art Using Primary Objects
Patricia C. Pongracz

**199**

1 All didactics cited appeared in the exhibition *Realms of Faith: Medieval Art from the Walters Art Museum,* Museum of Biblical Art, New York City, March 5–July 13, 2008.

2 Paul Vitello, "For Catholics, a Door to Absolution Reopened," *New York Times*, February 10, 2009, front page and A22.

3 Ibid.

4 *Abbot Suger on the Abbey Church of Saint-Denis and its Art Treasures*, edited, translated and annotated by Erwin Panofsky, second edition by Gerda Panofsky-Soergel (Princeton: Princeton University Press, 1979), 65.

Notes

### Teaching Medieval Architecture at The Cloisters
Nancy Wu

**200**

1   For the history of the construction of The Cloisters, see a brief account in the Introduction in Peter Barnet and Nancy Wu, *The Cloisters: Medieval Art and Architecture* (New York: The Metropolitan Museum of Art, 2005), 9–19. Charles Collens was contracted to design the museum in 1931, with the bulk of the construction taking place from 1935 to 1937. The museum opened to the public in May of 1938.

2   James J. Rorimer, *The Cloisters: The Building and the Collection of Mediaeval Art in Fort Tryon Park* (New York: The Metropolitan Museum of Art, 1938), 103–4, and figure 5. The name "Spanish Room" was in use well into the 1980s, when it was changed to "Campin Room" to reflect the focus of its setting around the famed *Annunciation* triptych, which came to The Cloisters in 1956. Due to continuing debate about the attribution of the painting, the name of the gallery has recently been changed to "Mérode Room" after the Belgian family who owned the painting in the nineteenth century. For a useful summary of scholarship through the late 1990s see Maryan Ainsworth, "The Annunciation Triptych," in Maryan Ainsworth and Keith Christiansen, eds., *From Van Eyck to Bruegel: Early Netherlandish Painting in The Metropolitan Museum of Art* (New York: The Metropolitan Museum of Art, 1998), 89–96. For the latest discussion about authorship, see Stephan Kemperdick and Jochen Sander, eds., *The Master of Flémalle and Rogier van der Weyden* (Ostfildern: Hatje Cantz, 2009), published in conjunction with the exhibition "Der Meister von Flémalle und Rogier van der Weyden", Städel Museum, Frankfurt am Main, and Gemäldegalerie der Staatlichen Museen zu Berlin.

3   Letter from Joseph Breck to Charles Collens, November 11, 1932. Cloisters Archives, Collection 32, Cloisters History, Box 68, henceforth referred to as Cloisters Archives 32/68.

4   Letter from Rorimer to Collens, October 28, 1933: "I am sending you a Photostat of a photograph showing a window in Barcelona. It will give you an idea of the detail of a Spanish window of the kind we spoke of and also suggest the proportions of late Gothic window openings." Cloisters Archives 32/68.

5   Eugène-Emmanuel Viollet-le-Duc, *Dictionnaire raisonné de l'architecture française du XIe au XVIe siècle* (Paris: Veuve A. Morel, 1875). Other publications consulted for the project included Camille Enlart, *Architecture civile et militaire* (Paris: A. Picard, 1929–32); Henry Revoil, *Architecture romane du Midi de la France* (Paris: Veuve A. Morel, 1867–74); and Viollet-le-Duc's monographs on Pierrefonds (1857) and Carcassonne (1858). Cloisters Archives 32/68.

6   For John D. Rockefeller Jr. and his involvement with The Cloisters see Calvin Tomkins, *Merchants & Masterpieces: The Story of The Metropolitan Museum of Art*, rev. ed. (New York, Henry Holt & Co., 1989), 245–61; and William Forsyth, "Five Crucial People in the Building of The Cloisters," in Elisabeth Parker and Mary B. Shepard, eds., *The Cloisters: Studies in Honor of the Fiftieth Anniversary* (New York: The Metropolitan Museum of Art in association with The International Center of Medieval Art, 1992), 51–62.

7   The Blumenthal objects formerly in the Salle de Musique were selected by Breck in 1933, with additional items added by Rorimer and Collens in the summer of 1934. Among them are the polylobed doorway from the former Augustinian priory in Reugny, and the large windows from the former Dominican convent in Sens. See letter from Rorimer to Collens, November 26, 1934, Cloisters Archives 32/68. For some of the Blumenthal objects at The Cloisters, see Barnet and Wu, *The Cloisters*, 61 and 68–69, and *Notice sur les fragments de monuments anciens ayant servi à construire la Salle de Musique de l'hôtel du 15 Boulevard de Montmorency à Paris* (Paris, 1930). For Blumenthal's life and involvement with The Metropolitan Museum of Art, see Calvin Tomkins, *Merchants & Masterpieces*, 218–28.

8   Letter from Rorimer to Collens, January 2, 1934. Cloisters Archives 32/68. See also Barnet and Wu, *The Cloisters*, 86.

Certainly conservation concerns played a significant role in the decisions of object placement; much of the collection is fragile and requires complete protection from the elements. The skylight covering the Saint-Guilhem-le-Désert Cloister is a case in point.

9  The abbey of Saint-Guilhem-le-Désert, now a World Monument site, has been studied extensively. For the most recent discussions see the series of papers published by the Association des Amis de Saint-Guilhem-le-Désert: *Saint-Guilhem-le-Désert au Moyen Age: nouvelles contributions à la connaissance de l'abbaye de Gellone* (Montpellier, 1996), *Saint-Guilhem-le-Désert dans l'Europe du haut Moyen Age* (Montpellier, 2000), and *Saint-Guilhem-le-Désert, la fondation de l'abbaye de Gellone: L'autel médiéval* (Montpellier, 2004).

10  For the history of the Fuentidueña Apse and its transport to The Cloisters, see articles by James Rorimer, Carmen Gómez-Moreno, and Margaret Freeman, "The Apse from San Martín at Fuentidueña," *The Metropolitan Museum of Art Bulletin* 19/10 (June, 1961): 265–96, and David L. Simon, "Romanesque Art in American Collections. XXI. The Metropolitan Museum of Art. Part 1: Spain," *Gesta* 23/2 (1984): 145–59.

11  For the Astudillo Crucifix, see Barnet and Wu, *The Cloisters*, p. 39, and Janice Mann, "Crucifix," in Charles T. Little, ed., *The Art of Medieval Spain, A.D. 500–1200* (New York: The Metropolitan Museum of Art, 1993), 222–23.

12  For the altar frontal, see Barnet and Wu, *The Cloisters*, p. 63, and Walter W. S. Cook, "The Stucco Altar-Frontals of Catalonia," *Art Studies* 2 (1924), 41, 81. Discussions about two comparable examples can be found in Little, ed., *The Art of Medieval Spain*, 324–27.

13  For recent discussions about Cuxa, see Thomas E. A. Dale, "Monsters, Corporeal Deformities, and Phantasms in the Cloister of St-Michel-de-Cuxa," *Art Bulletin* 83/3 (2001), 402–36.

14  There are many excellent articles dealing with monastic life. For the purpose of teaching elementary, middle, and high school students, the following texts are especially helpful: Paul Meyvaert, "The Medieval Monastic Claustrum," *Gesta* 12 (1973), 53–59; and Terryl N. Kinder, *Cistercian Europe: Architecture of Contemplation* (Grand Rapids, MI: Wm B. Eerdmans Publishing Co., 2002), especially chapter 2, "The Organization of Life in a Cistercian Abbey," 51–78. Passages from the *Rules of St Benedict* are often read to the students.

15  An especially useful study on the traffic patterns aimed at limiting visitors' access to certain parts of the monastery has been published recently by Sheila Bonde and Clark Maines, "*Ne aliquis extraneus claustrum intret*: Entry and Access at the Augustinian Abbey of Saint-Jean-des-Vignes, Soissons," in Terryl N. Kinder, ed., *Perspectives for an Architecture of Solitude: Essays on Cistercians, Art and Architecture in Honor of Peter Fergusson* (Turnhout: Brepols, 2004), 173–86.

16  For an extensive bibliography on the subject, see Dale, "Monsters, Corporeal Deformities, and Phantasms in the Cloister of St-Michel-de-Cuxa." For an in-depth discussion about Bernard's *Apologia*, see Conrad Rudolph, *The "Things of Greater Importance," Bernard of Clairvaux's Apologia and the Medieval Attitude toward Art* (Philadelphia: University of Pennsylvania Press, 1990).

17  Translation by David Burr: http://www.fordham.edu/halsall/source/bearnard1.html.

18  See Barnet and Wu, *The Cloisters*, 49–51.

19  For a detailed description of the Pontaut chapter house and its reconstruction at The Cloisters, see James Rorimer, *Medieval Monuments at The Cloisters as They Were and as They Are*, rev. ed. (New York: The Metropolitan Museum of Art, 1972), 24–27. See also Rorimer, *The Cloisters: The Building and the Collection of Mediaeval Art*, 31–35.

20  Unpublished report by William Forsyth on Pontaut in museum files.

21  See Terryl N. Kinder, *Cistercian Europe*, 245–67, for a useful survey of Cistercian chapter rooms. See also Megan Cassidy-Welch,

*Monastic Spaces and their Meanings: Thirteenth-Century English Cistercian Monasteries* (Turnhout: Brepols, 2001), especially Chapter Four, "Community, Discipline and the Body: The Cistercian Chapter House."

22 Mary B. Shepard, "The Campin Room," in Amelia Peck and others, *Period Rooms in The Metropolitan Museum of Art* (New York: Harry N. Abrams, Inc., 1996), 33–39.

23 J. Rorimer, "A Treasure at The Cloisters," *The Metropolitan Museum Bulletin* (1948): 237–60.

24 See letters from Breck to Collens, May 31, 1933, and from Rorimer to Collens, April 8, 1936. Cloisters Archives 32/68.

## Cataloguing Medieval Manuscript Fragments: A Window on the Scholar's Workshop, with an Emphasis on Electronic Resources

Margot Fassler

1 Readers might want to wander through Andy Holt's Virtual Library at http://www.utm.edu/vlibrary/vlhome.shtml (accessed March, 2009).

2 For a fascinating journey into the world of the medieval scribe, written by one of the greatest living paleographers, see Michael Gullick, "How Fast Did Scribes Write: Evidence from Romanesque Manuscripts," in *Making the Medieval Book: Techniques of Production*, ed. Linda L. Brownrigg (Los Altos Hills, CA: Anderson-Lovelace, 1995), 39–58.

3 For a brief but excellent introduction to parchment and parchment makers, see Christopher de Hamel, *Medieval Craftsmen: Scribes and Illuminators* (Toronto: University of Toronto Press, 1992), 8–26.

4 Barbara Shailor has written a clear description of how medieval books were made using the medieval books in the Beinecke Rare Book and Manuscript Library at Yale University: *The Medieval Book* (Toronto: University of Toronto Press, 1991); for the decoration of deluxe manuscripts, also using the collection of a single library, see Christopher de Hamel, *The British Library Guide to Manuscript Illumination: History and Techniques* (London: The British Library, 2001). You can get a brief introduction to the medieval book online from the Victoria and Albert Museum at http://www.vam.ac.uk/vastatic/microsites/1220_gothic/make_book.php; and from the Philadelphia Free Library at http://www.leavesofgold.org/learn/children/how_made/index.html (both accessed February, 2009). The Philadelphia Free Library's online Learning Center offers many other features especially for the use of classroom teachers who want to set up a "scriptorium." For a non-specialist introduction appropriate for young students, see Diane Tillotson's Medieval Writing webpage at http://medievalwriting.50megs.com/writing.htm (accessed March, 2009). A hilarious scene imagining the new technology of the book coming into medieval monastic life to replace the scroll is at http://www.youtube.com/watch?v=xFAWR6hzZ (accessed February, 2009).

5   de Hamel, *Scribes and Illuminators*, 7.

6   The Metropolitan Museum in New York offers an online discussion of the medieval book with excellent examples of deluxe manuscripts and discussion of various techniques for illumination. See http://www.metmuseum.org/toah/hd/book/hd_book.htm (accessed March, 2009). For books on the subject of medieval illuminators, see Jonathan J. G. Alexander, *Medieval Illuminators and their Methods of Work* (New Haven, CT: Yale University Press, 1992); and Michelle Brown, *Understanding Illuminated Manuscripts: A Guide to Technical Terms* (Malibu, CA: J. Paul Getty Museum, 1994), in addition to de Hamel's *British Library Guide to Manuscript Illumination*.

7   For an introduction to the medieval liturgy and liturgical books, see John Harper, *The Forms and Orders of Western Liturgy from the Tenth to the Eighteenth Century: A Historical Introduction and Guide for Students and Musicians* (Oxford: Oxford University Press, 1991); Eric Palazzo, *A History of Liturgical Books from the Beginning to the Thirteenth Century* (Collegeville, MN: Liturgical Press, 1998); and Margot Fassler and Rebecca A. Baltzer, eds., *The Divine Office in the Latin Middle Ages: Methodology and Source Study, Regional Developments, Hagiography* (New York: Oxford University Press, 2000); Janet Backhouse, *The Sherborne Missal* (Toronto: University of Toronto Press, 1999).

8   To understand the range of the work and its importance, see the collection of essays *Medieval Book Fragments in Sweden*, ed. Jan Brunius (Stockholm: Kungl. Vitterhetsakademien, 2005). Three of the essays deal with fragments of English manuscripts found in the collection. Another introduction to the book fragment is Linda L. Brownrigg and Margaret M. Smith, eds., *Interpreting and Collecting Fragments of Medieval Books* (Los Altos Hills, CA: Anderson-Lovelace, 2000).

9   See James R. Tanis, ed., *Leaves of Gold: Manuscript Illumination from Philadelphia Collections* (Philadelphia: Philadelphia Museum of Art, 2001).

10  After I had done my research and written the paper, I found that they had already catalogued these as "Italian, ca. 1450–1550."

11  An entire field of specialization has been left out here, codicology, which deals primarily with the physical features of books and book production. Some of the work we will do with page layout is in the realm of this study, but to engage the field completely one needs a book or part of a book rather than just some detached and heavily trimmed leaves as we have here. A quite wonderful introduction to the subject of codicology has been provided online by Georg Vogeler as part of a broader history project: WWW-VL HISTORY. For codicology, see http://www.vl-ghw.uni-muenchen.de/kodikologie_en.html (accessed March, 2009).

12  See Bill Hildebrandt, *Calligraphic Flourishing: A New Approach to an Ancient Art* (Boston: David R. Godine, Inc., 1995), especially 6off.

13  The Digital Scriptorium is the brainchild of Consuelo Dutschke. It is a fabulous tool for the researcher as well as for non-specialists who enjoy exploring the wonders of medieval manuscripts. She and her associates describe it on its website as follows: "As a visual catalog, DS allows scholars to verify with their own eyes cataloguing information about places and dates of origin, scripts, artists, and quality. Special emphasis is placed on the touchstone materials: manuscripts signed and dated by their scribes. DS records manuscripts that traditionally would have been unlikely candidates for reproduction. It fosters public viewing of materials otherwise available only within libraries. Because it is web-based, it encourages interaction between the knowledge of scholars and the holdings of libraries to build a reciprocal flow of information. Digital Scriptorium looks to the needs of a very diverse community of medievalists, classicists, musicologists, paleographers, diplomatists and art historians. At the same time Digital Scriptorium recognizes the limited resources of libraries; it bridges the gap between needs and resources

**203**

by means of extensive rather than intensive cataloguing, often based on legacy data, and sample imaging." Another excellent source, functioning as a grand portal to digitized medieval manuscripts, has recently been established at UCLA by Matthew Fisher and Christopher Baswell: Catalogue of Digitized Medieval Manuscripts (see http://manuscripts. cmrs.ucla.edu/; accessed April, 2009). The home page reads: "Welcome to the Catalogue of Digitized Medieval Manuscripts. This site was designed to enable users to find fully digitized manuscripts currently available on the web. You can use the search box to quickly search on specific terms, or use the 'Search Manuscripts' link to search on particular fields, such as date, or provenance information. You can also browse the Catalogue by the Location of an archive or library, the shelfmark of an item, by the author of a text (where that information is available), or by the language of a text (again, where available)."

14 See http://app.cul.columbia.edu:8080/exist/scriptorium/ individual/NNC-RBML-475.xml?showLightbox=yes (accessed March, 2009).

15 See http://www.columbia.edu/itc/music/manuscripts/ image_index.html (accessed March, 2009). The site also lists the liturgical books by function.

16 From the website: "The Project for American and French Research on the Treasury of the French Language (ARTFL) is a cooperative enterprise of the Laboratoire ATILF (Analyse et Traitement Informatique de la Langue Française) of the Centre National de la Recherche Scientifique (CNRS), the Division of the Humanities, the Division of the Social Sciences, and Electronic Text Services (ETS) of the University of Chicago." It is directed by Robert Morrissey at http://artfl. uchicago.edu/ (accessed April, 2009).

17 The standard introduction to medieval chant is David Hiley, *Western Plainchant: A Handbook* (Oxford: Oxford University Press, 1995). For numerous online sources, see especially the Gregorian Chant Home Page, maintained by Peter Jeffery (see http://www. music.princeton.edu/chant_html/; accessed April, 2009).

18 Found at http://www.lib.latrobe.edu.au/MMDB/ (accessed March, 2009). Because La Trobe University closed its music department in 1999, the director of this database has done a fine job keeping the work going, and those of us who use it frequently are ever concerned for its continuation.

19 See http://publish.uwo.ca/~cantus/ (accessed February, 2009).

20 Dom René-Jean Hesbert, *Corpus Antiphonalium Officii*. 6 vols. (Rome: Herder, 1963–79).

21 For an introduction to late medieval book hands, see Albert Derolez, *The Palaeography of Gothic Manuscript Books: from the Twelfth to the Early Sixteenth Century* (Cambridge: Cambridge University Press, 2003), who describes rotunda script and its widespread use as a late book hand in Italy, its land of origin, Southern France, and Spain in the later Middle Ages and into the Early Modern Periods. It was favored in these regions by many printers and so in this case manuscript production may have been influenced by the new technology in the sixteenth and seventeenth centuries.

22 For study of a group of fifteenth-century Spanish liturgical books, see Lorenzo F. Candelaria, *The Rosary Cantoral: Ritual and Social Design in a Chantbook from Early Renaissance Toledo*, Eastman Studies in Music (Rochester, NY: University of Rochester Press, 2008). A spectacular gradual from around 1500, now held as Ms. 11 in the Special Collections Library of Syracuse University, is an excellent example of strong Moorish influence in Spanish book decoration. For study of this manuscript, see George Catalano, "A Dominican Gradual of Saints, circa 1500," *The Courier* 27:2 (Fall 1992): 3–31. Select pages are digitized at http://library.syr.edu/digital/ collections/m/MedievalManuscripts/ms11/ms11.htm (accessed March, 2009).

23 See http://cdm.lib.usm.edu/cdm4/document.php?CISOROOT=/ rarebook&CISOPTR=1307&REC=1 (accessed April, 2009).

24 There are several other manuscripts or fragments online that make excellent points of comparison. I would mention two leaves from a sixteenth-century Spanish antiphoner, now at the library of Dartmouth College (see http://www.dartmouth.edu/~library/rauner/westmss/002082.html). Also quite close is the previously mentioned Barnard Ms. 3. This gradual will be the subject of a forthcoming study by Susan Boynton and Juan Ruiz Jiménez. From careful study of the chant variants, Jiménez has been able to determine that the manuscript is from Seville.

**The Living Past: Form and Meaning in a Late Medieval Eucharistic Chalice from the Walters Art Museum**
C. Griffith Mann

1 Charles Oman, "Some Sienese Chalices," *Apollo* 81 (1965): 279–81; and Elisabetta Cioni, *Scultura e smalto nell'oreficeria senese: dei secoli XIII e XIV* (Florence, 1998).

2 For this chalice, see Philippe Verdier, *The International Style: The Arts in Europe around 1400* (Baltimore: Walters Art Gallery, 1962), cat. 142, 136–37.

3 For Eucharistic practice through the centuries, and the concept of spiritual communion, see also the essays by Xavier Seubert and Mary Moorman in this volume.

4 Ippolito Machetti, "Orafi senese," *La Diana* 4 (1929): 9.

5 For the permeable nature of distinctions between past and present in the medieval period, see Giles Constable, "A Living Past: The Historical Environment of the Middle Ages," *Harvard Library Bulletin* n.s. 1/3 (1990): 49–70, esp. 49ff.

## Liturgical Instruments and the Placing of Presence
Xavier John Seubert, OFM, STD

1  See Alexander Schmemann, *The Eucharist: Sacrament of the Kingdom* (Crestwood, NY: St. Vladimir's Seminary Press, 1988); John Meyendorff, *Byzantine Theology: Historical Trends and Doctrinal Themes* (New York: Fordham University Press, 1979), 201–11; Robert Taft, SJ, *Through Their Own Eyes: Liturgy as the Byzantines Saw It* (Berkeley, CA: InterOrthodox Press, 2006).

2  See Robert Taft, *Through Their Own Eyes*, 112–17. See also Robert Taft, "Byzantine Communion Spoons: A Review of the Evidence," *Dumbarton Oaks Papers* 50 (1966): 209–38.

3  Roger Haight, SJ, *Christian Community in History*, vol. 1, *Historical Ecclesiology* (New York: Continuum International Publishing, 2004), 289–90.

4  The Trinitarian mystery at the heart of the Eucharist, both east and west, was articulated in the joint statement "The Mystery of the Church and the Eucharist in the Light of the Mystery of the Holy Trinity" in *The Quest for Unity: Orthodox and Catholics in Dialogue* (Crestwood, NY: St. Vladimir's Seminary Press, 1996), 53–64. See also John Zizioulas, *Being as Communion: Studies in Personhood and the Church* (Crestwood, NY: St. Vladimir's Seminary Press, 1985) and Miroslav Volf, *After Our Likeness: The Church as the Image of the Trinity* (Grand Rapids, MI: Eerdmans, 1998).

5  Schmemann. *The Eucharist: Sacrament of the Kingdom*, 17–18.

6  See Enrico Mazza, *The Celebration of the Eucharist: The Origin of the Rite and the Development of Its Interpretation* (Collegeville, MN: Liturgical Press, 1999), 161–224; Hans Bernhard Meyer, "Abendmahlfeier II (II. Mittelalter)," *Theologische Realenzyklopädie* (Berlin: Walter de Gruyter, 1977), 1:278–87.

7  David Powers, "Eucharist in Contemporary Catholic Tradition," *New Catholic Encyclopedia*, 2nd ed. (Washington, DC: Catholic University of America Press, 2003), 5:425.

8  Gary Macy, *Treasures from the Storeroom: Medieval Religion and the Eucharist* (Collegeville, MN: Liturgical Press, 1999), 172–95.

9  Margaret Miles, *Rereading Historical Theology: Before, during, and after Augustine* (Eugene, OR: Cascade Books, 2008), 208. See also her *Image as Insight: Visual Understanding in Western Christianity and Secular Culture* (Boston: Beacon Press, 1985), 6–12.

10 See Mary Carruthers, *The Book of Memory: A Study of Memory in Medieval Culture* (Cambridge: Cambridge University Press, 1990), esp. 16–79; R. A. Markus, "Augustine on Signs," *Phronesis* 2:1 (1957): 60–83.

11 St. Bonaventure's *Tree of Life* and John of Caulibus's (?) *Meditations on the Life of Christ* were the two most influential books of meditation in the thirteenth century and beyond. See Denise Despres, *Ghostly Sights: Visual Meditation in Late-Medieval Literature* (Norman, OK: Pilgrim Books, 1989), 19–54. See also Jeffrey Hamburger, "Medieval Self-Fashioning: Authorship, Authority, and Autobiography in Suso's *Exemplar*" in *The Visual and the Visionary: Art and Medieval Spirituality in Late Medieval Germany* (New York: Zone Books, 1998), 233–78. The example of Margery Kempe is also instructive for self-transformation through meditation. See Denise Despres, "Revisioning in *The Book of Margery Kempe*" in *Ghostly Sights*, 57–86.

12 See Despres, *Ghostly Sights*, 19–54.

13 See Edward Foley, *From Age to Age: How Christians Celebrated the Eucharist* (Chicago: Liturgy Training Publications, 1991), 110. Because of the danger of spillage of the consecrated wine and because the laity could not see the contents of the chalice, the elevation of the chalice was not on a par with the elevation of the host. They are not made equal until the Missal of Pius V in 1570. In the thirteenth century the elevation of the host is required in the Roman Missal. This requirement is further advanced by its appearance in the missals of both the Franciscan and Dominican Orders. See Miri Rubin, *Corpus Christi: The Eucharist in Late Medieval Culture* (Cambridge: Cambridge University Press, 1991), 55–8.

14 See Canon 840 and its commentary in James Coriden, Thomas Green, and Donald Heintschel, eds., *The Code of Canon Law: Text and Commentary* (New York: Paulist Press, 1985), 606–07. See also Vatican Council II's paragraph 59 of the *Constitution of the Sacred Liturgy* in Walter Abbott, SJ, *The Documents of Vatican II* (New York: The America Press, 1966), 158.

**A Theological Reading of Medieval Eucharistic
Vessels as Emblems of Embrace**
Mary C. Moorman

1   Thomas Aquinas, *Summa Theologiae* I.6.corpus, trans. Fathers
    of the English Dominican Province (New York: Benziger
    Brothers, 1948), 4.

2   "Here one must consider that the contemplation of wisdom
    is suitably compared to play on two counts, each of which is
    to be found in play. First, because play is delightful, and the
    contemplation of wisdom possesses maximum delight.…
    Second, because things done in play are…sought for their
    own sake, and this same trait belongs to the delights of
    Wisdom…(and) the delight of contemplating wisdom has
    within itself the cause of delight." Thomas Aquinas, *Expositio
    libri Boetii De ebdomadibus*, trans. Janice L. Schultz and
    Edward A. Synan (Washington, DC: The Catholic University of
    America Press, 2001), 3–4.

3   Abbot Suger, The *Book of Suger Abbot of St. Denis on What
    Was Done During his Administration* XXXII (1144–48), trans.
    David Burr, Fordham Center for Medieval Studies (1996).
    The full text from which this quotation is drawn states as
    follows: "To me, I confess, it always has seemed right that
    the most expensive things should be used above all for
    the administration of the holy Eucharist. If golden vessels,
    vials and mortars were used to collect 'the blood of goats
    or calves or the red heifer, how much more' should gold
    vases, precious stones and whatever is most valuable among
    created things be set out with continual reverence and full
    devotion 'to receive the blood of Jesus Christ' [Hebrews 9:13f].
    Certainly neither we nor our possessions are fit to perform
    this function. Even if by a new creation our substance should
    be changed into that of the holy cherubim and seraphim it
    would still offer an insufficient and unworthy service for so
    great and ineffable a victim. Nevertheless, we have such a
    great propitiation for our sins. To be sure, those who criticize
    us argue that holy mind, pure heart and faithful intention
    should suffice for this task. These are, we agree, the things that
    matter most; yet we profess that we should also serve God

    with the external ornaments of sacred vessels, in all internal
    purity and in all external nobility, and nowhere is this to be
    done as much as in the service of the holy sacrifice. For it
    is incumbent upon us in every case to serve our redeemer
    in the most fitting way for in all things, without exception,
    he has not refused to provide for us, has united our nature
    with his in a single, admirable individual, and 'setting us on
    his right hand' he has promised 'that we will truly possess
    his kingdom' [Matthew 25:33f.] (available at http://www.
    fordham.edu/halsall/source/sugar.html; accessed April, 2009).

4   Thomas Aquinas, *Summa Theologiae* III.83.3 objection 6.

5   Ibid., objection 4, 2508.

6   Ibid., ad 6, 2510.

7   Thomas Aquinas, *Summa Theologiae* III.83.5 ad 8, 2511.

8   The Catechism of the Catholic Church explains that a
    summary of the Christian faith acts as a token of recognition
    and a sign of communion for the members of the Christian
    community, which finds its fullest expression in the
    communal nature and function of the Eucharist, where the
    sacred vessels are used. The Catechism states: "From the
    beginning, the apostolic Church expressed and handed on
    her faith in brief formulae for all…such syntheses are called
    professions of faith since they summarize the faith that
    Christians profess. They are called 'creeds'…they are also
    called 'symbols of faith.' The Greek word symbolon meant half
    of a broken object, for example, a seal presented as a token of
    recognition. The broken parts were placed together to verify
    the bearer's identity. The symbol of faith, then, is a sign of
    recognition and communion between believers. Symbolon
    also means a gathering, collection, or summary. A symbol of
    faith is a summary of the principal truths of the faith."

9   Kenneth W. Stevenson notes that the verbal exchange of vows
    and demonstrated assent forms the nucleus of the medieval
    nuptial rite in *Nuptial Blessing: A Study of Christian Marriage
    Rites* (New York: Oxford University Press, 1983), 75.

**207**

Notes

10 The nuptial meaning of the Eucharist is emphasized in numerous other early texts, such as the *Prochatechesis* and *Catechesis* of Cyril of Alexandria (378–444), and the *De Mysteriis* and *De Sacramentiis* of Ambrose of Milan (339–397). These Patristic references were echoed in the liturgical poetry and hymnody of Adam of St. Victor (d. 1146). In contemporary theology, the Eucharist is most explicitly connected to the nuptial rite in the papal encyclical *Familiaris Consortio*, wherein the Catholic magisterium proposes that "the Eucharistic Sacrifice, in fact, represents Christ's covenant of love with the Church, sealed with His blood on the Cross. In this sacrifice of the New and Eternal Covenant, Christian spouses encounter the source from which their own marriage covenant flows, is interiorly structured and continuously renewed." (Pope John Paul II, *Familiaris Consortio* 57, November 22, 1981. Rome: Libreria Editrice Vaticana). The idea of a real and conceptual "profound bond" between marriage and the Eucharist has been promulgated in popular preaching by the current Pope Benedict XVI in 2008: "This supreme gesture of love is presented anew in each celebration of the Eucharist; and it is appropriate for the pastoral care of families to refer back to this sacramental fact as a reference point of fundamental importance." (Pope Benedict XVI, Papal Address, Vatican City, May 15, 2008).

11 Augustine, *Confessions* Book 1, trans. Edward B. Pusey (Toronto: Random House Publishing, 1999), 1–10.

12 Rev. A. E. Burn, *The Athanasian Creed: The History, Teaching and Latin and Greek Versions* (London: Rivingtons, 1930), 101–02.

13 By the medieval period, the early Christian understanding of the divine and human embrace in the Eucharist had become so confirmed that even the ninth-century debates between Abbots Radbertus and Ratramnus of Corbie did not dispute the fact that God makes Himself really present to the worshipper in the sacrament of the altar; at issue was merely the degree of Christ's presence. As even the supposedly anti-realist Ratramnus admits in his work *On the Body and Blood of God*, the *invisibilis substantia* of the Eucharist is truly the body and blood of Christ: *vere corpus et sanguis Christi*. (Abbot Ratramnus of Corbie, "De Corpore et Sanguine Domini xlix," in *The book of Bertram the priest : concerning the Body and Blood of Jesus Christ in the sacrament / written in Latin by the command of the Emperour Charles the Great above nine hundred years ago, and first translated into English in 1549* (London: Printed by B. Griffin, 1687).

14 Justin Martyr, *First Apology* 66.1., trans. John Kaye (London: Griffith, Farran, Okeden and Welsh, 1860).

15 "Canons of the Fourth Lateran Council, Canon I.1.3," in *The German Episcopacy and the Implementation of the Decrees of the Fourth Lateran Council, 1216–1245*, ed. Paul B. Prixton (Leiden: Brill Academic Publishers, 1995).

16 Bernard of Clairvaux, Sermon XII, *On the Song of Songs*, vol. 1, trans. Kilian Walsh (Kalamazoo, MI: Cistercian Publications, 1971), 77–87.

17 Bernard of Clairvaux, Sermon LII, *On the Song of Songs*, vol. 3, trans. Kilian Walsh (Kalamazoo, MI: Cistercian Publications, 1979), 49–58.

18 Konrad von Eberbach, *Exordium Magnum Cisterciense*, Dist. II. Cap 7, Ad codicum fidem recensuit Bruno Griesser, Series Scriptorum S. Ordinis Cisterciensis, vol. 2 (Rome: Editiones Cistercienses, 1961).

19 *Manuele Augustini* 23, PL 40, 951–68. Quoted in "In the Embrace of Christ (Amplexus Christi)," workshop prepared at the conference "Medieval Rituals IV: Transformations of Discourse," arranged by the Danish National Research Foundation and Centre for the Study of the Cultural Heritage of Medieval Rituals, Copenhagen, 14–17 June 2007 (available at http://ritualcenter.net/conf2007/amplexus.php; accessed April, 2009.) I am indebted to the conference proceedings for many of the images and ideas presented here.

20 Catherine of Siena, *Letter no. 165 to Bartolomea, wife of Salviato of Lucca*, ed. The Focolari Society, in the Vatican Digital Library,

http://www.vatican.va/spirit/documents/spirit_20010814_
caterina-siena_en.html (accessed April, 2009).

21  Bonaventure, *Sententiarum Libri* Book IV, Distinction I,
Part I, Article I, Question 1: conclusion (Nuremberg: Anton
Koberger, 1491).

22  Albertus Magnus, *Commentary on the Sentences* Book III, Dist 36,
Article 2 ad 2.

23  Ibid.

24  Valerius Herberger, *The Crux Christi*, Leipzig 1618. Quoted in
"In the Embrace of Christ (Amplexus Christi)" (available at
http://ritualcenter.net/conf2007/amplexus.php; accessed
April, 2009.).

25  Johann Sebastian Bach, *Matthäuspassion* (1727), libretto
compiled by C. F. Henrici: No. 60, "Sehet, Jesus hat die Hand."

26  Duns Scotus, "The Love of God, Self, and Neighbor," in *On the Will
and Morality* Part VII, trans. Allan Bernard Wolter (Washington,
DC: Catholic University of America Press, 1998), 89–97.

27  Fr. Henry Beck, OFM, quoted in Mary Beth Ingham, CSJ, *Scotus
for Dunces: An Introduction to the Subtle Doctor* (St. Bonaventure,
NY: Franciscan Institute Publications, 2003), 125 n. 3.

## Arms and Armor: a Farewell to Persistent Myths and Misconceptions

Dirk H. Breiding

1 Rick Fields, *The Code of the Warrior in History, Myth, and Everyday Life* (New York: HarperCollins, 1991), cited on the book's back cover.

2 Ortwin Gamber, 'Die Bewaffnung der Stauferzeit', *Die Zeit der Staufer: Geschichte—Kunst—Kultur*, vol. 3 (Stuttgart: Württembergisches Landesmuseum, 1977), 114.

3 Examples from the first group are Old Testament accounts of Judas Maccabeus (1 Maccabees) or texts dealing with Christ as the "lover knight," while the genre of the *Uomini Famosi* or Nine Worthies in literature and the visual arts usually encompassed Biblical and historical figures such as Caesar or Charlemagne. Among mythological subject matter that featured prominently in chivalric literature are the Aeneid, the story of Jason and the Argonauts, or the Labors of Hercules.

4 The literature on these aspects of chivalry is too numerous to even list a survey here; still considered standard works among the wealth of publications dealing entirely or at least in part with these particular problems are Joachim Bumke, *Studien zum Ritterbegriff im 12. und 13. Jahrhundert, Beihefte zum Euphorion*, vol. 1, *Zeitschrift für Literaturgeschichte* (Heidelberg: C. Winter, 1977); Joachim Bumke, *Höfische Kultur*, 2 vols. (Munich: Deutscher Taschenbuch Verlag, 1986); Georges Duby, *Le Temps des cathédrales: L'Art et la société (980–1420)* (Paris: Gallimard, 1976); Georges Duby, *Les Trois Ordres, ou L'imaginaire du féodalisme* (Paris: Gallimard, 1978); Maurice Keen, *Chivalry* (New Haven, CT: Yale University Press, 1986); and Erich Köhler, *Ideal und Wirklichkeit in der höfischen Epik* (Tübingen: Niemeyer, 1970).

5 A recent exception is an exhibition catalogue for Allentown Art Museum, *Knights in Shining Armor: Myth and Reality, 1450–1650*, ed. Ida Sinkeviç (Piermont, NH: Bunker Hill Publishing, 2006).

6 One of the earliest instances I was able to find, at least for the use of the phrase "shining armour" in a literary context, is its appearance in John Dryden's translation of Virgil's *Æneid*, first published in 1697. One of the earliest uses of the entire phrase from the nineteenth century appears to be in the poem "The Ancient Ballad of Prince Baldwin" in Thomas Rodd, *The History of Charles the Great and Orlando* (London, 1812), 46: "Many a Knight in shining armour / Shews his dauntless prowess there."

7 This list, although by no means comprehensive, is a Thematic Page entitled "Arms and Armor—Common Misconceptions and Frequently Asked Questions." It can be found on the *Heilbrunn Timeline of Art History*, a sub-site of the main museum's website (www.metmuseum.org/toah/hd/aams/hd_aams.htm). All misconception-related explanations in the article's main text, although occasionally updated, edited, and/or summarized, are either directly quoted or at least based on my research for this Thematic Page.

8 Unfortunately, even the official German equivalent to the *Oxford English Dictionary*, the *Duden* dictionary, defines the term incorrectly: "Ritterrüstung, die: von Rittern getragene Rüstung" (= "armor worn by knights"); and to make matters worse, the same word "Ritterrüstung" is also given as the first definition or alternative for the correct term "Harnisch"! See *Duden: Deutsches Universalwörterbuch*, 6th edition (Mannheim, F. A. Brockhaus, 2007) (accessed online at www.duden.de on January 6, 2009).

9 Although falling prey to similar unsubstantiated assumptions, Rainer Schoch's relevant catalogue entry (no. 131) in *Gothic and Renaissance Art in Nuremberg, 1300-1550* (catalogue to the exhibition, jointly organized by the Metropolitan Museum of Art, New York, and the Germanisches Nationalmuseum, Nuremberg) (Munich: Prestel-Verlag, 1986), 310–11, still gives a good description and summary of the major arguments (including further literature). More recently see the brief discussion in Ida Sinkeviç, ed., *Knights in Shining Armor*, 68–69

10 Schoch (see note 9 above) characterizes the armor as "splendid" and the "knight" as "idealized," while the entire equipment is called "outmoded" by A. V. B. Norman, "Albrecht Dürer: Armour and Weapons," *Apollo* 94 (July 1971): 37.

While the last term is not entirely wrong, it is nonetheless slightly misleading. Certainly, the armor is practically identical with that in his earlier watercolor sketch of 1498 (today in the Graphische Sammlung Albertina, Vienna, inv. no. W. 176), and some characteristics of the decoration, the form of the knee-defence, and the type of helmet are indeed late fifteenth- or turn-of-the-century in style. But the armor, although not in the very latest fashion, is not as such untypical for the first decade of the sixteenth century. After all, not every man-at-arms could be expected to acquire an entire new outfit with every change in style and fashion, which occurred around every five or ten years. Likewise, one look at today's streets will confirm that not every car to be seen was built within the last twelve months.

11 Rudolf Endres, "Turniere und Gesellenstechen in Nürnberg" in Helmut Bräuer and Elke Schlenkrich, eds., *Die Stadt als Kommunikationsraum: Beiträge zur Stadtgeschichte vom Mittelalter bis ins 20. Jahrhundert* (Leipzig: Leipziger Universitätsverlag, 2001), 263–80.

12 A similar stained-glass panel, dating from the late sixteenth century but depicting armor clearly reminiscent of mid-fifteenth-century style, shows the citizens of Basle, fully armed on foot and horseback, leaving their city to go on campaign; see C. H. Baer, *Die Kunstdenkmäler des Kantons Basel-Stadt*, vol. 1 (Basel: Birkhauser Verlag, 1932), fig. 166 (before p. 248).

13 A somewhat more reliable indication that a person is probably a knight, regardless of whether he is shown wearing armor or not, is the attribute of golden spurs.

14 For discussion of the definition of this term see the literature quoted in note 4 above.

15 See the Time Line of Art History's Thematic Essay on "Arms and Armor—Common Misconceptions and Frequently Asked Questions" (www.metmuseum.org/toah/hd/aams/hd_aams. htm) for a brief discussion on the question of women in armor or partaking in warfare.

16 Although attempts to clear up doubts about the weight of armor go back to the early twentieth century (Charles John ffoulkes, *The Armourer and His Craft*, London: Methuen, 1912), the best summary is found in the relevant chapter of Claude Blair's *European Armour, ca. 1066–ca. 1700* (London: Batsford, 1958, reprinted 1972), which is still the standard work on the subject.

17 Use of the term "suit-of-armor," although strictly speaking not entirely wrong, should also be avoided since it implies that all the pieces were made together or belonged together. While some rich clients did indeed have entire armors made by one master or workshop, there is also ample documentary evidence that some people, even noblemen, often purchased individual elements of armor (and probably mixed and matched depending on specific requirements of a given situation).

18 Denis Lalande, *Jean II le Meingre, dit Boucicaut (1366–1421): Étude d'une biographie héroïque* (Geneva: Librairie Droz, 1988), 13.

19 For an example of medieval attitudes toward men in helpless situations or at the mercy of others (especially women), see the medieval legend of Virgil. Several different versions relate the story how the Roman poet attained the amorous promise of the emperor's daughter to meet him at night. When she hauls Virgil up the palace wall in a basket at night, she leaves him suspended in mid-air, since he had been boasting about his imminent conquest. The following morning, the helpless poet is exposed to the ridicule of the Roman populace. See Dione Flühler-Kreis, 'Die Bilder: Spiegel mittelalterlichen Lebens?', *edele frouwen—schoene man: Die Manessische Liederhandschrift in Zürich*. ed. C. Brinker and D. Flühler-Kreis (Zurich: Schweizerisches Landesmuseum, 1991), 68–69; and Friedrich Maurer, "Der Topos von den 'Minnesklaven': Zur Geschichte einer thematischen Gemeinschaft zwischen bildender Kunst und Dichtung im Mittelalter," *Deutsche Vierteljahresschrift für Literaturwissenschaft und Geistesgeschichte* 27 (1953): 182–206.

20 No mention of a crane is made in Twain's book, although in chapter XI ("The Yankee in search of adventures") the protagonist describes that after putting on his armor, "[t]hey carry you out, just as they carry a sun-struck man to the drug store, and put you on [the horse], and help get you to rights, and fix your feet in the stirrups; and all the while you do feel so strange and stuffy and like somebody else—like somebody that has been married on a sudden, or struck by lightning, or something like that, and hasn't quite fetched around yet, and is sort of numb, and can't just get his bearings."

21 I am grateful to my friend and colleague, Tobias Capwell, Curator of Arms and Armour at The Wallace Collection, London, for allowing me to use his original research (personal communication, October 2003). This paragraph, although based on Dr. Capwell's findings, is a summary of both our investigations into the origins of this misconception, and in its updated form is here put into print for the first time. However, in which production(s) a crane was actually used is still not certain. For a comprehensive history of the play see www.robertbuchanan.co.uk/html/knights.html (I am grateful to David Rose for providing this reference, the existence of which was unknown to me; email communication, April 2009).

22 For information on the *When Knights Were Bold* movies—a silent version was made in the USA in 1914, and a British one in 1936—see www.robertbuchanan.co.uk/html/knights2.html (accessed April 16, 2009); as well as www.imdb.com/title/tt1265707 and http://movies.nytimes.com/movie/54144/When-Knights-Were-Bold/overview, respectively (both accessed February 10, 2009). I have been unable to find information about a 1921 silent movie of *A Connecticut Yankee*; for information on a 1931 version see www.imdb.com/title/tt0021759/ (accessed April 16, 2009).

23 The exact title of Olivier's movie (in fact the original title of Shakespeare's play) is: *The Chronicle History of King Henry the Fift with his Battell Fought at Agincourt in France* (United Artists); the infamous scene is part of Act IV, Scene III.

24 In a passage from Chaucer's *Tale of Sir Thopas*, the protagonist is described as *climbing* into his saddle (instead of jumping or leaping). Such rare historical instances like the description of a fumbling Sir Thopas were undoubtedly intended as a parody and joke. See the discussion of this scene in Steven H. Gale, ed., *Encyclopedia of British Humorists*, vol. 1 (New York and London: Routledge, 1996), 233.

25 While some of the History Channel's earlier programs, as well as some of their web pages, are at least acceptable, content quality and research appear to have markedly declined in recent years. Among the worst examples of History Channel (mis)information was an episode of the "hit series" *Mail Call*. During one part of the program, the viewer was taken "back in time to the 1580s" and had host Gunnery Sergeant R. Lee Ermey explain "the different components of medieval [*sic*!] armor." Apart from the fact that no historian would ever classify the 1580s as "medieval," the program used an entirely inaccurate reproduction armor (which was based, by some stretch of the imagination, on armor of the late fifteenth *not* the late sixteenth century). Mr. Ermey appeared to have absolutely no knowledge of his subject but nonetheless pontificated about the armor's incredible weight and the wearer's impaired vision. The video clip is accessible at http://www.history.com/video.do?name=militaryhistory& bcpid=1681694250&bclid=1683773499&bctid=1641204080 (accessed January 13, 2009). The channel's new series *Warriors* appears to be only marginally better: although none of the "medieval" episodes had aired by the time this article was written, the program's website features one page about the "English knight" with a content so generalized that it can hardly be called historically correct; see http://www.history.com/content/warriors/warrior-cultures/english-knights (accessed March 20, 2009). Spike TV's most recent enterprise, *Deadliest Warrior*, an obvious competition that is scheduled to air throughout the spring and summer of 2009, appears to

abandon any historical accuracy in favor of such bloodthirsty sensationalism that it is not worthy of discussion here.

26 Depending on numerous factors (type of statistic, demographics, time of year, etc.), the galleries of the Department of Arms and Armor are frequently among the five or even three most popular departments (together with Egyptian Art, and European Paintings); information provided by the museum's Department of Visitor Services and the Security Department, respectively (January 2009).

27 One of the best coffee-table books on arms and armor, originally published in German, English, French and Italian, is long out of print (but still frequently available second-hand on the internet): B. Thomas, O. Gamber and H. Schedelmann, *Die schönsten Waffen und Rüstungen aus europäischen und amerikanischen Sammlungen* (Heidelberg: Keysersche Verlagshandlung, 1963). A few years ago, an author, a designer and a photographer demonstrated what happens when such a task is undertaken by people who possess absolutely no knowledge or understanding of their subject or its historical background. The lavishly produced book was published in a German edition: Landesmuseum Joanneum, Graz. ed., *Welt aus Eisen: Waffen und Rüstungen aus dem Zeughaus Graz* (Vienna, Springer-Verlag: 1998); and in an English translation carrying the unfortunate title *Shiny Shapes* [*sic*!]. The text of this regrettable book, a mixture of philosophical musings, attempts at poetry, and political correctness, is so full of misconceptions, misleading generalizations, and serious historical inaccuracies that it would require its own review to list them all. It is inconceivable that this book was published by a museum and lauded by that institution's director as exemplary "for all future publications of the Landesmuseum Joanneum"! A gleam of hope, on the other hand, is presented by the latest publications in this genre, both by Carlo Paggiarino, *The Churburg Armoury* (Milan: Hans Prunner, 2006) and *The Wallace Collection* (Milan: Hans Prunner, 2008).

The only minor criticism, which especially applies to *The Churburg Armoury*, is that often only close-ups and details are shown, but no, or few, views of the entire objects; this, however, is not the case in the later book.

28 Tobias Capwell, *The Real Fighting Stuff: Arms and Armour at Glasgow Museums* (Glasgow: Glasgow City Council (Museums), 2007); see also the detailed review by D. Breiding, "T. Capwell, The Real Fighting Stuff: Arms and Armour at Glasgow Museums," *Waffen- und Kostümkunde* 50:2 (2008), 76–80.

29 Helga Bartmann and Peter W. Sattler, *Schloss Erbach: Ein Führer durch die Residenz und ihre gräfliche Sammlungen* (Schwetzingen: K. F. Schimper-Verlag, 2000).

30 This book by Chuck Wills appears to have been published simultaneously under two similar titles: *The Illustrated History of Weaponry: From Flint Axes to Automatic Weapons*, and *Weaponry: An Illustrated History* (both Irvington, NY: Hylas Publishing, 2006); it was also translated into German as *Die illustrierte Geschichte der Waffen: Von Der Steinaxt zum Maschinengewehr* (Munich: Bassermann-Verlag, 2007).

31 In North America, important collections of arms and armor are to be found in the following institutions: the Metropolitan Museum of Art in New York, the Philadelphia Museum of Art, the Art Institute of Chicago, the Higgins Armory Museum in Worcester, Massachusetts, the Cleveland Museum of Art, and the Detroit Institute of Arts.

32 It is not uncommon for members of the public, as well as colleagues from other fields of art-historical study, when given a genuine element of armor or a weapon, to ask whether it is a fake, "because it is so light." A few years ago, a visitor informed the department indignantly that all arms and armor gallery labels listing the material 'steel' were "wrong" since "steel was not invented until the nineteenth century," concluding that "none of the armor or early firearms could therefore be made from steel." He was probably referring to the Bessemer process for the mass-production of steel on an

industrial scale (developed simultaneously in Europe and the USA between 1851 and 1855), and quite unaware that the non-industrial production of steel in its various forms has a history stretching back more than 3,000 years.

33 These and all consequent definitions in this passage are quoted after the online version of the *Oxford English Dictionary* (*OED*), found at www.oed.com (last accessed through the Metropolitan Museum's online resources on March 1, 2009). According to the *OED*, "arms" is the plural word for the "defensive and offensive outfit for war, things used in fighting," or more specifically, "instruments of offence used in war; weapons." "Armour" is defined as "military equipment or accoutrement, both offensive and defensive, in the widest sense; the whole apparatus of war," or again more specifically, as "defensive covering worn by one who is fighting." In modern times, the definition of "armor" has been extended to encompass armored vehicles as a group, especially in the case of cars and tanks, and the defensive plating of any vehicle such as ships, cars, and planes. On the other hand, "armament" is in fact "a force military or [more usually] naval, equipped for war," sometimes also including "equipment or apparatus for resistance or action of any kind" and "the process of equipping for purposes of war"; while an "armory" by its modern definition refers either to "a place where arms are kept, an arsenal" or, more specifically in US-English, to "the workshop of an armourer; a place where arms are manufactured." In earlier periods the word "armo[u]ry" was in fact used as an all-encompassing term for "arms and armor" or as "armor collectively." Even used in this outdated definition, however, its use in the expression "arms and armory" would be grammatically incorrect, a pleonasm. Just to prevent any possible speculation: the Metropolitan Museum's Department of Arms and Armor has never intended, is not currently, nor is it likely to collect in the future entire fleets or buildings.

34 The *armet* is a certain type of helmet while *couters* and *poleyns* refer to elbow and knee defenses respectively.

35 *Haute-pieces* are upturned flanges or separate plates of the shoulder defense(s) that lend additional protection for the neck; *volant* pieces are elements of a particular type of jousting armor, which are attached to the main armor in such a way that they fly off when properly struck by the opponent's lance.

36 This is a combination of two separate quotes, "[l]ife is infinitely stranger than anything which the mind of man could invent" and "no ghosts need apply," originally found in Sir Arthur Conan Doyle's short stories 'A Case of Identity' (1891) and 'The Adventure of the Sussex Vampire' (1924), respectively; quoted after Arthur Conan Doyle, *The New Annotated Sherlock Holmes*, ed. Leslie S. Klinger (New York: W. W. Norton & Company, 2005), vol. 1, p. 74 ('A Case of Identity') and vol. 2, p. 1558 ('The Adventure of the Sussex Vampire').

**The Cure of Perfection: Women's Obstetrics
in Early and Medieval Islam**
Kathryn Kueny

1  al-Jahiz, *Chance or Creation? God's Design in the Universe*, trans. M. A. S. Abdel Haleem (Reading, Berkshire: Garnet Publishing Limited, 1995), 76.

2  Ibid., 72.

3  Ibid., 80.

4  Ibid., 81.

5  The name "al-Jahiz" itself means "pop-eyed," which suggests Jahiz suffered from a severe form of eye disease.

6  See Suras 13:8; 31:34; 35:11; 19:6; 41:47.

7  Sura 23:12-14. See also Sura 22:5.

8  Good food, as well as intoxicants, are mentioned as God's "signs" (*ayat*) in Sura 16:67.

9  Sura 4:162. Belief in "God and the last day" are the core beliefs that unify all monotheists, according to the Qur'an. For example, Sura 2:62 states, "Believers, Jews, Christians, and Sabaeans, whoever believes in God and the Last Day and does what is right, shall be rewarded by their God."

10  Sura 81:89.

11  *Kitab khalq al-janin wa-tadbir al-habala wa-'l-mawludin*, ed. Nur al-Din 'Abd al-Qadir wa-Hanri Jahiyah (Algeria: Maktabat Farraris, 1956), 9.

12  Muhammad ibn Abi Bakr ibn Qayyim al-Jawziya, *al-Tibyan fi aqsam al-Qur'an*, Tab`ah 1 (Beirut: Mu'assasat al-Risalah, 1994), 304.

13  Jahiz, 89. See also 'Arib ibn Sa`d, who suggests the cervix is designed in such a way as to "embrace" the penis (13).

14  Abu Hamid al-Ghazali, *Marriage and Sexuality in Islam: a Translation of al-Ghazali's Book on the Etiquette of Marriage from the Ihya' 'ulum al-din*, trans. Madelain Farah (Salt Lake City: University of Utah Press, 1984), 53.

15  'Ali ibn Sahl Rabban al-Tabari notes that the maleness of an embryo becomes evident in thirty days, while the femaleness of an embryo only becomes evident after forty-two days. This is due to the fact that the seed that makes the male is stronger and hotter from that which creates the female (*Firdaws al-hikma fi 'l-tibb* [Beirut, 1970], 30).

16  'Arib ibn Sa`d, 18-19. According to Ibn Sa`d, if you burn frankincense underneath a woman's legs, and the scent of the incense wafts from her nostrils, then she is pregnant, for all the channels of the womb are open as a result of the impregnation.

17  Ibn Sa`d, 19.

18  Jalal al-Din 'Abd 'l-Rahman al-Suyuti, *As-Suyuti's Medicine of the Prophet (Tibb al-nabi)* (London: Ta-Ha Publishers Ltd., 1994), 19.

19  Rabban al-Tabari, 38.

20  Ibid., 39.

21  *Zad al-musafir wa-qut al-hadir* (Provisions for the traveller and the nourishment of the sedentary), Book 6, trans. and ed. Gerrit Bos as *Ibn al-Jazzar on Sexual Diseases and their Treatment* (London and New York: Kegan Paul International, 1997), 289.

22  Ibn Jazzar suggests certain types of food will produce more sperm in a man, such as chickpeas, beans mixed with something that adds warmth, moist meat, egg yolks, figs, pine nuts, and peppercorns (243).

23  Ibn Sa`d, 15. There is also some discussion here, too, about limiting the times a man masturbates. Too much masturbation results in decreased seed production during intercourse.

24  Rabban al-Tabari, 36.

25  Ibid., 35.

26  The Qur'an simply prohibits the consumption of pork, and does not provide any justification for its stance. Later tradition suggests the pig is a lazy, disgusting animal that consumes its own feces and thereby corrupts the health and well-being of those who ingest it. While not prohibited in the Qur'an, the keeping of dogs in the house as pets is condemned in the hadith. Dogs, like pigs, are carriers of disease, and may frighten away guests.

27  Abu 'Abdallah Muhammad b. Isma'il b. Ibrahim al-Bukhari, in *Sahih al-Bukhari* vol. 5 (al-Tab`ah 1 ed. [Cairo, 1990]), nos. 164, 165.

216

28 Ibid., no. 168. See also Ahmad ibn 'Ali ibn Hajar al-'Asqalani, *Kitab al-isbaha fi tamyiz al-sahabah*, vol. 4 (Calcutta, 1873), 541; Ahmad ibn Hanbal, *Musnad*, vol. 6 (Cairo, 1895–96), 117ff, 154.

29 Sura 66:5, which states, "It may be, if he divorced you two, that God will give him in exchange consorts better than you, who submit (their wills), who believe, who are devout, who turn to God in repentance, who worship, who travel and fast, previously married or virgins."

30 Bukhari, vol. 5, no. 166. In this and other examples, the Prophet often elevated Khadija (and later Mariya the Copt, with whom he bore a son, Ibrahim) over and above the rest of his wives for their ability to bear children.

31 Sura 37:100–101; Sura 19:5.

32 Ibn 'Arabi (Muhyi 'l-Din), *Tafsir al-qurian al-karim*, ed. Mustafa Ghalib, vol. 1 (Beirut: al-Andalus, 1978), 180 (commentary on Sura 3:35).

33 Ghazali, 107.

34 Suyuti, 10.

35 *The Zoological Section of the Nuzhatu-l-qulub of Hamdullah al-Mustawfi al-Qazwini*, ed. Lieut. Colonel J. Stephenson (London: Royal Asiatic Society, 1928), 48.

36 Ibid.

37 Ibid., 54.

38 Ibid., 50.

39 For a summary of the practice of *tahnik*, see Muslim ibn al-Hajjaj al-Qushayri, *Sahih Muslim*, "Kitab al-adab" (al-Tab`ah 1 ed. [Beirut: Dar al-Kutub al-'Ilmiyah, 1994]), nos. 5340, 5341. Muslim also records traditions that suggest the first thing to put in a child's mouth is the prophet Muhammad's saliva (ibid., nos. 5344, 5347).

40 Rashid al-Din ibn Shahrashub, *Manaqib Al Abi Talib* (Najaf: Haydariyyah Press, 1965), 207, 209.

41 Abu Dawud Sulayman ibn al-Ash`ath al-Sijistani, "Kitab al-nikah," in *Sunan Abi Dawud*, ed. Muhammad Muhyi 'l-Din `Abd al-Hamid (Cairo: Matba`at Mustafa Muhammad, 1935),

no. 2166; A. J. Wensinck, *Hand Book of Early Muhammadan Tradition* (Leiden: E. J. Brill, 1960), 112.

42 Jahiz, 90.

43 Ibn Jazzar, 290.

44 Ibid., 291.

45 Ibid., 292.

46 Ibid., 290.

47 Ibid., 291.

48 Muhammad ibn Musa al-Damiri, *Hayat al-hayawan*, vol. (Cairo, 1901), 207–8.

49 Ibid., 157.

50 Ibid., vol. 2, 189.

51 Ibid., vol. 1, 34.

52 Ibid., 60.

53 Ibid., 57–58.

54 Ibid., 214

55 Ibid., 591.

56 Clearly many of the practices mentioned by Damiri were intended for women (or men) to cast spells over other women. For example, Damiri records, "If a woman be given to drink without her knowledge, the organ of generation of a male hyena ground fine, it will take away from the desire for sexual intercourse" (ibid., 644).

57 Bukhari, vol. 1, no. 101; vol. 2, nos. 340, 341, 342, 463.

# Suggestions for Further Reading

Alexander, Jonathan J. G. *Medieval Illuminators and their Methods of Work.* New Haven, CT: Yale University Press, 1992.

Barnet, Peter and Nancy Wu. *The Cloisters: Medieval Art and Architecture.* New York: The Metropolitan Museum of Art, 2005.

Bernard of Clairvaux. *Selected Works.* Translated by G. R. Evans. New York: Paulist Press, 1987.

Brown, Michelle. *Understanding Illuminated Manuscripts: A Guide to Technical Terms.* Malibu, CA: J. Paul Getty Museum, 1994.

Brownrigg, Linda L., and Margaret M. Smith, eds. *Interpreting and Collecting Fragments of Medieval Books.* Los Altos Hills, CA: Anderson-Lovelace, 2000.

Cahill, Thomas. *Mysteries of the Middle Ages: The Rise of Feminism, Science, and Art from the Cults of Catholic Europe.* New York: Nan A. Talese/Doubleday, 2006.

Carruthers, Mary. *The Book of Memory: A Study of Memory in Medieval Culture.* Cambridge: Cambridge University Press, 1990.

Constable, Giles. "A Living Past: The Historical Environment of the Middle Ages," *Harvard Library Bulletin* n.s. 1/3 (1990): 49–70.

Dale, Thomas E. A. "Monsters, Corporeal Deformities, and Phantasms in the Cloister of St-Michel-de-Cuxa," *The Art Bulletin* 83, no. 3 (2001): 402–36.

De Hamel, Christopher. *Medieval Craftsmen: Scribes and Illuminators.* Toronto: University of Toronto Press, 1992.

Despres, Denise. *Ghostly Sights: Visual Meditation in Late-Medieval Literature.* Norman, OK: Pilgrim Books, 1989.

Diebold, William. *Word and Image: An Introduction to Early Medieval Art.* Boulder, CO: Westview Press, 2000.

Eco, Umberto. "The Return of the Middle Ages," in *Travels in Hyperreality.* San Diego, New York and London: Harcourt, Inc., 1986, 59–85.

Foley, Edward. *From Age to Age: How Christians Celebrated the Eucharist.* Chicago: Liturgy Training Publications, 1991.

Frisch, Teresa G. *Gothic Art, 1140–c1450: Sources and Documents.* Toronto: University of Toronto Press, 1987.

Gaybba, B. P. *Aspects of the Medieval History of Theology: Twelfth to Fourteenth Centuries.* Pretoria: University of South Africa, 1988.

Geary, Patrick J. *Furta Sacra: Thefts of Relics in the Central Middle Ages.* Princeton: Princeton University Press, 1990.

Gilchrist, Roberta. *Contemplation and Action: The Other Monasticism.* New York: Leicester University Press, 1995.

*Good News Bible with Deuterocanonicals/Apocrypha*, Today's English Version. New York: American Bible Society, 1992.

Grabar, André. *Christian Iconography A Study of Its Origins.* Princeton: Princeton University Press, 1980.

Hamburger, Jeffrey F., and Anne-Marie Bouché, eds. *The Mind's Eye: Art and Theological Argument in the Middle Ages.* Princeton: Princeton University Press, 2006.

Hamburger, Jeffrey. *The Visual and the Visionary: Art and Medieval Spirituality in Late Medieval Germany.* New York: Zone Books, 1998.

Holt, Elizabeth Gilmore. *A Documentary History of Art,* vol. 1, *The Middle Ages and Renaissance.* Princeton: Princeton University Press, 1981.

Hourihane, Colum, ed. *Image and Belief: Studies in Celebration of the Eightieth Anniversary of the Index of Christian Art.* Princeton: Princeton University and Princeton University Press, 1999.

Jacobus de Voragine. *The Golden Legend Readings on the Saints,* translated and edited by William Granger Ryan, 2 vols. Princeton: Princeton University Press, 1993.

Kessler, Herbert L. "On the State of Medieval Art History," *The Art Bulletin* 70, no. 2 (June 1988): 166–87.

—. *Seeing Medieval Art (Rethinking the Middle Ages).* Peterborough, ON, Canada: Broadview Press, 2004.

Kinder, Terryll N., ed. *Perspectives for an Architecture of Solitude: Essays on Cistercians, Art and Architecture in Honor of Peter Fergusson.* Turnhout, Belgium: Brepols, 2004.

LaRocca, Donald J. *The Gods of War: Sacred Imagery and the Decoration of Arms and Armor*. New York: Metropolitan Museum of Art, 1996.

Lawrence, C. H. *Medieval Monasticism: Forms of Religious Life in Western Europe in the Middle Ages*, 2nd ed. New York: Longman, 1990.

Macy, Gary. *Treasures from the Storeroom: Medieval Religion and the Eucharist*. Collegeville, MN: Liturgical Press, 1999.

Mâle, Emile. *The Gothic Image: Religious Art in France of the Thirteenth Century*. New York: Harper & Row Publishers, 1972.

McNamara, Jo Ann. *The Ordeal of Community: The Rule of Donatus of Besançon; The Rule of a Certain Father to the Virgins*, translated by Jo Ann McNamara and John E. Halborg. Toronto: Peregrina Publishing Co., 1993.

Mazza, Enrico. *The Celebration of the Eucharist: The Origin of the Rite and the Development of Its Interpretation*. Collegeville, MN: Liturgical Press, 1999.

Merrifield, Mrs. Mary P. *Medieval and Renaissance Treatises on the Arts of Painting, Original Texts with English Translations*. Two volumes bound as one. New York: Dover Publications, 1967.

Nickel, Helmut, Stuart W. Pyhrr, and Leonid Tarassuk. *The Art of Chivalry: European Arms & Armor from the Metropolitan Museum of Art*. New York: Metropolitan Museum of Art, 1982.

Oakeshott, R. Ewart. *The Sword in the Age of Chivalry*. Woodbridge: Boydell Press, 2002. First published 1964 by Boydell Press.

Ozment, Steven. *The Age of Reform, 1250–1550: An Intellectual and Religious History of Late Medieval and Reformation Europe*. New Haven, CT: Yale University Press, 1980.

Palazzo, Eric. *A History of Liturgical Books from the Beginning to the Thirteenth Century*. Collegeville, MN: Liturgical Press, 1998.

Panofsky, Erwin. *Abbot Suger on the Abbey Church of St.-Denis and its Art Treasures*, 2nd edition by Gerda Panofsky-Soergel. Princeton: Princeton University Press, 1979.

Pfaffenbichler, Matthias. *Medieval Craftsmen: Armourers*. Toronto and Buffalo: University of Toronto Press, 1992.

Rivard, Derek. *Blessing the World: Ritual and Lay Piety in Medieval Religion*. Washington, DC: Catholic University of America Press, 2008.

Ross, James Bruce, and Mary Martin McLaughlin. *The Portable Medieval Reader: The Astonishing World of the Middle Ages brought to life for the modern reader through a rich variety of writings from four centuries*. New York: The Viking Press, 1949.

Rubin, Miri. *Corpus Christi: The Eucharist in Late Medieval Culture*. Cambridge: Cambridge University Press, 1991.

Rudolph, Conrad. *"The 'Things of Greater Importance," Bernard of Clairvaux's Apologia and the Medieval Attitude toward Art*. Philadelphia: University of Pennsylvania Press, 1990.

*The Rule of St. Benedict*, translated with introduction and notes by Anthony Meisel and M. L. del Mastro. New York: Doubleday, 1975.

Sears, Elizabeth, and Thelma K. Thomas, eds. *Reading Medieval Images: The Art Historian and the Object*. Ann Arbor, MI: University of Michigan Press, 2002.

Stoddard, Whitney. *Art and Architecture in Medieval France*. New York: Harper & Row Publishers, 1972.

Stokstand, Marilyn. *Medieval Art*. New York: Harper and Row Publishers, 1986.

Swanson, R. N. *Religion and Devotion in Europe, c. 1215–c. 1515*. Cambridge: Cambridge University Press, 1995.

Theophilus. *On Divers Arts: The Foremost Medieval Treatise on Painting, Glassmaking and Metalwork*, translated from the Latin with Introduction and notes by John G. Hawthorne and Cyril Stanley Smith. New York: Dover Publications, Inc., 1979.

Tierney, Brian. *The Middle Ages*, vol. 1: *Sources of Medieval History*, 6th ed. New York: McGraw-Hill College, 1999.

—. *The Middle Ages*, vol. 2: *Readings in Medieval History*, 5th ed. New York: McGraw-Hill College, 1999.

# Contributors

**Dirk H. Breiding** is an assistant curator in the Department of Arms and Armor at The Metropolitan Museum of Art. Mr. Breiding earned his MA in the History of Art at University College in London. He is the author of several articles and catalog entries on the subject of medieval and Renaissance armor and effigies including "Dynastic Unity: Fourteenth Century Military Effigies in the Chapel of Castle Kronberg" (2001) and "The Crossbow of Count Ulrich V von Württemberg —A Reassessment" to be published in the *Metropolitan Museum of Art Journal*. Mr. Breiding has also contributed extensively to the Metropolitan Museum of Art's online resource the *Heilbrunn Timeline of Art History.*

**Thomas Cahill** is the author of the best-selling series *The Hinges of History*®, a prospective seven-volume series (including so far the volumes *How the Irish Saved Civilization; The Gifts of the Jews; Desire of the Everlasting Hills; Sailing the Wine-Dark Sea;* and most recently *Mysteries of the Middle Ages*) in which the author endeavors to retell the story of the Western world through little-known stories of individuals who had pivotal impacts on history and contributed immensely to Western culture and the evolution of Western sensibility, thus revealing how we have become the people we are and why we think and feel the way we do today. Mr. Cahill has taught at Queens College, Fordham University, and Seton Hall University, served as the North American education correspondent for *The Times* of London, and was for many years a regular contributor to the *Los Angeles Times Book Review.* Prior to retiring to write full-time, he was director of Religious Publishing at Doubleday.

**Margot Fassler** is Robert S. Tangeman Professor of Music History and Liturgy, Yale University (her appointment includes the Institute of Sacred Music, the Yale School of Music, the Divinity School and the Department of Music). She earned her PhD in Medieval Studies with a specialization in music history from Cornell University. Professor Fassler's numerous publications include: *Making History: The Liturgical Framework of Time and the Virgin of Chartres* (Yale, forthcoming 2009); *Psalms in Community: Jewish and Christian Textual, Liturgical, and Artistic Traditions* (2nd printing 2007, ed., with Harold Attridge); *Musicians for the Churches: Reflections on Formation and Vocation* (ed., 2001); *The Divine Office in the Latin Middle Ages: Methodology and Source Studies* (ed., with Rebecca Baltzer, Oxford, 2000); and *Gothic Song: Victorine Sequences and Augustinian Reform in Twelfth-Century Pari*s (Cambridge, 1997) for which she won the John Nicholas Brown Prize from the Medieval Academy of America and the Otto Kinkeldey Prize of the American Musicological Society.

**Ena Giurescu Heller** is executive director, Museum of Biblical Art (MOBIA), New York City. Dr. Heller earned her PhD in Art History from the Institute of Fine Arts, New York University, with a specialty in medieval art and architecture. Prior to becoming the first director of MOBIA, she has taught art history at the College of the Holy Cross and Manhattanville College, and was the founding director of the Gallery at the American Bible Society. Dr. Heller edited the volume *Reluctant Partners: Art and Religion in Dialogue* (2004) and the exhibition catalogs *Tobi Kahn: Sacred Spaces for the 21st Century* (2009), and *Icons or Portraits? Images of Jesus and Mary from the Collection of Michael Hall* (2001). She is a contributor to the volumes *From the Margins: Women of the Hebrew Bible and their Afterlives* (forthcoming), *Women's Space: Patronage, Place, and Gender in the Medieval Church* (2005) and *The Art of Sandra Bowden* (2005).

**Robin M. Jensen** is the Luce Chancellor's Professor in the History of Christian Art and Worship at Vanderbilt Divinity School in Nashville, Tennessee. She earned her PhD jointly from Columbia University and Union Theological Seminary and her MDiv from Union Theological Seminary. Professor Jensen has published extensively for both popular and scholarly audiences. Her books

include: *Face to Face: The Portrait of the Divine in Early Christianity* (2005); *The Substance of Things Seen: Art, Faith and the Christian Community* (2004); *Understanding Christian Art* (2000) and *The Art and Architecture of Ancient Christian Baptism* (2009).

**Kathryn Kueny** is director of the Religious Studies Program and Clinical Associate Professor of Theology at Fordham University. She earned her PhD in the History of Religions and her MA in Divinity from the University of Chicago. Professor Kueny's numerous publications include *The Rhetoric of Sobriety: Wine in Early Islam* (2001), "The Birth of Cain: Reproduction, Maternal Responsibility, and Moral Character in Early Islamic Exegesis" in *History of Religions* 48, no. 2; "From the Bodies of Bees: The Classical and Christian Echoes in *Surat al-Nahl*," *Comparative Islamic Studies* 3, no. 2 (2007) 145–168; and "Abraham's Test: Islamic male circumcision as ante/anti-covenantal practice" in *Bible and Qur'an: Essays in Scriptural Intertextuality* (2003). She has also contributed to the *Encyclopaedia of the Qur'an* (2005, 2006) and the *Encyclopedia of Islam and the Muslim World* (2003). Currently she is preparing a book entitled *Maternity and Maternal Identities in Islamic Discourse and Practice.*

**C. Griffith Mann** is the chief curator at the Cleveland Museum of Art. He earned his PhD in Medieval Art from Johns Hopkins University. As a curator, Dr. Mann has organized and contributed to several exhibitions, including *Sacred Arts and City Life: The Glory of Medieval Novgorod* (2005) and *The Book of Kings: Art, War, and the Morgan Library's Medieval Picture Bible*, which received a National Endowment for the Humanities implementation grant in 2002. A specialist in the arts of late medieval Italy, Dr. Mann is a contributor to the *Lion Companion to Christian Art* (Michelle Brown, ed., Oxford: Lion Hudson, 2008) and the *Oxford Dictionary of the Middle Ages* (forthcoming).

**Mary C. Moorman** is a PhD candidate and lecturer in Systematic Theology at Southern Methodist University. She earned her Master of Arts in Religion with a focus in systematic theology at Yale Divinity School in 2006, and a law degree focused on religious legal systems from Boston University School of Law in 2004. Ms. Moorman has published and presented primarily in the areas of ecclesiology and ecumenical dialogue, and has held teaching positions at Boston University and the University of New Haven.

**Patricia C. Pongracz** is curator-at-large at MOBIA and an adjunct professor at the College of Saint Elizabeth, Morristown, New Jersey. She earned her PhD in the History of Art and Architecture with a specialty in medieval art history from Brown University. Her publications include several catalogs for MOBIA: *Biblical Art and the Asian Imagination* (2007); *The Word on the Street: The Photographs of Larry Racioppo* (2006); *The Next Generation: Contemporary Expressions of Faith* (co-authored with Wayne Roosa, 2005); *Threads of Faith: Recent Works from the Women of Color Quilters Network* (co-authored with Carolyn Mazloomi, 2004); as well as articles on stained glass: "Scientific Investigations of Glass Excavated at the Abbey of Saint-Jean-des-Vignes," co-authored with Robert Brill, *Journal of Stained Glass* 46 (Spring 2004); and "The Chapel's First Installation and Move to Saint John the Divine," *The Tiffany Chapel at the Morse Museum* (2002).

**Xavier John Seubert** is Thomas Plassmann Distinguished Professor for Art and Theology at St. Bonaventure University, St. Bonaventure, New York, where he is currently the director of the Art History Department. Dr. Seubert earned a Doctor of Sacred Theology at Albert-Ludwigs Universität, Freiburg im Breisgau, Germany and an MA and Certificate in Curatorial Studies at the Institute of Fine Arts, New York University. He has contributed to the volumes *In Solitude and Dialogue: Contemporary Franciscans Theologize* (2000); *Postmodern Worship and the Arts* (2002) and

*Between the Human and the Divine: Philosophical and Theological Hermeneutics* (2002), and has written articles for *Worship, New Theology Review, Cross Currents* and *The Heythrop Journal*.

**Nancy Wu** is the Museum Educator at The Cloisters, The Metropolitan Museum of Art. She earned her PhD in Art History from Columbia University and has been the recipient of numerous awards and distinctions. Her publications include *The Cloisters: Medieval Art and Architecture*, co-authored with Peter Barnet (2005) and *Ad Quadratum: The Application of Practical Geometry in Medieval Architecture* (2002), for which she was both a contributor ("The Hand of the Mind: The Ground Plan of Reims as a Case Study") and volume editor; and "Hugues Libergier and his Instruments," *Avista Forum Journal* 11, no. 2 (1998–99). Her most recent article, "Le chevet de la cathédrale de Reims et le plan du début du XIIIe siècle," appeared in Bruno Decrock and Patrick Demouy, eds., *Nouveaux regards sur la Cathédrale de Reims* (Langres: Editions Dominique Guéniot, 2008) 67–79.

# Index

Page numbers in *italic* refer to illustrations

**A**

Abraham, 193
Abu Sa'id, 195
Abu-Ghraib, 12
Adam of St. Victor, 208n10
Adams, Henry, 42
'Aisha, 192–93
Albert the Great, St., 162
Alexander of Hales, 141–42
Ambrose of Milan, *De Mysteriis* and *De Sacramentiis*, 208n10
American Bible Society, Rare Scripture Collection, 111
Anas, 195
anti-Semitism, 24–26
antiphonary,
    Portuguese, *119*
    Spanish
        detail of leaf, *60*, *108*, *122*, *124*
        Page A, 112–15, *113*, *116*, 117
        Page B, *114*, 115–17
    Spanish (16th century), leaf, 123–25, *124*
antiphoner (office book), 118–20
Aquinas, St. Thomas, 155, 157
Aristotle, 155, 188
arms and armor, misconceptions about, 167–86
ARTFL Project, University of Chicago, 120
Assisi, Santa Chiara, *Crucifix of St. Damiano*, 55, 57
Astudillo, convent of Santa Clara, 100
Athanasian Creed, 159
Augustine of Hippo, St., 142, 143, 154, 158–59, 162

**B**

Bach, Johann Sebastian,
    *Matthäuspassion*, 162
    *Actus Crux*, 162
Baroncelli family, 14, 18
Beard, Charles, 179
Benedict XVI, Pope, 208n10
Bennett, Adelaide, 123
Bern, Switzerland, 112
Bernadone, Pietro di, 58
Bernard of Clairvaux, St., 161
    *Apologia*, 102
    *Sermons on the Song of Songs*, 160
Bjorkvall, Gunilla, 111
Blumenthal, George, 93
Bonaventure, St., 13–14, 141, 162
Book of Kells, detail of the Genealogy of Christ, *30*, 31
Boucicaut, Marshal (Jean de Meingre), 174, 179
Boynton, Susan, 118
Breck, Joseph, 93, 106
Brooks, Mel, 11
Brusius, Jan, 111
Byzantine liturgy, 137–40

**C**

Calvin, John, 152
cameo with *St. Theodore Stratelates*, Byzantine, *78*
cameo with *The Virgin Mary Praying*, 90–91, *90*
CANTUS database, 121–22
Capwell, Tobias, 179
Catacomb of St. Priscilla, Virgin and Child with a prophet and a star, 36, *37*
Catechism of the Catholic Church, 208n8
Catherine of Siena, St., 161
*Catholic Encyclopedia*, 11
ceiling tiles,
    with hare, Spanish, 82, *83*
    with lion's head, Spanish, 82–85, *84*
chalices, 137, 143–44
    Bohemia or Austria/Germany, 140, *142*
    Byzantine, 137, *139*, 140
    Italian ('Walters chalice'), 127, *128*, 129–35, 137, 141, *161*
    of Peter of Sassoferrato ('Cloisters chalice'), 133, *134*, 143
Charles Martel, 151
Chartres Cathedral, *44–45*
    *Notre Dame de la Belle-Verrière*, 42, *43*
*Christ before Caiaphas* (miniature), 24, *25*
*Christ Pantokrator*, mosaic, Daphni, 49–57, *53*
Cimabue, *Virgin and Child with Angels*,
    detail (St. Francis), *56*, 58
Clement IV, Pope, 24
Cleveland Museum, 181
The Cloisters Museum, Fort Tryon Park, New York, 93–107
    Chapter House from Notre-Dame-de-Pontaut, *101*, 102–6
    Cuxa Cloister, 96, 100–102, 107
    Fuentidueña Chapel, 96–100, 103
    Gothic Chapel, 96
    Gothic Hall, 96
    Mérode Room (formerly Spanish Room), 93, *94–95*, 96, 106–7
    Pontaut Chapter House, 96
    upper driveway entrance in winter, *92*
*Cohen's Advertising Scheme*, 26
Collens, Charles, 93
Columbia University, Rare Book and Manuscript Library, 118, 123
communion, spiritual, 143
*Communion and Consecration of St. Francesca Romana*, panel from Italian altarpiece, 151, *153*
Communion of the Faithful, 91, 138, 140
Constantinople, 91
Crucifixion of Christ, 135
Cyril of Alexandria, *Prochatechesis* and *Catechesis*, 208n10

**D**

al-Damiri, Kamal al-Din Muhammad ibn Musa, *Hiyat al-hayawan*, 196
Dante Alighieri, *72*
    *The Divine Comedy*, 71
De Sica, Vittorio, 61
al-Dhababī, *al-ṭibb al-nabawī*, 192
Digital Scriptorium, 118
diptych with the *Nativity, Adoration of the Magi, Crucifixion, and Last Judgment*, ivory, Flemish or French, *80*
Doyle, Sir Arthur Conan, 186
Duns Scotus, Blessed John, 163
Dürer, Albrecht,
    *Knight, Death, and the Devil*, 170–73, *171*
    *Melencolia I*, 170
    *St. Jerome in his Study*, 170

**E**

Eco, Umberto, 12
Eleanor of Aquitaine, Queen, 42–47, *46*, 57
England, 111

Eucharist, 86–89, 127, 129, 130–32, 137–45, 151–56
  *res* of, 140–41, 154
Eucharistic doves, 152
  Limoges, *146*, 147, 155
Eucharistic vessels, as emblems of embrace, 157–63
*Everyman*, 61
Extreme Unction, 90

F
*Familiaris Consortio* (encyclical), 208*n*10
Fatima, 194
Filippo da Verona, *Apparition of St. Anthony to the Blessed Luca Belludi*, man-at-arms mounting a horse, *178*
Florence, Baptistery, *70–71, 72*
Fontevraud Abbey, France, tomb of Eleanor of Aquitaine, *46*
Francis of Assisi, St., *56,* 58–65
Fuentidueña, San Martín church, Spain, *96, 97*

G
Gaddi, Taddeo, 14
Germanos, St., patriarch of Constantinople, 20
al-Ghazali, Abu Hamid, 189–90
  *'Ihya 'ulum al-din,* 193
Giacomo Nicolo di Berardello, 130
Ginestarre de Cardós, Lleida province, Spain, 100
Giotto di Bondone, 14
  *Betrayal of Christ,* 65–72, *68–69*
  *Celebration of Christmas at Greccio,* Assisi, *60,* 61
  *Crucifixion,* Scrovegni chapel, Padua, *54–55, 57*
  *Dream of Pope Innocent III,* 61, *62*
  frescoes, Scrovegni Chapel, Padua, *64, 65*
  *Lamentation,* Scrovegni Chapel, Padua, 65, *67*
  *Last Judgment,* Baptistery, Florence
    detail (Dante), *72, 72*
    detail (*Giotto among the Group of the Elect*), 65–72, *73*
    detail (*Satan in Hell*), *70–71, 72*
  *Nativity 66,* 65, Scrovegni Chapel, Padua, *64, 65*
  *St. Francis Mourned by St. Clare,* Assisi, 61–65, *63*
  *St. Francis Renounces All Worldly*

*Possessions*, Assisi, *59*
Glasgow Museums, 181
Gouvert, Paul, 106
Greccio, Italy, 61
Gregory I (the Great), Pope St., 184
Guccio di Mannaia, 133
Guido, Bishop of Assisi, 58
Guinness, Alec, 26

H
Heidegger, Martin, 144
Henry II, King of England, 47
*Henry V* (movie), 179–80
Herberger, Valerius, 162
Hesbert, René-Jean, *Corpus Antiphonalium Officii,* 121
Hildegard of Bingen, 31–35, 40, 47
  and the Four Seasons, *De operatione Dei,* *33,* 35
  *Scivias, 32, 33,* 35
Hippocrates, 188, 189
Hugh of St. Victor, 12
*The Hunt of the Unicorn* (tapestry), 20–24, *20–21*
  detail, *22*
Husayn (son of Fatima), 194

I
Ibn 'Arabi, Muhyi al-Din, 193
Ibn Jazzar al-Qayrawani, Abu Ja'far ibn Abi Khalid, 191, 196
Ibn Muhammad ibn Aḥmad ibn Yūsuf ibn Ilyās, *Tashiīḥ-i badan-i insān,* 191
Ibn Qayyim al-Jawziyya, 189
Ibn Sa'd, 'Arib, 189, 190
Ibn Shahrashub, 194
Illescas, Spain, 93
Incarnation of Christ, 138, 147, 154, 159
indulgences, 85–86
Innocent III, Pope, 61, *62*
Iraq war, 11
Isaac of Norwich, Moses Mokke and Abigail (miniature from Jewish Receipt Roll ), 26, *27*
Islam, early and medieval, 187–97

J
Jāmī, *Kitāb Salāmān va Absāl,* miniature of couple having sexual intercourse, *191*
Jacopo da Voragine, *The Golden Legend,* 90, 151
al-Jahiz, Abu 'Uthman 'Amr ibn Bahr, 187,

196, 197
Jean de Meung, *L'Art de Chevalerie,* man-at-arms mounting his horse, *166, 176*
Jews, representations of, 24–26
Justin Martyr of Ephesus, St., 159

K
Khadija, 192
knights, 167–86
*A Knight's Tale,* 11
Konrad von Eberbach, *Exordium,* 160–61

L
La Tricherie, France, 96
La Trobe Medieval Music Database, 121, 122
Lacoste, Debra, 121
*Lady and the Unicorn* series, *48*
*Last Judgment,* west porch and tympanum, Ste. Foy abbey church, Conques, France, *149,* 151
Lateran Council, 4th, 24
Ledger, Heath, 11
Lee, Lorenz, "He's illuminating something called 'The Book of Billable Hours'" (*New Yorker* cartoon), *28,* 29
Leo VI, Emperor, 91
Limoges, 147, 155
lion, symbolism of, 23
Luke, Gospel of, 31, 122

M
Mann, Sir James, 179
*Manuale Augustini,* 161
Marlowe, Charles (Harriett Jay), and Buchanan, Robert, *When Knights Were Bold,* 179
Martini, Simone, *St. Martin and the Miraculous Mass,* 130, *131,* 132
Mass, Catholic, 85, 86–89, 110, 138
Master of Flemalle, Workshop of, *Annunciation* Triptych (Mérode Altarpiece), *94–95,* 104–5, *106–7*
Master of St. Giles, *Mass of St Giles,* 86, *87, 150,* 151
Matthew, Gospel of, 58
Metropolitan Museum, New York, 169
  Department of Arms and Armor, 180
  "Heilbrunn Timeline of Art History", "Arms and Armor" section, *168*
*miles christianus,* 170

Miles, Margaret, 142
miracles, 151, 152
*Miraculous Mass of St. Martin of Tours*,
    Franconian School, *13*
*Monty Python and the Holy Grail*, 11
    film poster, *10*
Muhammad (prophet), 192, 194, 195

N
Nevers, France, 100
Nicholas IV, Pope, 133
Notre-Dame-de-Pontaut, abbey, France,
    Chapter House, *101*, 102–6
Nuremberg, 173

O
obstetrics, early and medieval Islamic,
    187–97
*Oliver Twist* (movie), 26
Olivier, Laurence, 179

P
Padua, Scrovegni Chapel, *53*, 57, 65, *65*
Paolo di Giovanni di Tura, 130
patens, 129, 144
    Byzantine, 127, *136*, 137, 140, 141
pelican, as symbol of Christ, 47
Peter of Sassoferrato, 133
Philadelphia Free Library, 111
Pizan, Christine de, *L'Epître d'Othéa*,
    Hector's family begs him not to go
    into battle, *177*
Plato, 142
Princeton University, Index of Christian
    Art, 123
*The Procession of (Saint) Gregory the Great
    for the cessation of the plague in Rome
    (Très Riches Heures du Duc de Berry)*, 19
pyx, gilt and copper, French, *88*, 89–90

Q
al-Qazwini, Hamdullah al-Mustawfi,
    *'Ajā'ib al-makhlūqāt wa-gharā'ib al-
    mawjūdāt*, creatures from the Island
    of Zanj, *194*
    *Nuzhatu-l-qulub*, 193
Qur'an, 187–89, 190, 193, 197

R
Rabban al-Tabari, 'Ali ibn Sahl, 190–91, 192
    *Firdaws al-hikma*, 191
Radbertus of Corbie, Abbot, 208*n*13

Ratramnus of Corbie, Abbot, 208–9*n*13
*Realms of Faith* (exhibition), 76, 77–91, 87,
    127, 137, 143, 144, 158, 165
reliquary with scenes from the *Life of
    Christ*, Limoges, *78*
Resurrection of Christ, 85, 90
Rockefeller, John D., Jr., 93
Rome,
    St. John Lateran, 61, *62*
    San Clemente, apse mosaic, 47–49, *50–52*
    Santa Maria in Trastevere, apse mosaic,
        *38–39*, 40, 42
        detail (*Christ Enthroned and the
        Crowned Virgin*), *41*
Rorimer, James, 93, 106
Rossellini, Roberto, 61

S
St. Gall, Switzerland, Benedictine
    monastery, 112
*St. George Killing the Dragon*, icon,
    Byzantine, *78*
Saint-Guilhem-le-Désert, Benedictine
    abbey, 96
Saint-Michel-de-Cuxa, Benedictine
    monastery, *98–99*
saints, 90–91
Santa Croce, Florence, Baroncelli Chapel,
    14–18
    general view, *16–17*
    interior of church with, *15*
Schmemann, Alexander, 138
Seupel, Johann Adam, *Levies of Strasbourg*,
    *172*, 173
Shi'ite Islam, 194
Siena, 127, 129, 132
Southern Mississippi, University of, 118–
    20, 123–25
spoon, liturgical, Byzantine, 137, 140, *140*
square notation, 112–15, *115*
Stafleu, Gerard, 121
Steiner, Ruth, 121
Strasbourg Cathedral, 173
Suger, Abbot, 89, 157
Sunni Islam, 194
al-Suyūṭī, Jalāl al-Dīn, 190, 193
    *al-Manhaj al-sawī wa-al-manhal al-rawī
    fī al-ṭibb al-nabawī*, 197
Sweden, National Archives, 111

T
Theodoret of Cyrus, 158

Thomas of Celano, 57
transubstantiation, 86–89, 140, 147, 155
Trier, Cathedral of St. Peter and
    Liebfrauenkirche, *34–35*, 35
Twain, Mark, *A Connecticut Yankee at King
    Arthur's Court*, 179

U
unicorn, as symbol of Christ, 20–23, 47

V
Valentino, Pacino di, 132–33
Vienna, 181
Villard de Honnecourt, man-at-arms
    mounting a horse, *175*
Viollet-le-Duc, Eugène-Emmanuel,
    *Dictionnaire raisonné de l'architecture
    française du XIe au XVIe siècle*, 93
Virgin Birth, 90
*Virgin and Christ with Two Angels* and *The
    Crucifixion*, crosier, French ivory, *78*
vision, doctrine of, 142–43
Vitello, Paul, 85–86
Volmar, 35

W
Walters Art Museum, Baltimore, 129
Western Ontario, University of, 121
William of St.-Thierry, Abbot, 102

Z
Zakariya, 193
Zürich, 112